UNDER CAPE COD WATERS

UNDER CAPE COD WATERS

ETHAN DANIELS

UNION PARK PRESS

BOSTON

Union Park Press
Boston, MA 02118
www.unionparkpress.com

Printed in China
First Edition

© 2010 Ethan Daniels

Library of Congress Control Number: 2009943551
ISBN: 978-1934598-05-4; 1-934598-05-4

Book and cover design by theBookDesigners

DEDICATION

This book is dedicated to my entire family, who were the greatest encouragement one could wish for during the arduous process of producing characteristic underwater images of Cape Cod. Thirty-seven years ago, my family first introduced me to the wonders of this great New England peninsula, and my appreciation for the area continues to grow season after season, year after year. I can only hope that my daughter and her cousins, who now have the opportunity to explore the Cape's secrets and will be inheriting its beauty, resources, and quandaries, will grow to love and care for the area as much as I do.

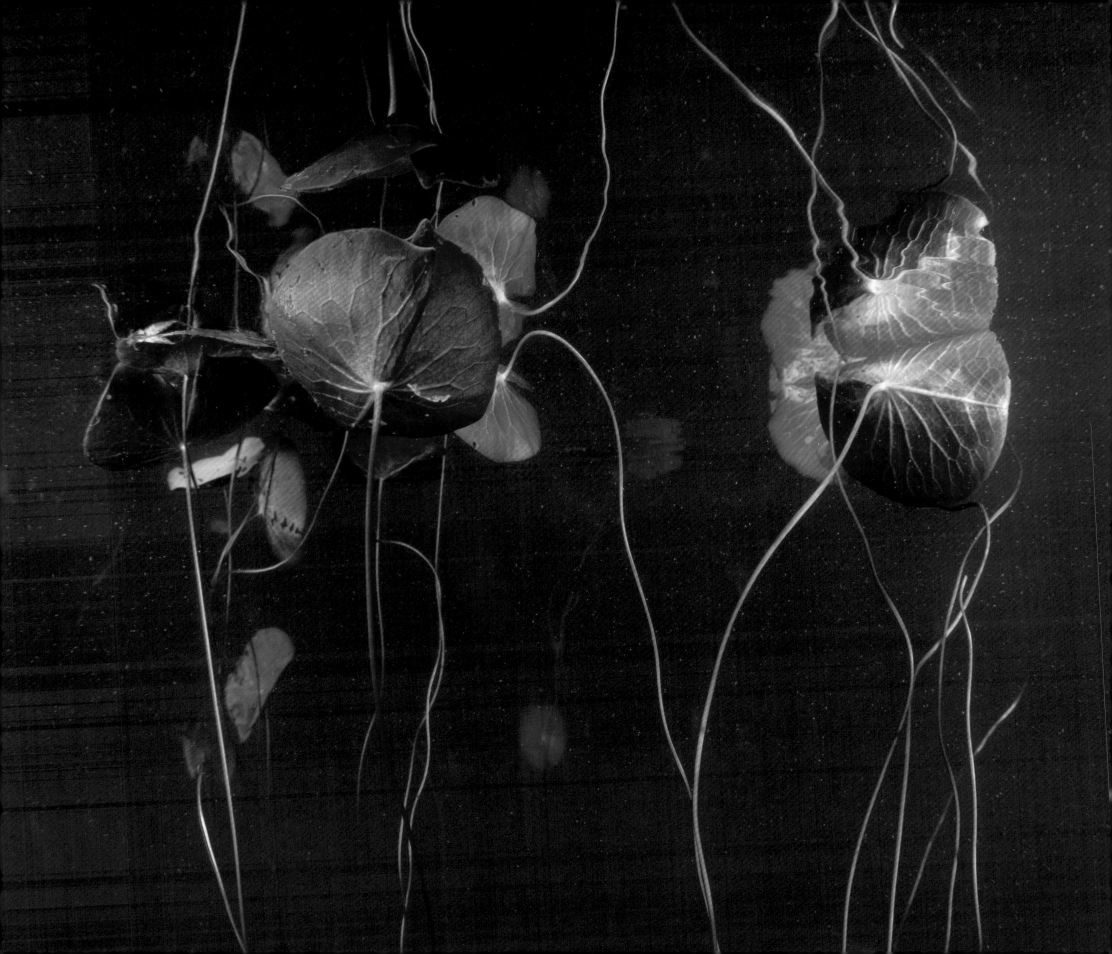

ACKNOWLEDGEMENTS

I would like to thank Bob Daniels, Bill Sargent, Jerry Cronin, and Nicole Vecchiotti, who have been immensely helpful in the generation and evolution of this project. Without their enthusiasm and assistance, this book would never have materialized. I'd also like to thank Ila Deiss and Jasmine Daniels for being incredibly supportive and putting up with my prolonged absences during long trips away from home.

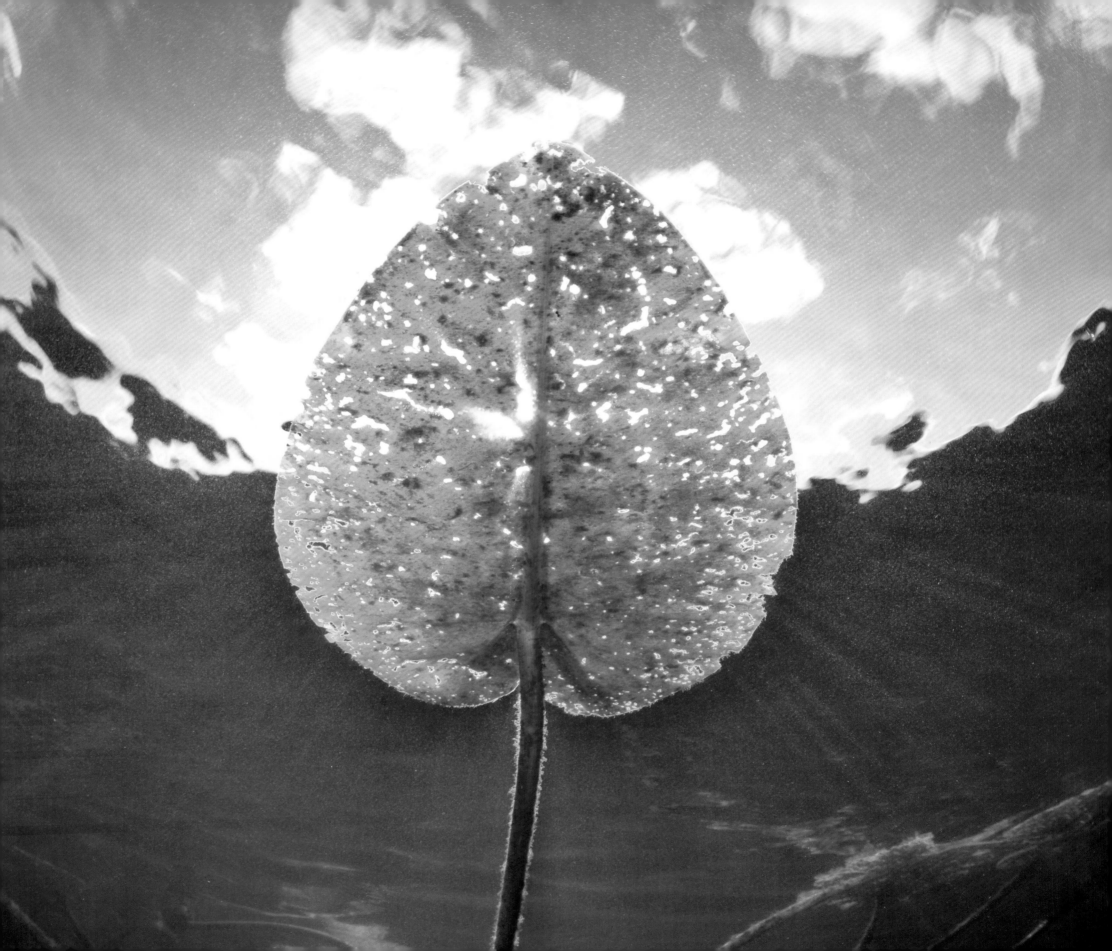

ETHAN'S EYES BY WILLIAM SARGENT

For centuries Cape Cod kids have grown up to become ship captains, whalers, China traders, and banana merchants. They have learned to laze under Polynesian palms and to iron whales amidst the Roaring Forties and towering icebergs of Antarctica. They have learned to buy and sell in Mandarin and Cantonese. They have made great fortunes and sailed famous ships in record-breaking times around the Horn to San Francisco.

Then, sometime in their middle years, they suddenly become gripped with the realization that where they really want to be is back on Cape Cod. The memories of those languid days and limpid nights of their youth make them homesick for the zip and tang of Cape Cod waters. All they want to do is return home and see Cape Cod, as if for the first time.

In recent years, we have discovered a new subset of these Cape Cod kids. They grew up diving in Cape Cod's creeks and marshes, but have gone on to become surfers, writers, oceanographers, and photographers.

One of these young men is Ethan Daniels. For the past decade, Ethan has lived the dream. He's led diving expeditions and taken underwater photographs in Tahiti, Palau, Bora Bora, and Sumatra. With all the requisite equipment and all the tricks and tools of the trade, he shows us the underwater world through his eyes.

Photographing the brilliant colors and clarity of tropical waters has made Ethan all the more appreciative of the subtlety of Cape Cod. It's pretty hard to miss the obvious colors and startling clarity of a coral reef, but in a Cape Cod creek, one has to focus not only on the brilliant colors of the red beard sponge, but also on the tiny Dr. Seussian Caprellids that sit amidst the sponge's fissures and sulci. One must concentrate on the marsh shrimp holding stationary in the current as well as the tiny leech picking bacteria off the shrimp's carapace.

It has been a pleasure to rediscover Cape Cod's waters through Ethan's eyes. With this book, you too will be able to enjoy his unique view of our underwater legacy.

Pleasant Bay, April 2009

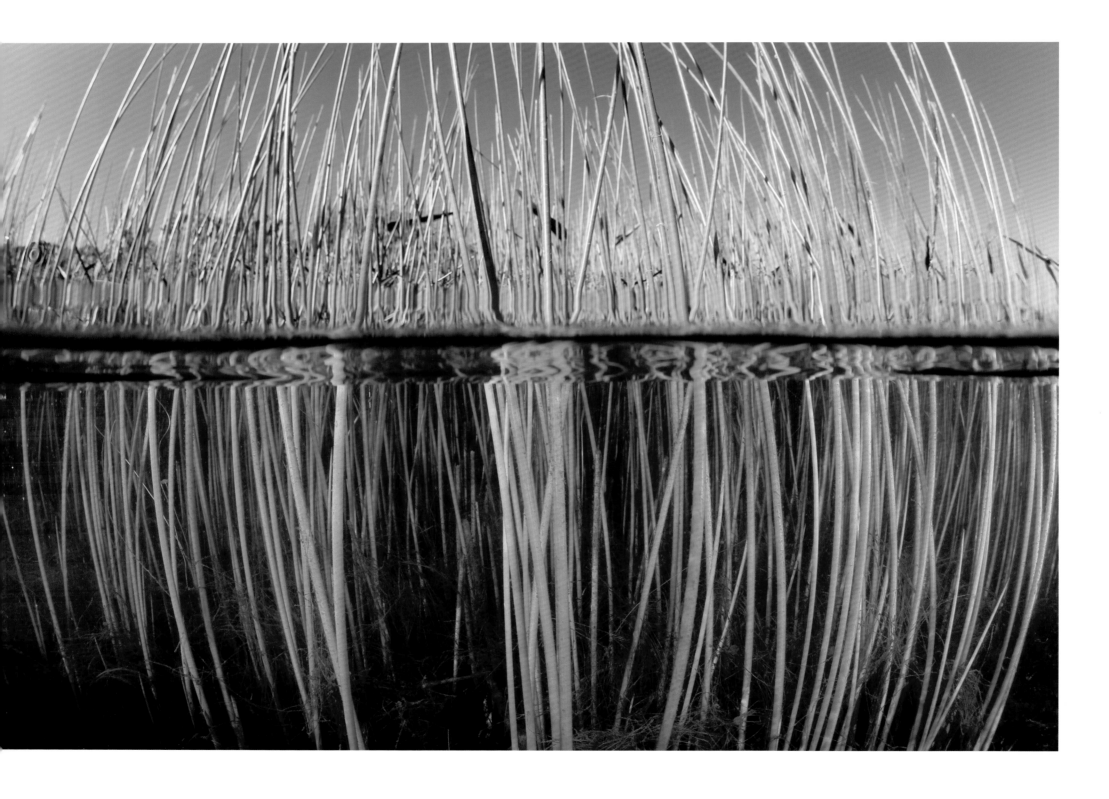

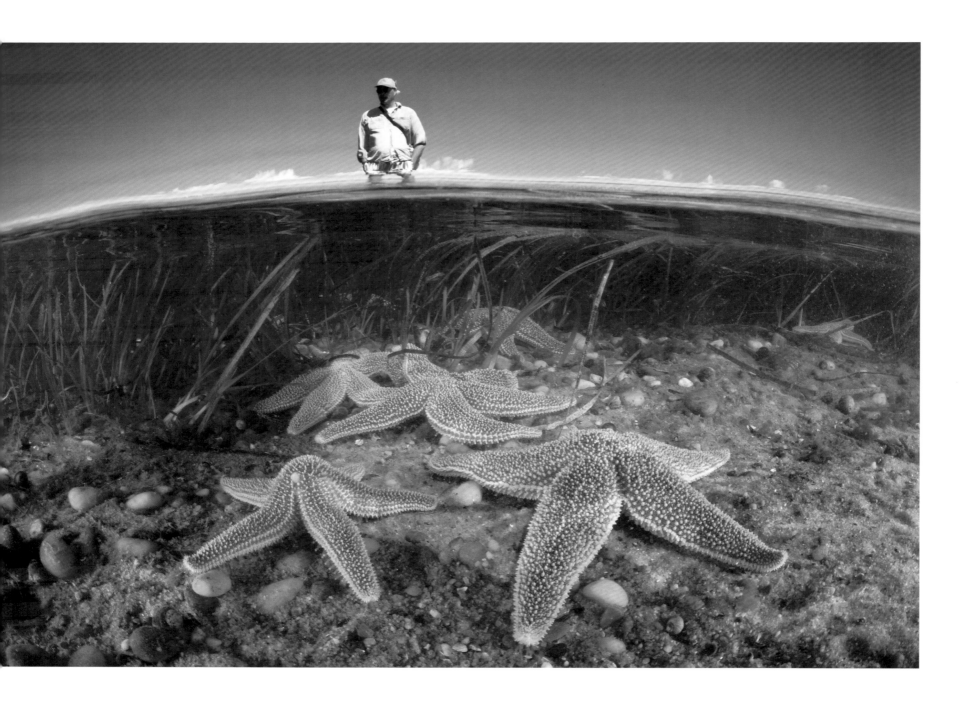

PREFACE

Some of my deepest and most vivid memories comprise adventures, big and small, amongst the many coves, beaches, and ponds of Cape Cod. Learning to swim in Pilgrim Lake, sailing wooden beetle cats in Pleasant Bay, being rolled by waves at Nauset Beach, gazing over the late afternoon waters toward Sampson Island from my grandmother's house near Namequoit River—these recollections have attended me throughout my travels across the planet. They have informed my interests and passions and pulled me back to the Cape again and again. Though my work—a mishmash of guiding adventure travel trips, writing, and shooting images for various publications—takes me to distant and picturesque locales from Antarctica and South Africa to Indonesia, Micronesia, and Myanmar, Cape Cod's shores are rarely far from my thoughts.

Several authors, including Henry David Thoreau and Henry Beston, have written Cape Cod into history, but few have either attempted or had the ability to portray the least known elements of the Cape—those below the waterline. One book that does go beneath the surface is *Shallow Waters* by Bill Sargent. This book, published in 1981, greatly affected my path of schooling. Following the cyclical chronicle of a bay on the outer Cape, *Shallow Waters* describes the underwater ecological happenings over the course of four seasons. To this day, that book continues to sit in my living room, acting as my baseline reference for the outer Cape's inshore marine habitats. I have since become friends with Bill Sargent, who is often found exploring the area's coastal waters, just as I continue to do.

Shallow Waters brought to light a relatively unknown piece of Cape Cod through words. *Under Cape Cod Waters* means to do similar work through photography, showing natural views of underwater surroundings using the latest in imaging technology. From my point of view, photography unlocks a window on Cape Cod whereby the unique textures, colors, and patterns of native life are simplified into two dimensions.

Though trained as a scientist, there has always been a part of me that sees conventional scenes in a different and extraordinary way. This is why nature photography has always nourished my curiosity. Capturing an iconic moment in time as sunlight or clouds paint an environment is both a way to observe and a way to create. Digital photography has been an especially useful tool, not only for studying organisms but also for illustrating fascinating aspects of the physical world. Images have the ability to capture assorted and sometimes fleeting moods of the natural world. Light, temperature, humidity, cloud cover—everything varies moment by moment, and shooting in the field is never the same twice. In this way, photography is similar to looking through a diving mask at an underwater scene. It is continuously shifting.

> Capturing an iconic moment in time as sunlight or clouds paint an environment is both a way to observe and a way to create

However, as a photographer with a scientific background, I can't help but be preoccupied with the daily struggles of wildlife. I find myself returning repeatedly to the places I photographed, searching for the inevitable changes occurring not only to individual animals but also to their surroundings. Revisiting these sites centers me; it gives me a bit of an idea where I fit into it all. It is this urge that prompted this book, and it has made me well aware of the natural and the anthropomorphic influences that are constantly affecting the aquatic and marine environments of Cape Cod.

While I don't intend this book to bring to light anything that isn't already scientifically established, I am eager to display the elements of a local environment that few people ever see and even fewer know much about. I'm a firm believer in the more one knows about the world, the more one cares. Our species has potential to do great and constructive acts, but we have also proven the ability to do enormous and irreparable harm. In this regard, my hope is that the images in this book come not only as a revelation but also call all those who know and love Cape Cod to get involved.

Whether it is the intricate detail of a Canada goose feather or the armor-like carapace of a horseshoe crab, the splendor of the natural world lies just beyond our doors. For me, nothing is more inspirational than the sea and its associated life. The world beneath Cape Cod's near-shore waters is what nature is all about—beauty, mystery, and constant change. And this is what keeps bringing me and others far more eloquent than I back to this unique peninsula, so well known, yet always so fresh and baffling and magnetic. I hope this pictorial view of what lies below the surface of the Cape's many marine and aquatic habitats explains where my words falter.

The world beneath Cape Cod's near-shore waters is what nature is all about—beauty, mystery, and constant change

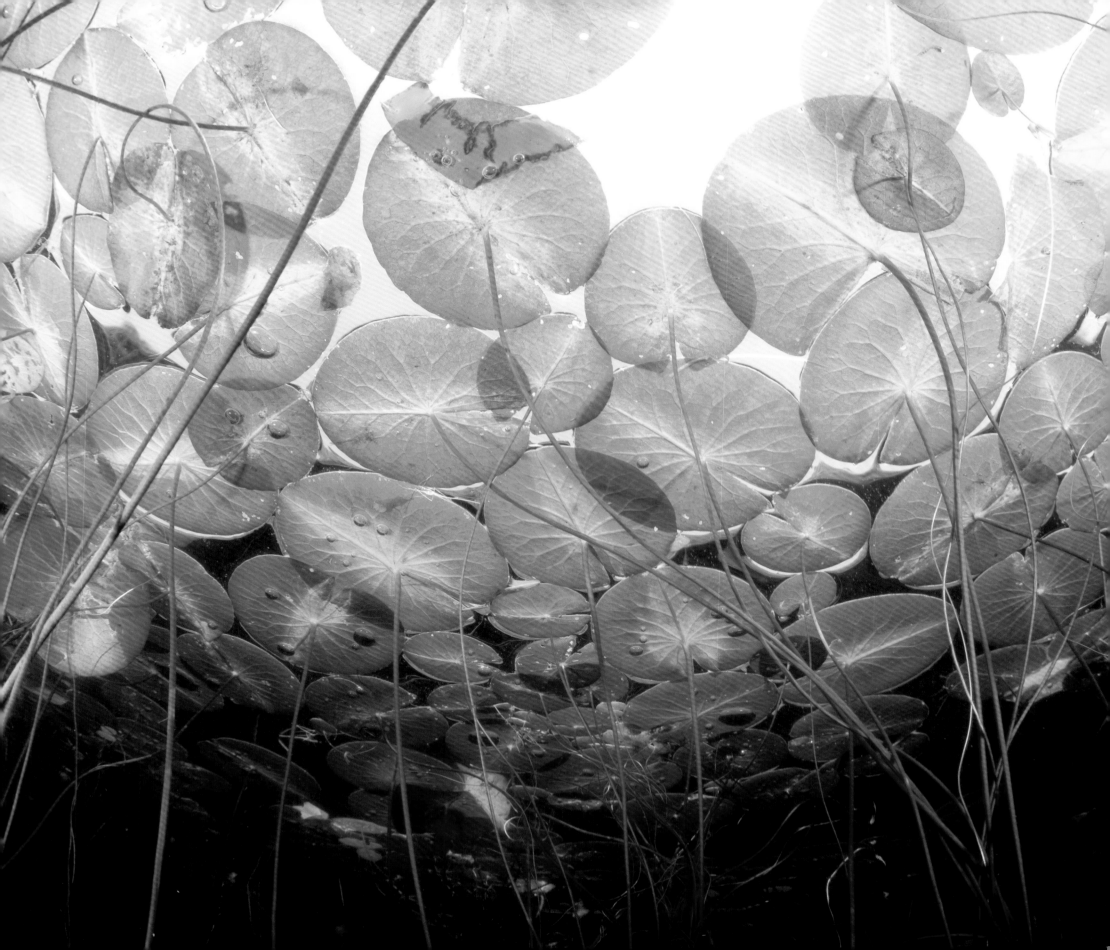

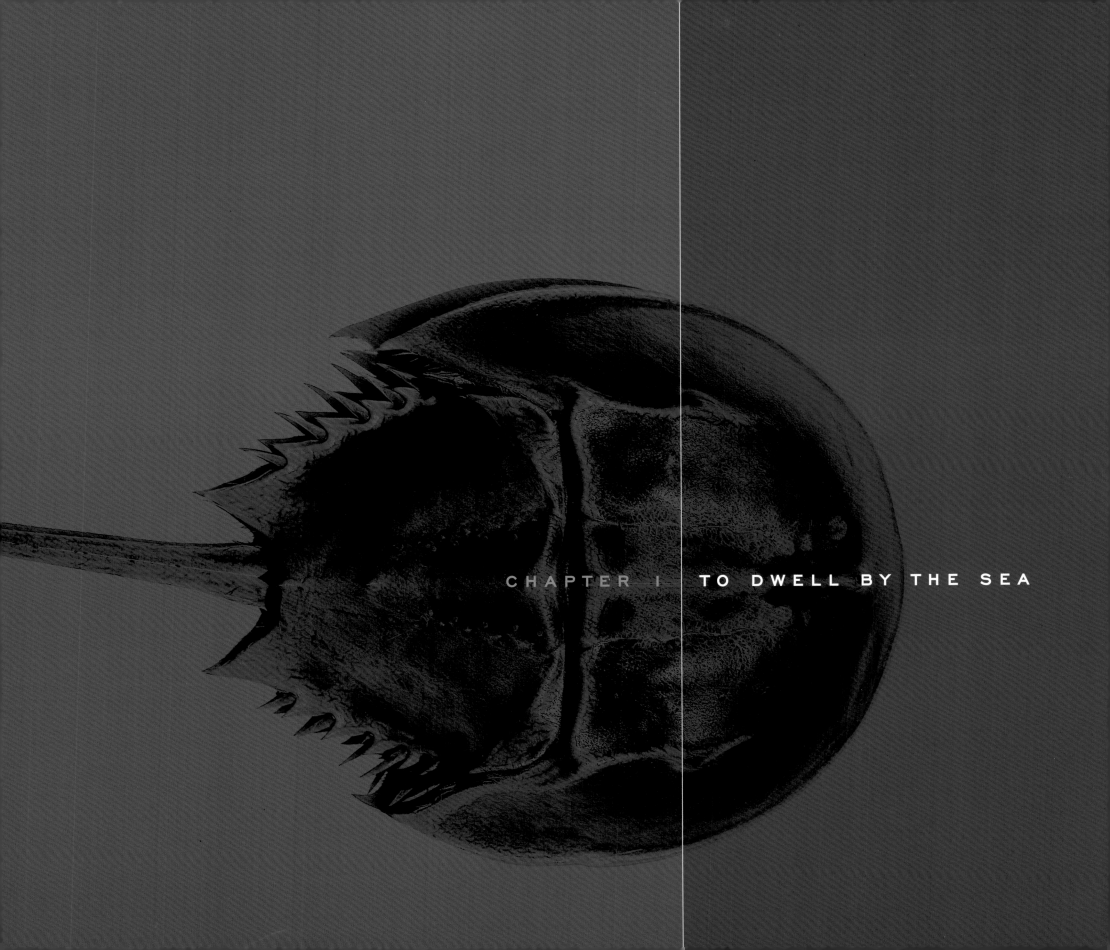

CHAPTER I TO DWELL BY THE SEA

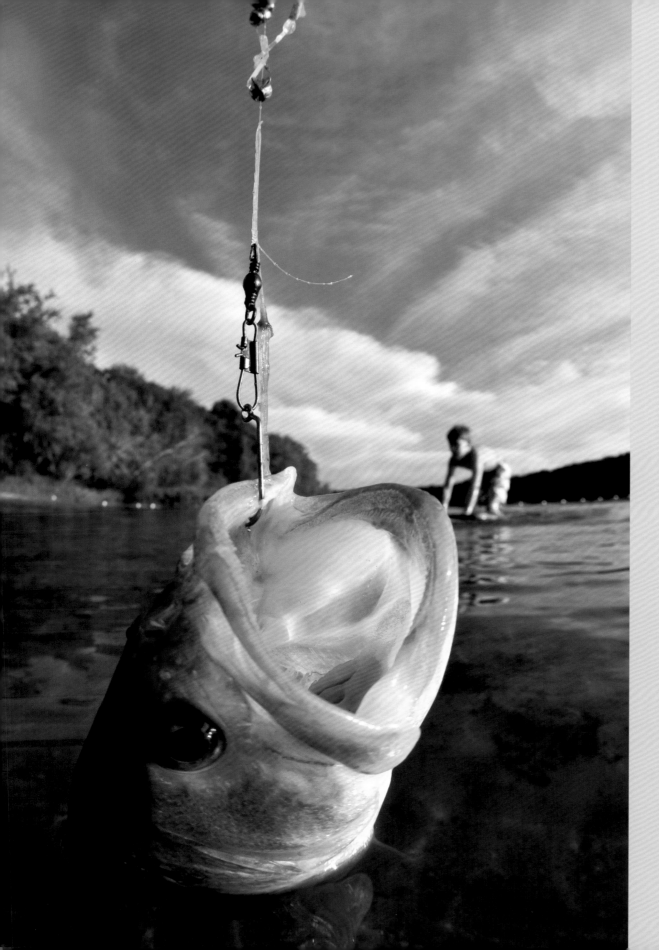

Fishing is both a pastime and a multi-billion dollar industry in New England. In the late summer, there is nothing like spending a lazy afternoon casting over a still pond. Largemouth and smallmouth bass, perch, bluegills, pickerel, and trout are common fish to cast for throughout many freshwater habitats.

6

Surrounded by thousands of square miles of cold, rough water, Cape Cod is an iconic landmass and an integral part of New England. Its near-shore waters are both diverse and productive, making the Cape's coastal ecosystems as dynamic and prodigious as any along the Atlantic shoreline. Like the mysterious depths of the ocean, the shoreline captivates those who take the opportunity to extensively explore it. The wealth of marine and aquatic life and the people who dwell on the peninsula are influenced by many factors, some easy to assess and others difficult to imagine.

Whether it is obvious or not, Cape Cod's marine and aquatic ecosystems are incessantly altering

The present view of Cape Cod and its flora and fauna is only a momentary snapshot that will eventually be altered by seen and unseen influences over geologic time. In fact, some geologists believe that the Cape will be unrecognizable within two thousand years and will have completely vanished within four thousand years due to the sea's powerful erosive forces. Today's ever-shifting, sandy and rocky coastline is still untamed in certain places, leaving natural selection to shape the current and future flora and fauna. Whether it is obvious or not, Cape Cod's marine and aquatic ecosystems are incessantly altering, changing with the tides and currents and the immigration and extinction of organisms.

Seventeen thousand years ago the Cape was merely a crest on an immense sandy plain that is now highly productive fishing grounds—Stellwagen Bank to the north and Georges Bank to the east. The Cape's recognizable shores were fashioned into recent form over fifteen thousand years ago by massive glaciers, sharp winds, and relentless waves. When sea level was more than three hundred feet below what it is today, mastodon and other extinct animals of the Pleistocene epoch and most, if not all, of the native animals and plants that now live in northeastern North America once flourished on New England's exposed continental shelf. As the end of the most recent cold period melted ice sheets worldwide, water returned to ocean basins. Somewhere around six thousand years ago, the rising sea began eroding the Cape's glacial sediment deposits, sculpting the peninsula's current distinctive contours.

What is so striking about the shape of Cape Cod's exposed peninsula is its ostensible strength. Covering over four hundred and thirty square miles, the peninsula juts sixty miles east and north from the mainland into the North Atlantic Ocean. This flexing arm of sand and rock plunges into the face of a frigid sea south of the Gulf of Maine, yet oceanic currents help generate a temperate maritime climate, cooler in the summer and warmer in the winter compared to further inland. Influenced from the north by the fertile waters of the Labrador Current and from the south by the warmer Gulf Stream, the Cape continues to play a role in the migrational patterns of many birds, marine mammals, fish, and marine invertebrates. And for good reason, it has long held appeal to people, catching attention with both genuine beauty and bountiful natural resources.

In the not-so-distant past, Paleo-Indians and Wampanoag Native Americans resided on the Cape due to access to plentiful protein. Since 1620 when the Pilgrims landed, first in Provincetown then Plymouth, it has been mostly seafaring folk inhabiting Cape Cod. Today, Cape Cod is a residence for hundreds of thousands of people who have come to associate its many miles of shoreline, bays, ocean, ponds, and lakes with the pleasant passing of warm summer days as well as long bracing winters. Unsurprisingly, Cape Cod is one of the most favored vacation areas in the northeastern United States. Only two hundred and sixty thousand full-time residents currently make their home on the peninsula, but each year millions of visitors converge here during summer months.

Even so, Cape Cod has demonstrated a centuries-old resistance to the encroachments of man. The surrounding sea has repulsed most of mankind's efforts to gentle its contours, to extract its riches, and tame its native roughness. Large swathes of forest, dune, beach, and marsh continue to separate modern developments, and what lies beneath the waters remains a mystery to many.

Few places along the eastern seaboard exist today where nature proceeds so unhindered. There is something archaic about the waters of Cape Cod—a feeling that the environment is both settled and unstable. Here, a unique web of marine and aquatic species

has been working continuously to endure. Ultimately, what is most compelling about Cape Cod's underwater environments is its industry of life. Beyond quaint villages lined by lobster shacks and boutique hotels is a world that remains fundamentally similar to the way things were thousands of years ago.

Beneath the surface of Cape Cod's many bodies of sheltered water lie tenacious yet tenuous marine and aquatic systems that have always provided for Cape Codders. Fishing is a historic method of making a living and remains one of the core economic drivers in a few towns, including Chatham and Provincetown. Though marine resources have been in overall decline throughout New England due to over-fishing, pollution, and habitat destruction, particular fisheries remain sustainable due to (or despite) complex fisheries policies and management techniques. Shellfish, squid, mackerel, bluefish, striped bass, black sea bass, scup, flatfish, and other species continue to provide livings for local fishermen.

These wet ecosystems and habitats are not only economically important, they also provide intrinsic ecological and spiritual values. There is romance in a life lived on the water, but any Cape Codder will tell you it takes a truly hearty soul to experience firsthand the temperate seascape's underlying splendor, finding in the hazy, dark waters pale yellows and greens, the bright orange of a sponge, the silvery flash of fish

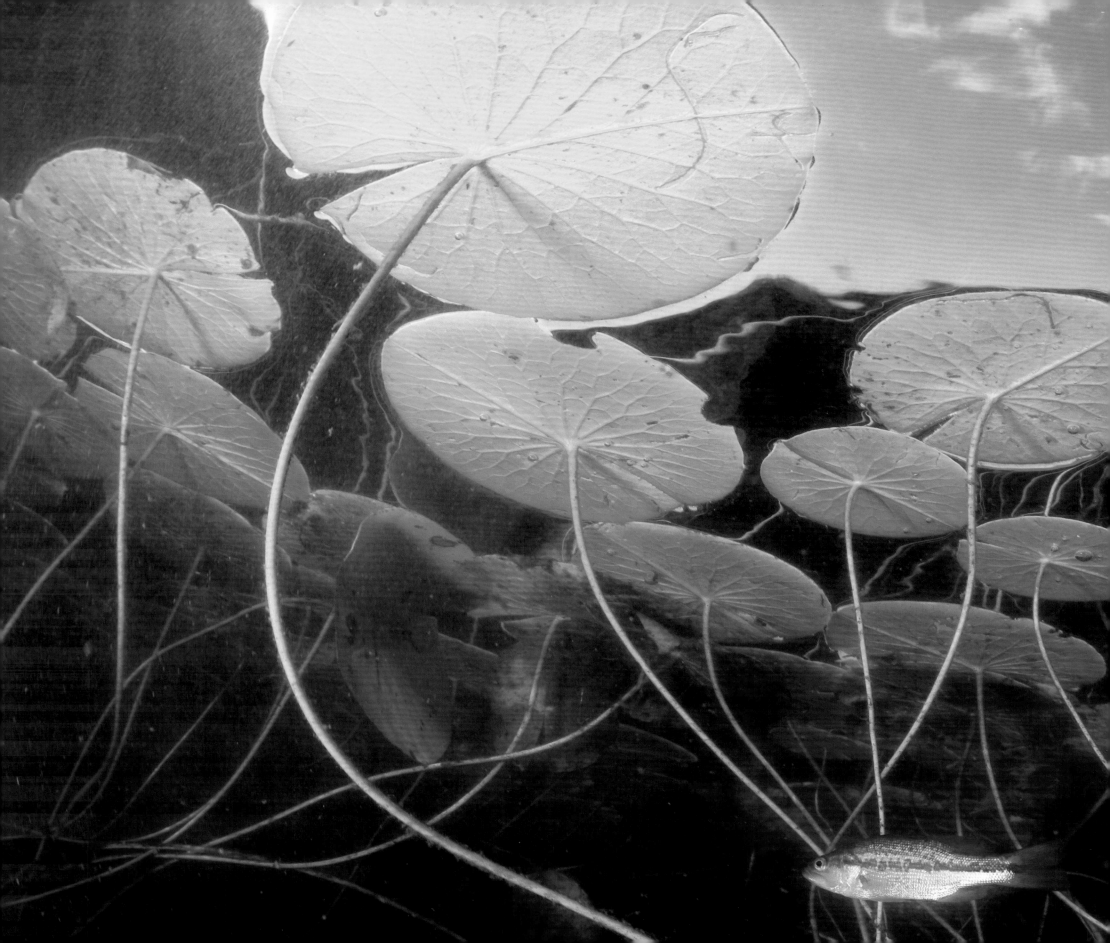

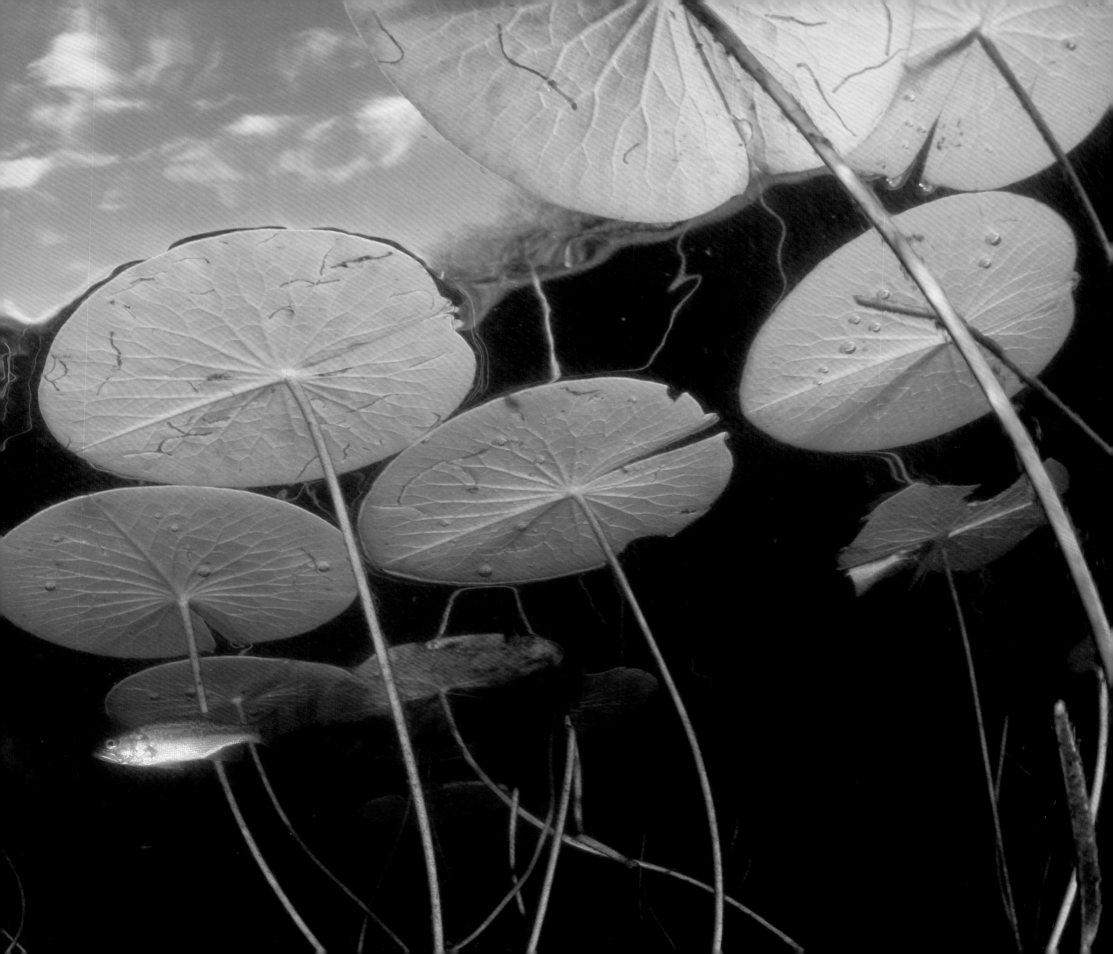

A rarely seen spadefoot toad (*Scaphiopus holbrooki*) is caught out of its burrow amongst the dunes of the Cape Cod National Seashore. With short legs and protruding eyes, these toads, which belong to a primitive amphibian family, like to dig and camouflage themselves in a variety of habitats.

scales, or the vivid blue of a crab claw. Subtle beauty is the essence of Cape Cod's underwater habitats, and as some intrepid Cape Codders know, it takes time and sensitivity to appreciate these mysterious environments.

Cape Cod's fishing fleets, scientists, locals, and tourists are intimately tied to both inshore and offshore waters. Whether they realize it or not, people are reliant on the watery connections between the Cape's salt marshes, bays and coves, ponds, and open ocean. The future of local communities and the peninsula they love and depend on is at the mercy of the proper management, use, and treatment of both marine and aquatic environments: those environments support critical populations of plankton, invertebrates, fish, and mammals. The people of Cape Cod abide by the sea for many reasons, and though change is inevitable, the essence of the sea will always remain in their blood.

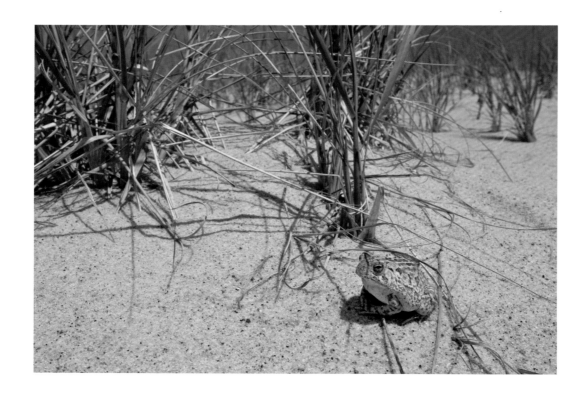

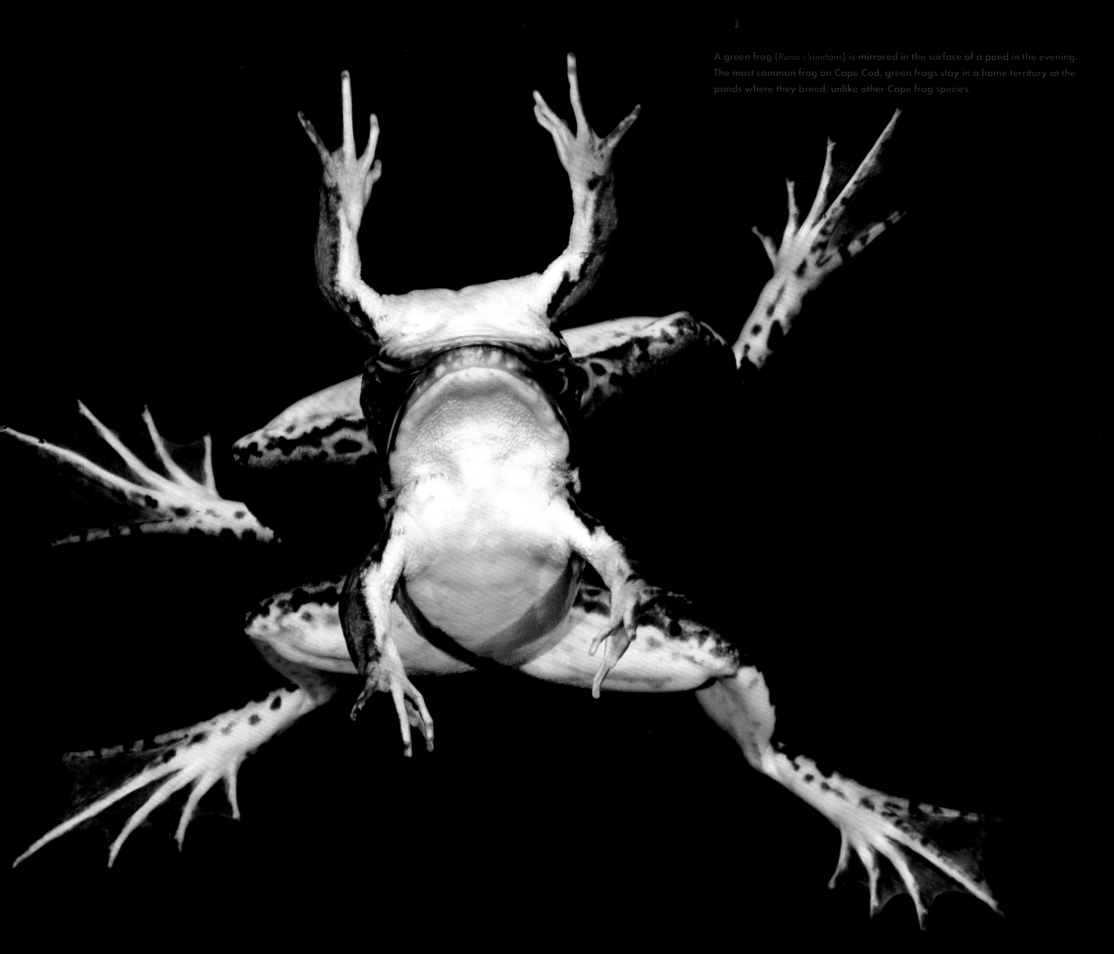

A green frog (*Rana clamitans*) is mirrored in the surface of a pond in the evening. The most common frog on Cape Cod, green frogs stay in a home territory at the ponds where they breed, unlike other Cape frog species.

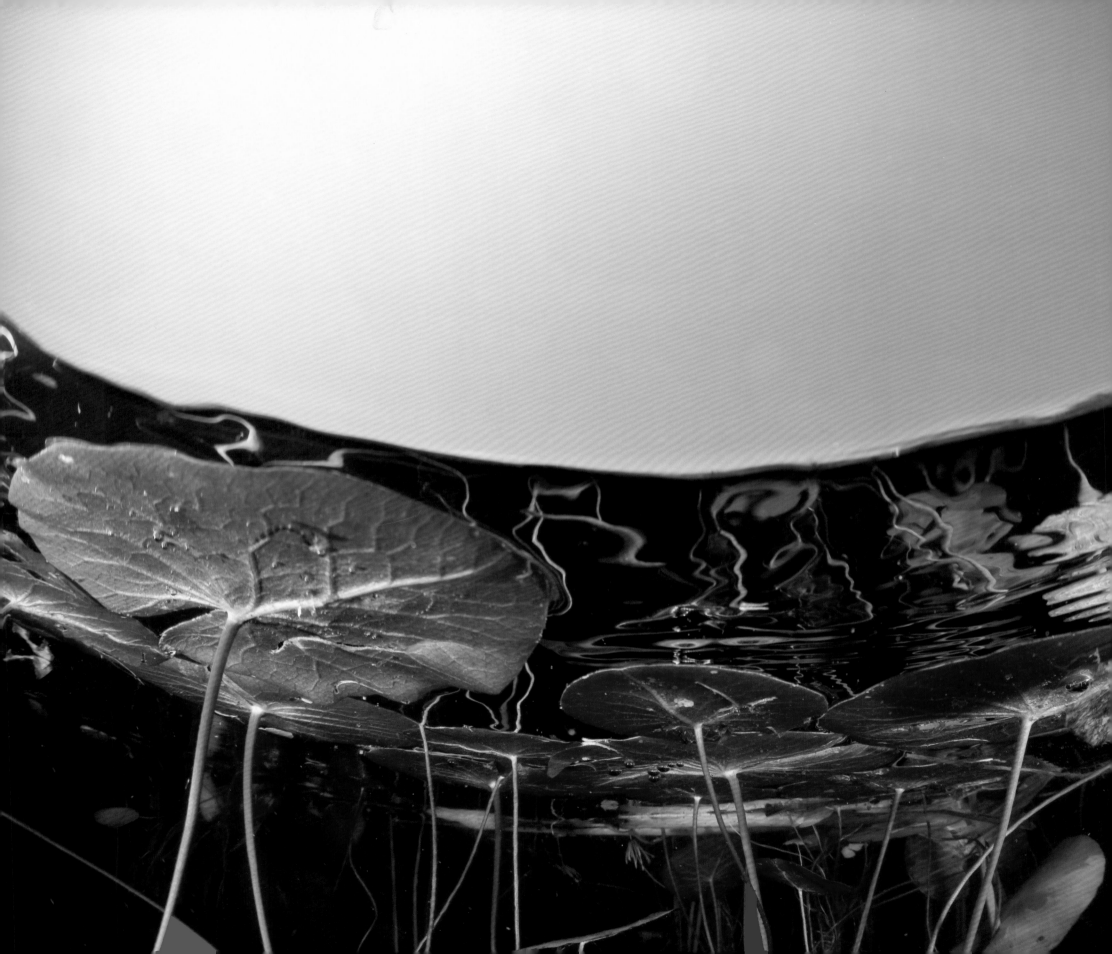

Ridges and valleys give the calcium carbonate shell of a bay scallop (*Argopecten irradians*) an iconic shape. Although they have grown increasingly rare in recent years, these sought-after, free-swimming bivalves are still found in shallow bays and eelgrass beds.

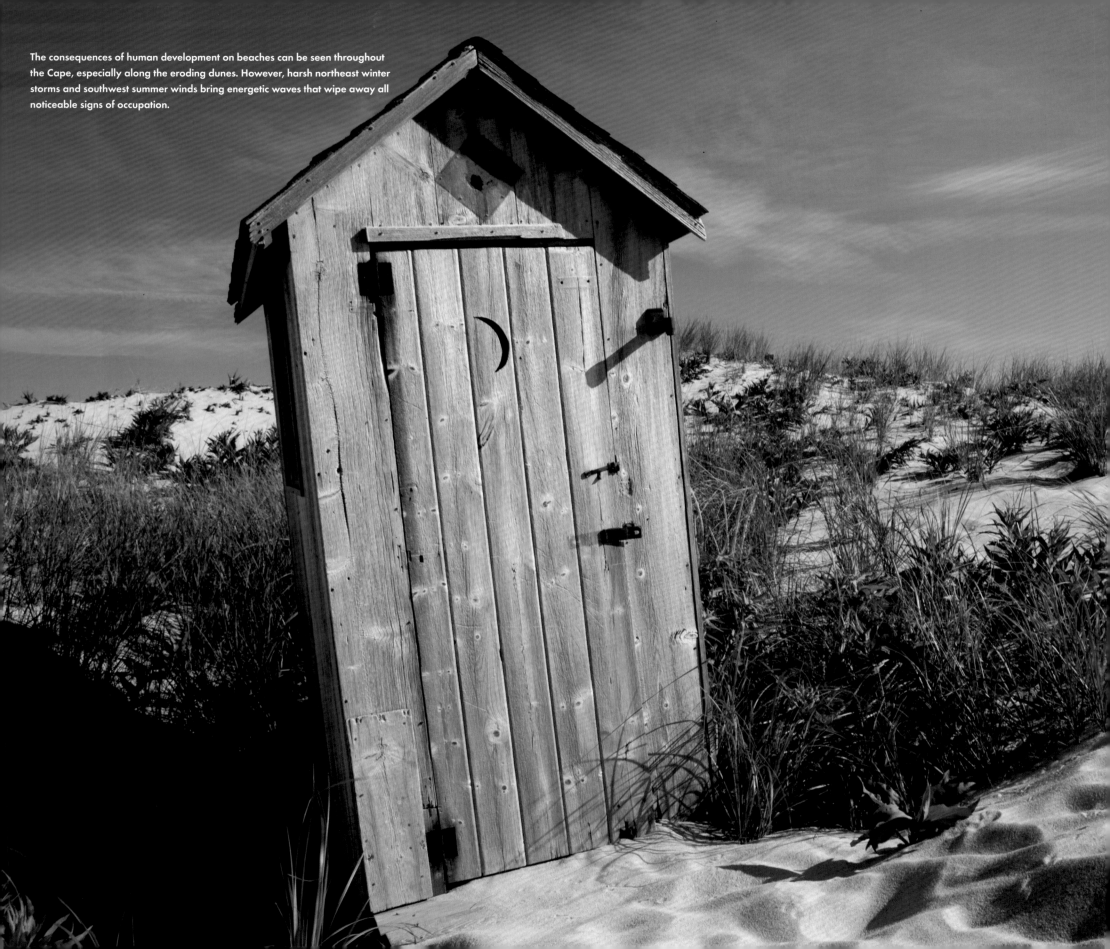

The consequences of human development on beaches can be seen throughout the Cape, especially along the eroding dunes. However, harsh northeast winter storms and southwest summer winds bring energetic waves that wipe away all noticeable signs of occupation.

Like most plants, lilies need plenty of energy in order to convert carbon dioxide into organic compounds. Near the pond bottom, leaves quickly unfurl and grow toward the surface, where they flatten and use the energy from sunlight to run photosynthesis.

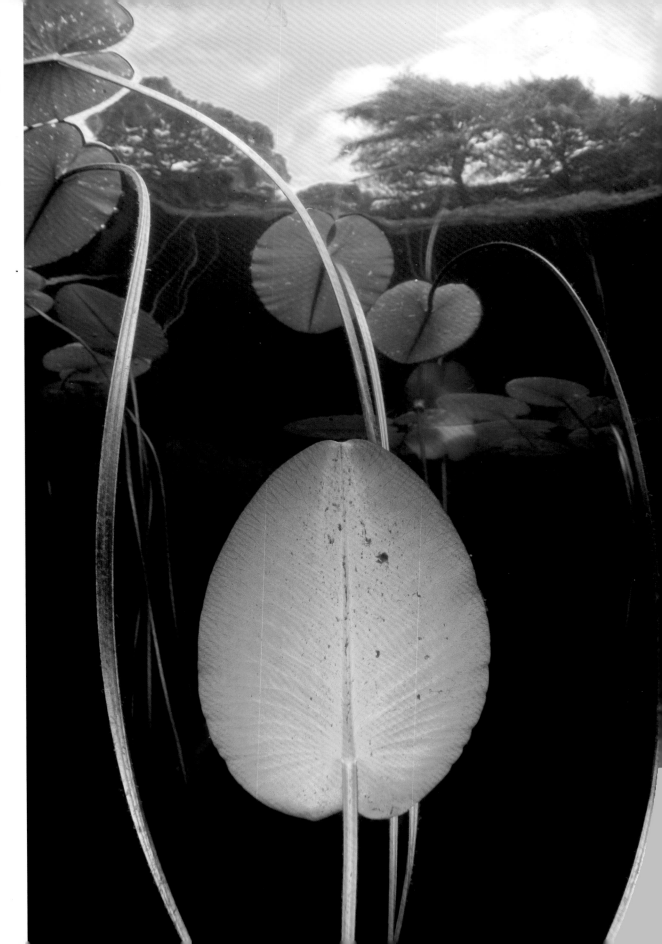

The only way to truly explore the Cape's underwater world is by donning a mask and getting into the water. Water temperatures vary a great deal from one part of the peninsula to the other, but the open ocean is by far the coolest, often dropping into the forties.

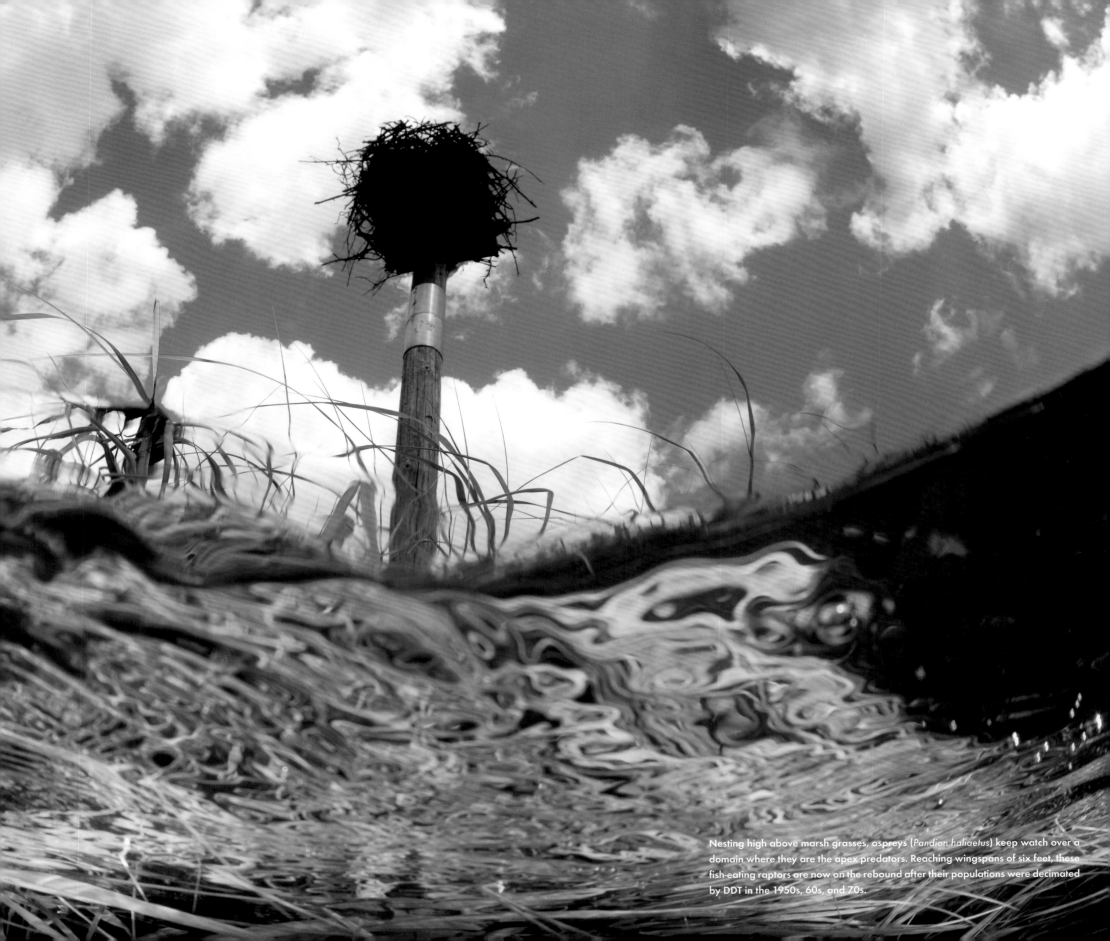

Nesting high above marsh grasses, ospreys (*Pandion haliaetus*) keep watch over a domain where they are the apex predators. Reaching wingspans of six feet, these fish-eating raptors are now on the rebound after their populations were decimated by DDT in the 1950s, 60s, and 70s.

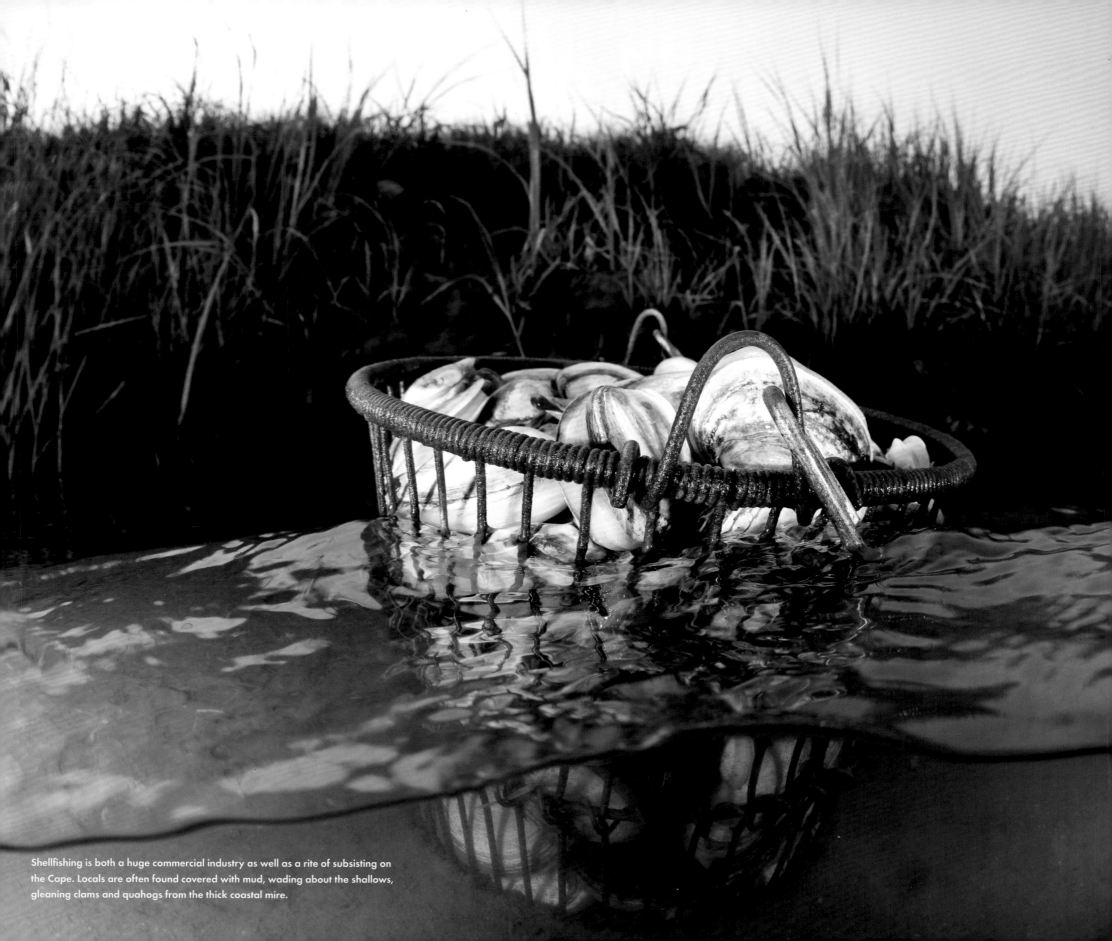

Shellfishing is both a huge commercial industry as well as a rite of subsisting on the Cape. Locals are often found covered with mud, wading about the shallows, gleaning clams and quahogs from the thick coastal mire.

Along with other vegetation, pickerelweed (*Pontederia cordata*) begins to decompose in warm lake waters near the end of summer. With spring sun and rising temperatures, the freshwater vegetation will again be renewed, growing luxuriantly for months.

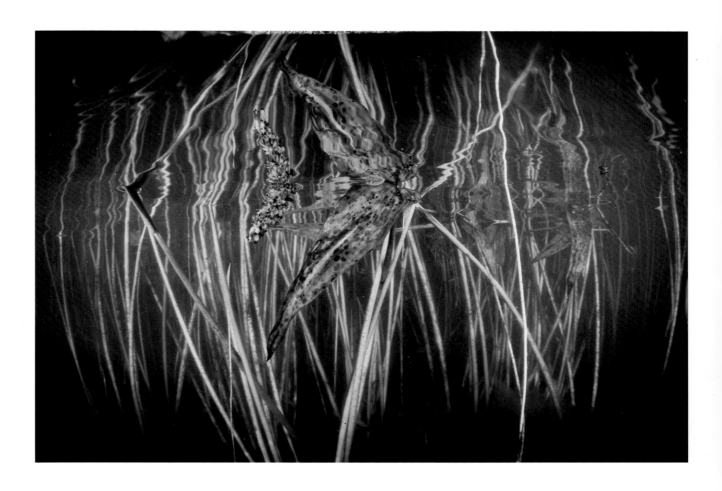

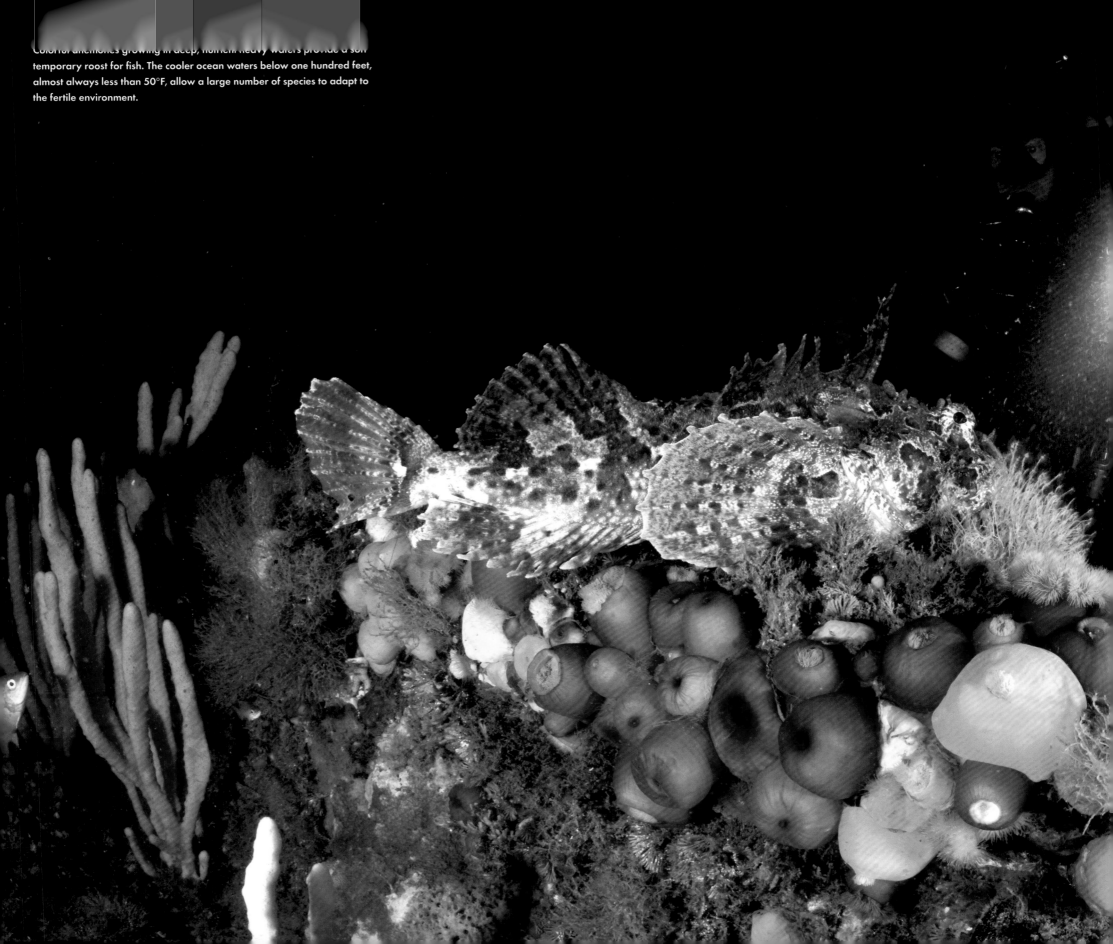

Colorful anemones growing in deep, nutrient-heavy waters provide a soft temporary roost for fish. The cooler ocean waters below one hundred feet, almost always less than 50°F, allow a large number of species to adapt to the fertile environment.

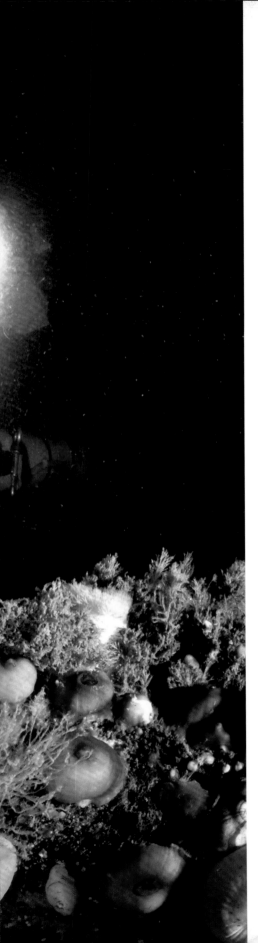

Lobstering has changed dramatically over the decades, but it has always been an important livelihood for many Cape Cod fishermen. Though still occasionally used today, the traditional wooden lath trap that is said to have originated in Cape Cod in 1810 has typically been replaced with longer-lasting metal traps.

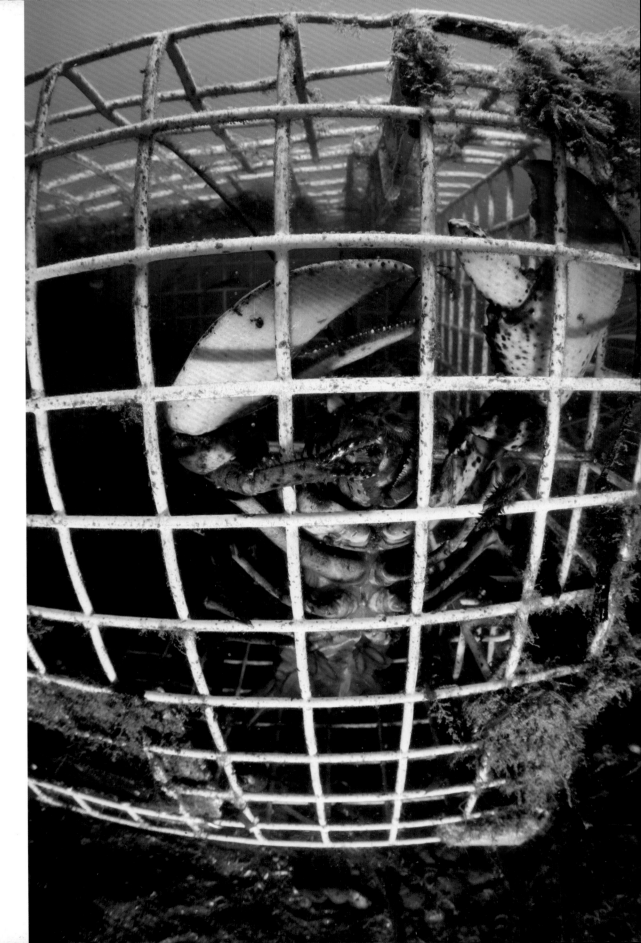

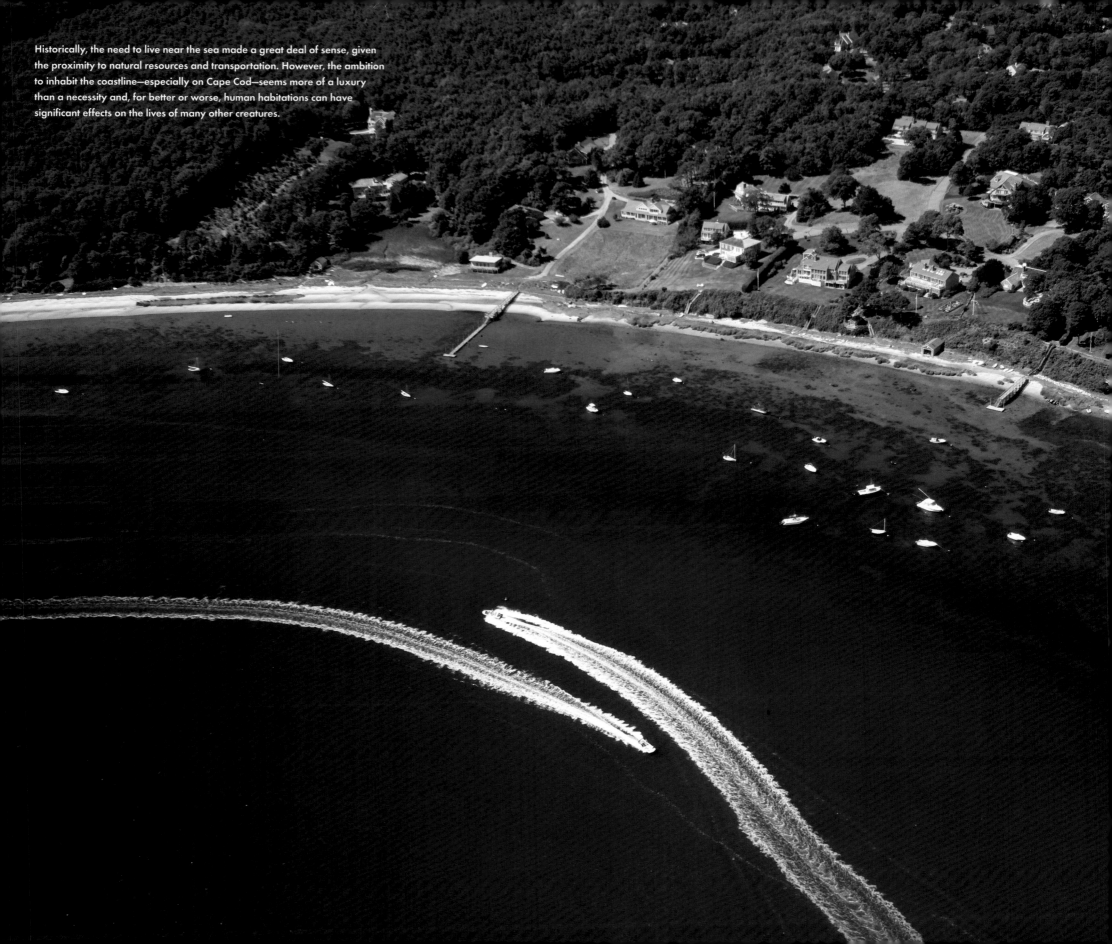

Historically, the need to live near the sea made a great deal of sense, given the proximity to natural resources and transportation. However, the ambition to inhabit the coastline—especially on Cape Cod—seems more of a luxury than a necessity and, for better or worse, human habitations can have significant effects on the lives of many other creatures.

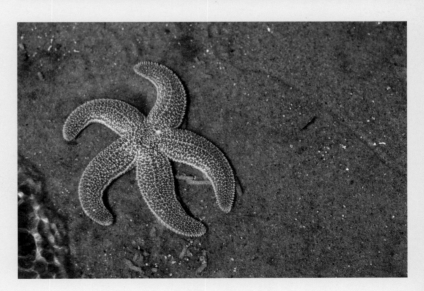

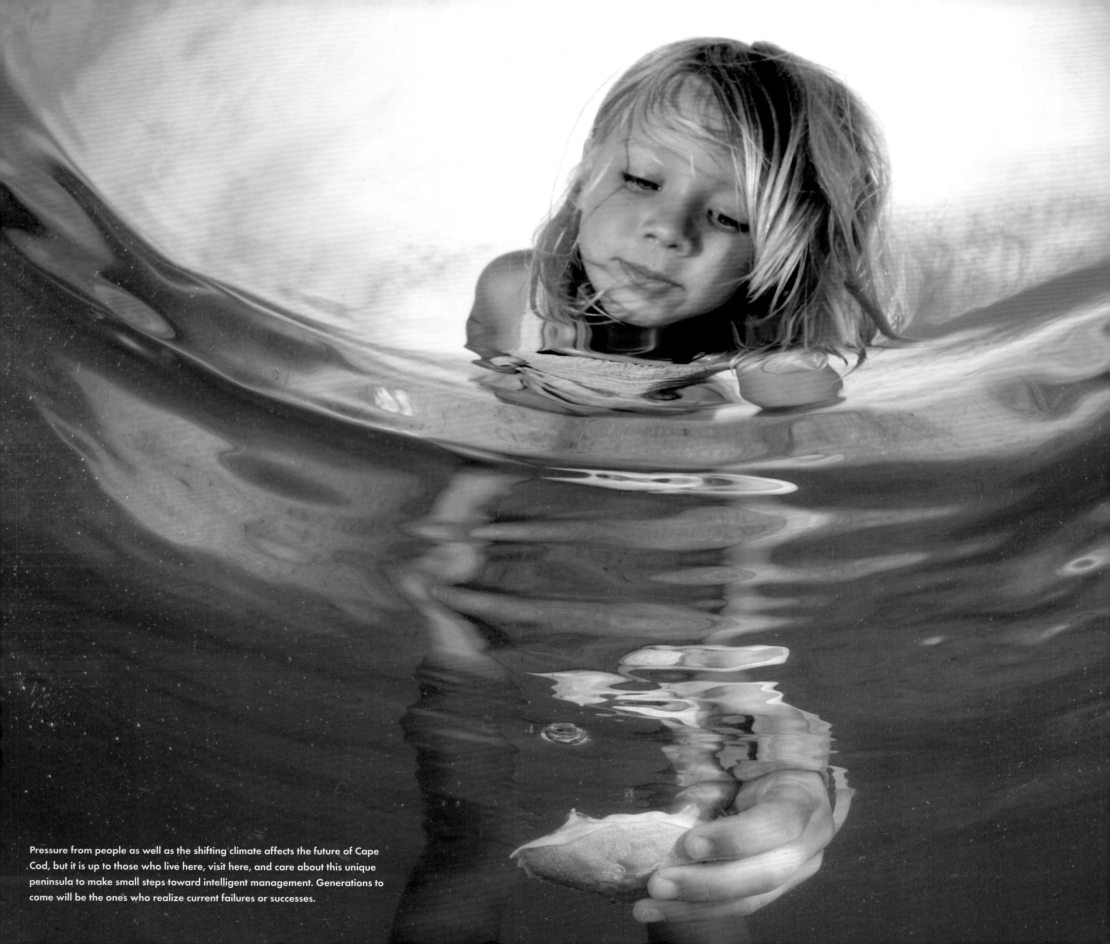

Pressure from people as well as the shifting climate affects the future of Cape Cod, but it is up to those who live here, visit here, and care about this unique peninsula to make small steps toward intelligent management. Generations to come will be the ones who realize current failures or successes.

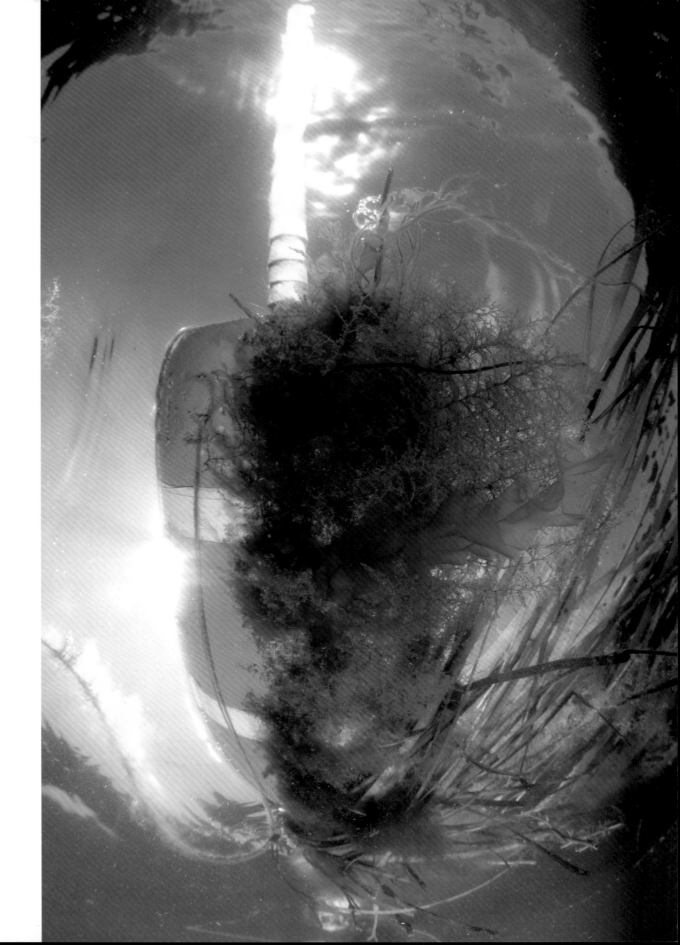

CHAPTER 2 THE STRUGGLE
BETWEEN LAND AND SEA

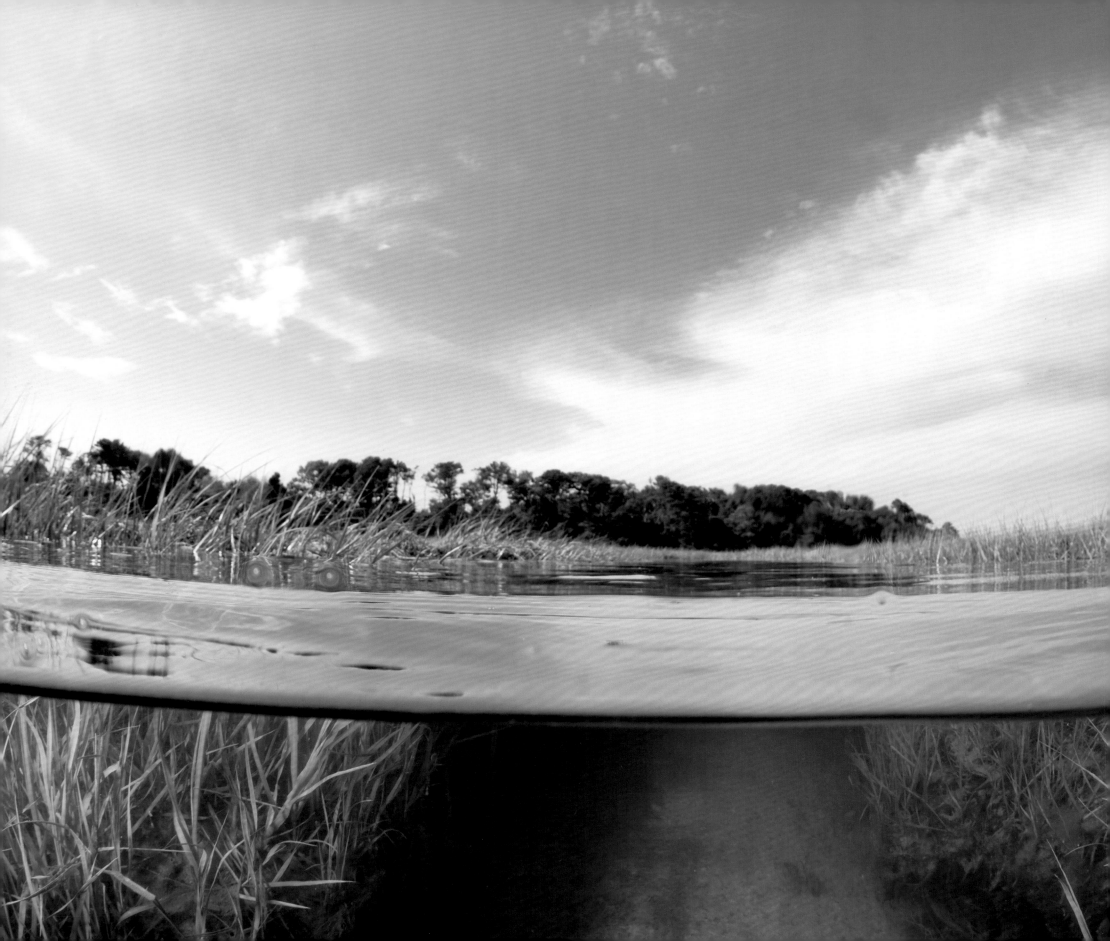

CHAPTER 2: THE STRUGGLE BETWEEN LAND AND SEA

This oft overlooked ecosystem is not only a haven for marine organisms, from crustaceans to fish, but it also provides habitat for many of the Cape's migratory bird populations. While Spartina grasses persistently endeavor seaward, the tides adhere to their lunar rhythms, creating winding creeks and salty ponds within the unexplored emerald acres of water, mud, algae, and grass. The salt marsh ends up in an apprehensive truce between the sea and land.

Thick gray storm clouds and a clinging mist have clamped down hard on the water. Darkness abounds. The outgoing tide is murky, soaking up the light that filters through the overcast sky. Drooping *Spartina* grass waves in the wind—vibrant greens spattered with rich golden hues. A narrow channel snakes through the grass, leading deep into an expanse of slim, still blades. The salt marsh is an area where few people venture, known more for the abundance of biting insects than for its vital ecological functions.

The sights, smells, and sounds of a salt marsh are not things that immediately come to mind when thinking of pleasant surroundings. Yet this semi-marine habitat can seize hold of the imagination due to its fantastic array of marine and terrestrial organisms. The marsh is a primeval ecosystem, a meeting place of fundamental elements, an area of concession and perpetual variation. It is here that water and land meet, each struggling for dominance that will never be attained.

Growing on the leeward side of Cape Cod's barrier beaches, salt marshes are customarily loathed due to the voracious mosquitoes and infamous greenhead flies and deerflies that breed there in the billions. Warm summer evenings can easily convince us that every blood-sucking species on the planet inhabits the marsh. But for all these bothersome insects, salt marshes offer pleasure in beauty, solitude, and adventure. More important, salt marshes provide crucial habitat, nutrients, and nursery areas for fish and invertebrates, which in turn sustain associated marine food webs.

In the outer Cape's southeast corner, between the long stretch of sandy dunes and the mainland, lie the calm waters of Pleasant Bay. Within the bay, a great expanse of salt marsh grows, virtually impassable by any vessel but a kayak or canoe. Pleasant Bay is a small, almost quaint, series of interconnected habitats where land, sea, and sky interface in a fertile and wet plane. Acres upon acres of shallow water and luxurious, golden green *Spartina alterniflora* grass provide many of the best places on the Cape for observing less conspicuous life forms that crawl, skitter, swim, buzz, and fly amidst the stiff cordgrass. In an ecological sense, salt marshes are the temperate equivalent of a tropical mangrove forest, evolved over millions of years to exist in both the air and saltwater. In fact, there is no natural system more valuable to Pleasant Bay's overall environmental health than the breadth of salt marshes lining the western and interior side of the ever-shifting barrier dunes.

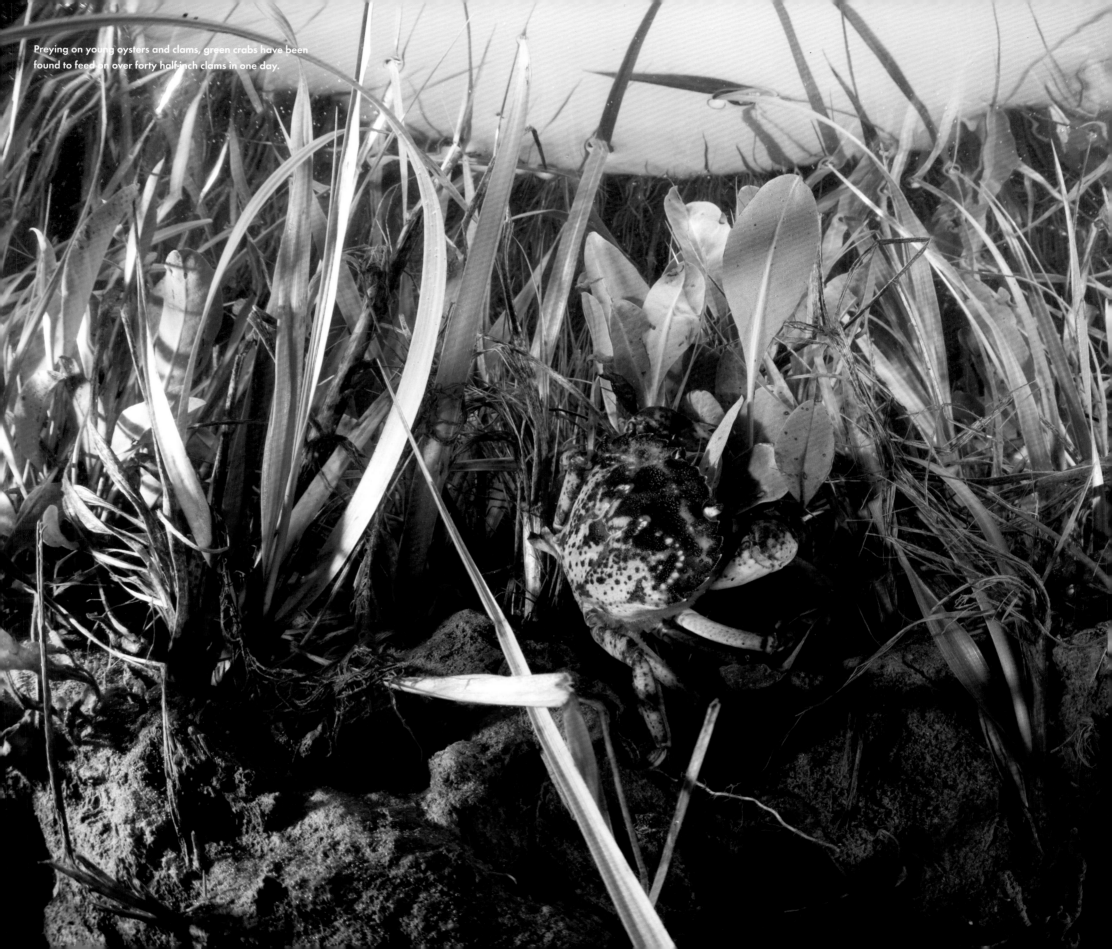

Preying on young oysters and clams, green crabs have been found to feed on over forty half-inch clams in one day.

Similar to mangrove forests, flora diversity within the temperate marsh is relatively low due to repeated inundation by seawater and the soft anoxic soil in which the grasses grow. Though few plants have adapted to this challenging environment, it is still a highly productive area, and the monotypic vista is actually far more complex than what meets the eye. The marsh's highly photosynthetic plants are the very base of an intricate marine food web, providing detritus and other organic materials that feed an untold number of species, from microscopic bacteria to worms, shrimp, and fish, which in turn feed birds, seals, whales, and humans.

In the murky water that winds its way through the marsh grows thick stands of eelgrass and brown algae known as bladder wrack. The growth slows currents and allows suspended particulate matter to settle out of the water, creating fertile marine soil. *Spartina* cordgrasses obtain a foothold near the mid-tide line; their roots stabilize the soft mud so that other plants may eventually colonize there. Slightly more elevated along the banks of the marsh, and not quite as salt-tolerant, the tiny succulent glasswort, also known as pickleweed, matures along with a slender, delicate species of salt meadow hay, *Spartina patens*. Where the highest tides rarely stretch, lacy sea lavender proliferates; their summer flowers add just a hint of purple to the otherwise green spread.

Marsh grasses, seeds, and insects feed a number of fish, birds, and other animals. Pleasant Bay's salt marsh fauna is a chaotic mix of hardy scavengers, tiny predators, and planktivorous and herbivorous beasts, some with but many without backbones. The shallow marsh is a physically rigorous environment, making the overall number of species low, but animals that can endure salinity and temperature fluctuations, as well as being totally immersed and stranded given the tide, take full advantage of resource abundance. Like many of the Cape's habitats, looking closely amongst the fringes of marsh grass and algae reveals a fascinating world of overlooked creatures.

Along the waterline, the curves of blue mussels cling in clumps to thick peat. Periwinkle snails, adapted to life on the soft sediment, carve meandering trails through the mud below. A juvenile horseshoe crab no larger than a nickel buries itself under a thin layer of mud next to a razor clam, hiding during the day as it grows into a more sizable critter. Almost transparent, frenetic sevenspine bay shrimp washed in with the tide scoot around in just inches of water as they feed on organic material, while tiny long wrist hermit crabs, with rounded periwinkle shells on their backs, crawl along the bottom looking rather lost. The flash of green crabs add to the eclectic gathering of invertebrates that

Surrounded by cordgrass, marsh pools provide rich environments for gastropods, amphipods, copepods, shrimp, and crabs.

skitter amongst the grasses, though most noticeable is the occasional blue crab waving its sharp claws in resolute warning. A bit more advanced on the evolutionary tree are the sticklebacks, mummichog, and Atlantic silversides that nervously flash by; these small fish all prefer the marsh's shallow waters, where they can evade the appetites of larger, deeper water fish.

Winged inhabitants of the marsh glide elegantly on light feathered limbs. In the distance, across a wide muddy creek, herons and egrets prey upon small fish and crabs. Spotted sandpipers scurry along the waterline. Far above the waving cordgrass, gaining altitude for a literal bird's eye view of its hunting grounds, an adult osprey soars silently under low thick clouds. Marsh wrens dart sporadically from perch to perch, and depending on the season, American bitterns and black ducks dwell within the tall protective grasses. Watching it all, it's easy to feel small yet free amongst this bit of wilderness.

Due to the new break in Pleasant Bay's barrier beach, ceaseless tides—actually long-period waves—have grown more dramatic in recent years. These changing tides are part of the never-ending ecological processes that enrich Cape Cod's waters. Tidal fluctuations have stretched intertidal plants and animals to their environmental limits, fully immersing them for hours, then exposing them to air for equally long stretches of time.

Certain shrubs and trees that have crept seaward over the years are unable to handle the higher tides' saline waters and are dying off, while native grasses seem to be expanding their territories. Tidal creeks are becoming slightly wider with faster currents, and though there is not yet evidence that water quality has been enhanced, undoubtedly most of the bay's inhabitants, including many of those in the salt marsh, will benefit from the effects of the break.

Stray shafts of light now beam through the low clouds, momentarily scattering mist and illuminating the marsh. If one thing stands out watching the Cape's natural cycles, it is that transformation is inevitable. As sure as clouds are followed by sun, there will be natural adjustments made by the salt marsh as it develops more in some places and erodes in others. Climate change, rising sea levels, sea surface temperature change, and increasing ocean acidity will all affect the Cape's salt marshes over the coming years, but given reprieve from continual human development, they will endure. Cape residents are watching a natural experiment of succession within Pleasant Bay, and the future outcome is still unclear. Whatever happens, these remarkable ecosystems play important and prominent economic and ecological roles, and their wellbeing is intimately tied to other nearby ecosystems. Cape Cod without these beautiful salt marshes would not be Cape Cod.

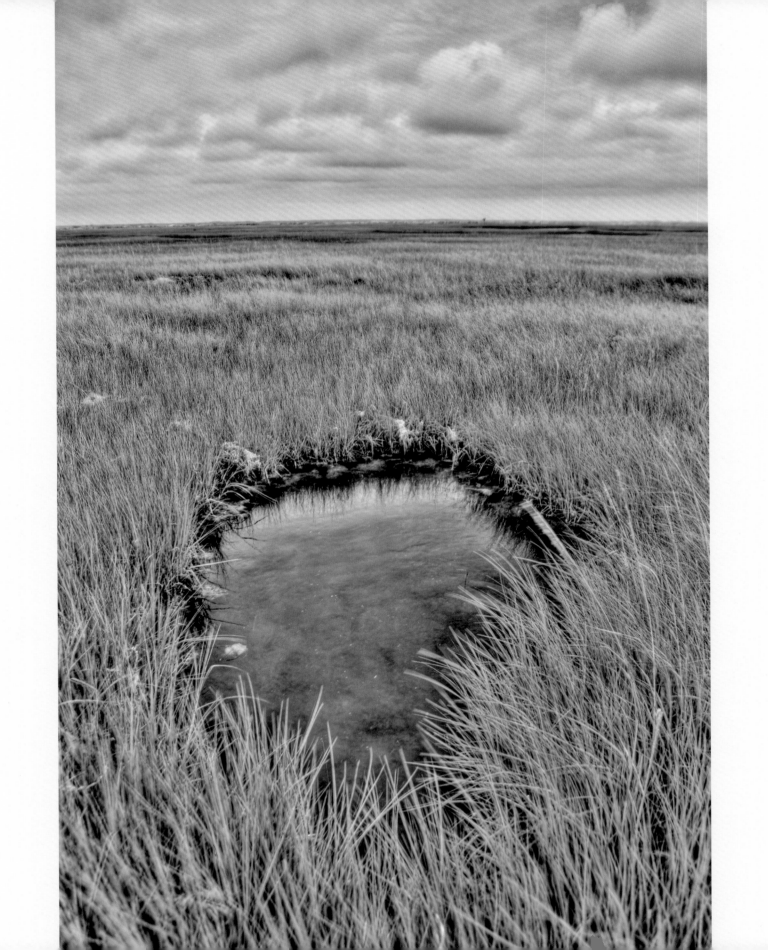

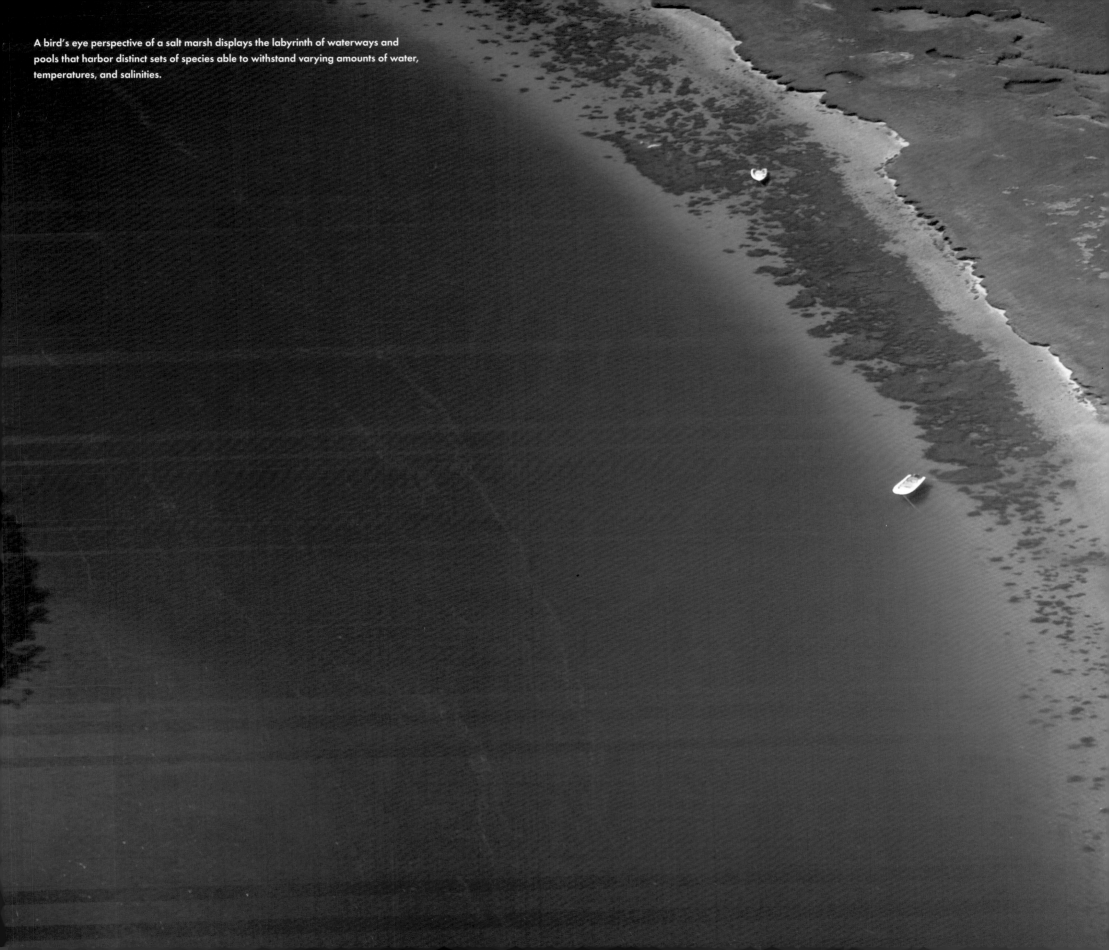

A bird's eye perspective of a salt marsh displays the labyrinth of waterways and pools that harbor distinct sets of species able to withstand varying amounts of water, temperatures, and salinities.

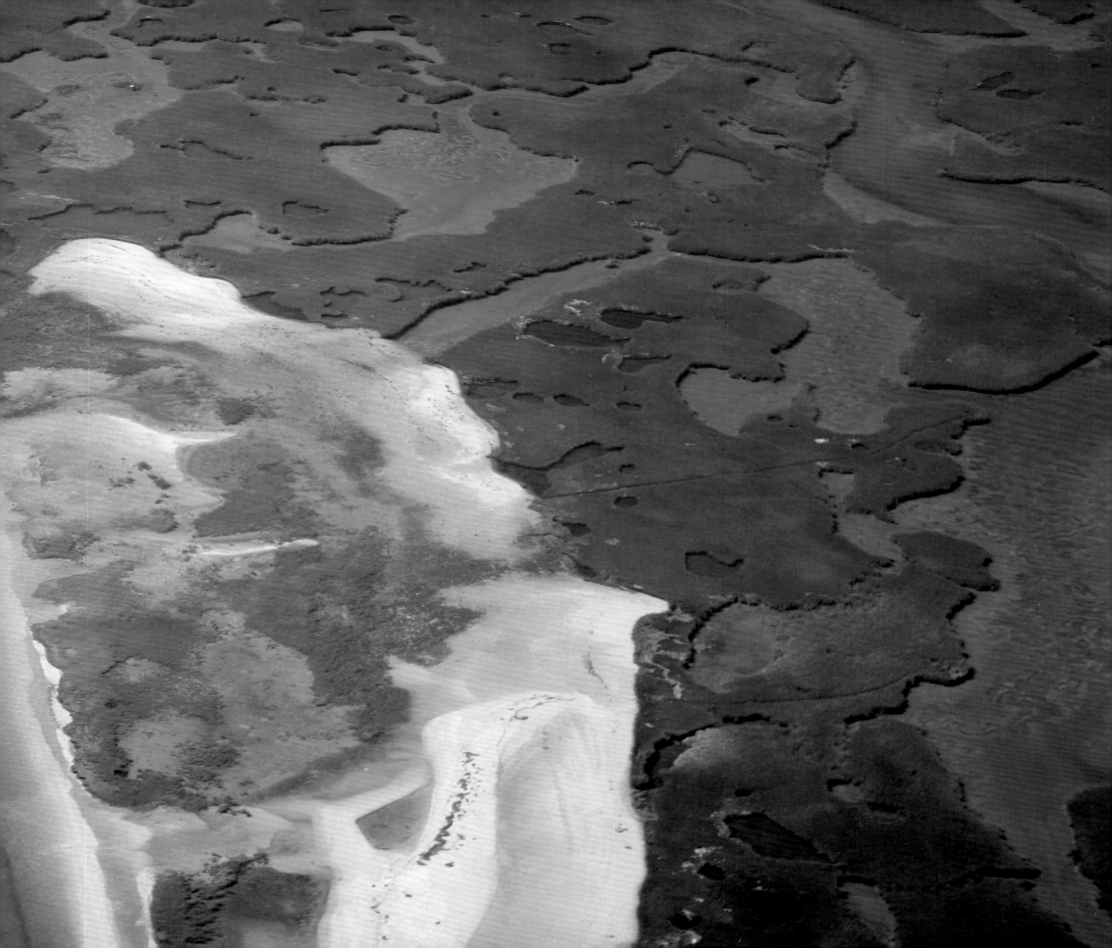

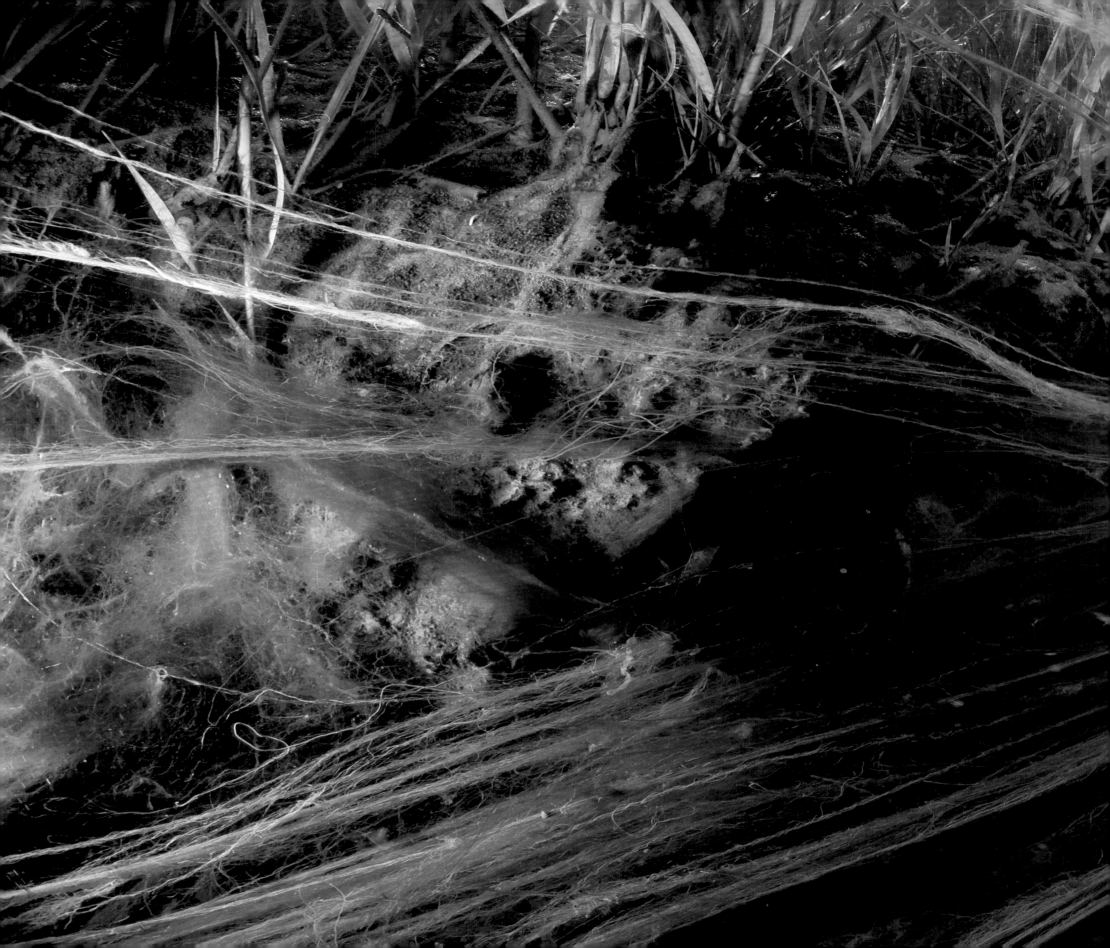

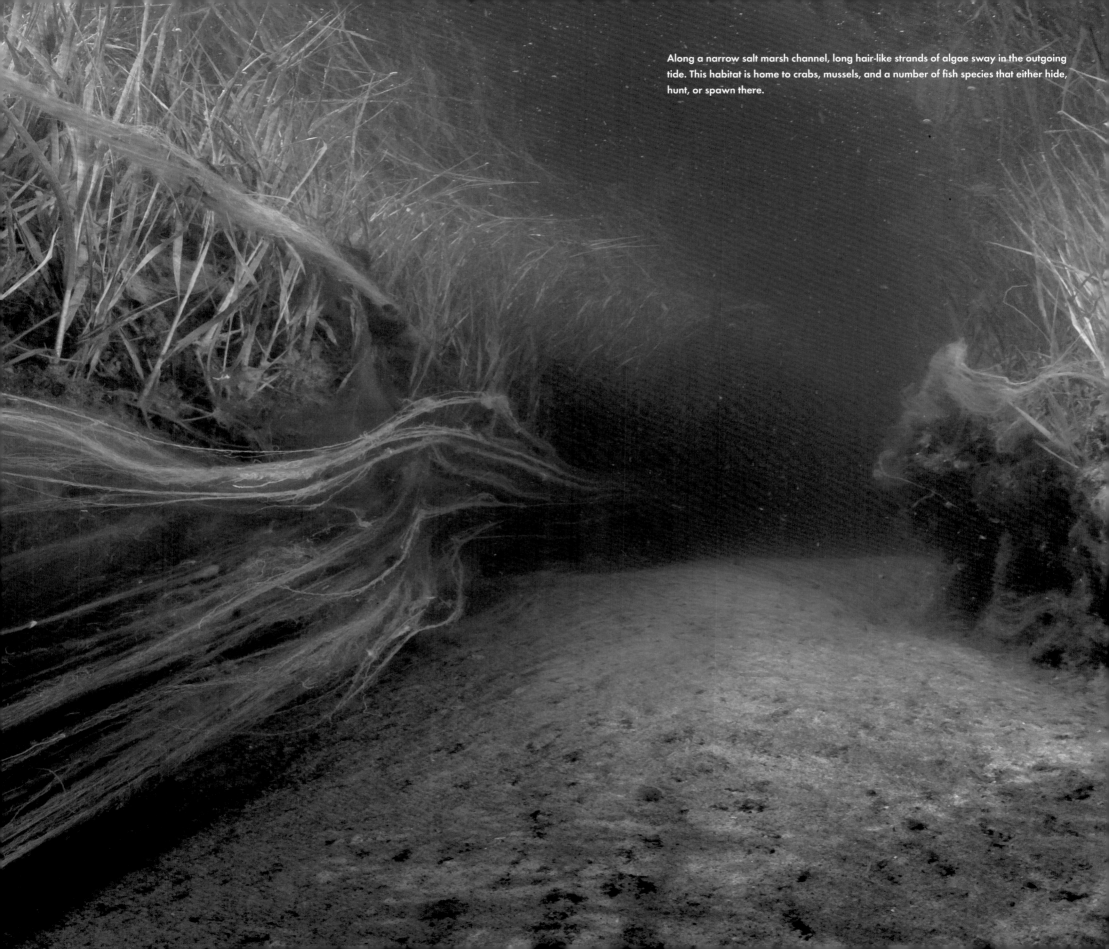

Along a narrow salt marsh channel, long hair-like strands of algae sway in the outgoing tide. This habitat is home to crabs, mussels, and a number of fish species that either hide, hunt, or spawn there.

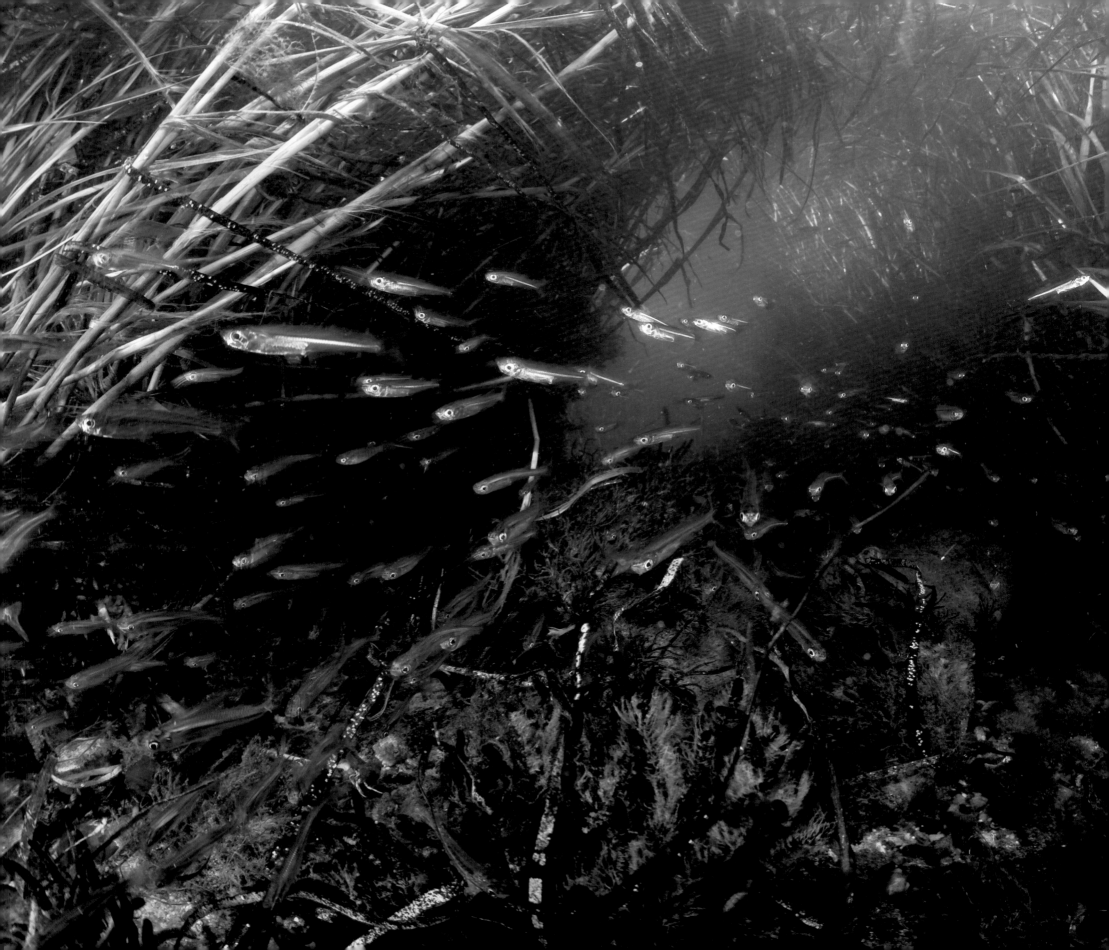

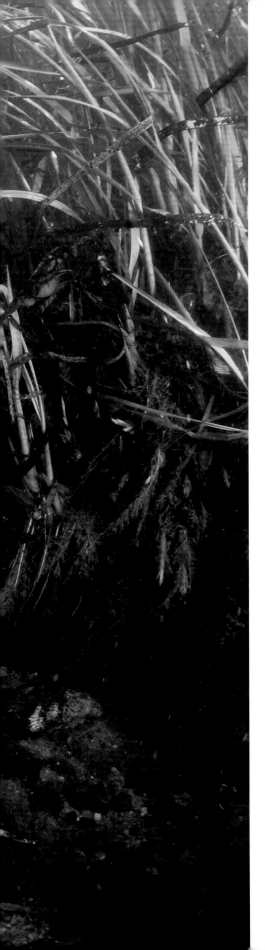

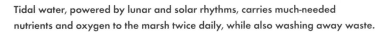

Tidal water, powered by lunar and solar rhythms, carries much-needed nutrients and oxygen to the marsh twice daily, while also washing away waste.

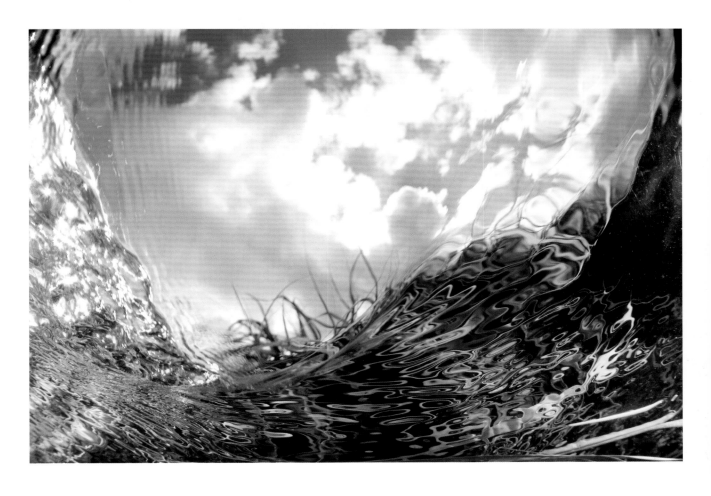

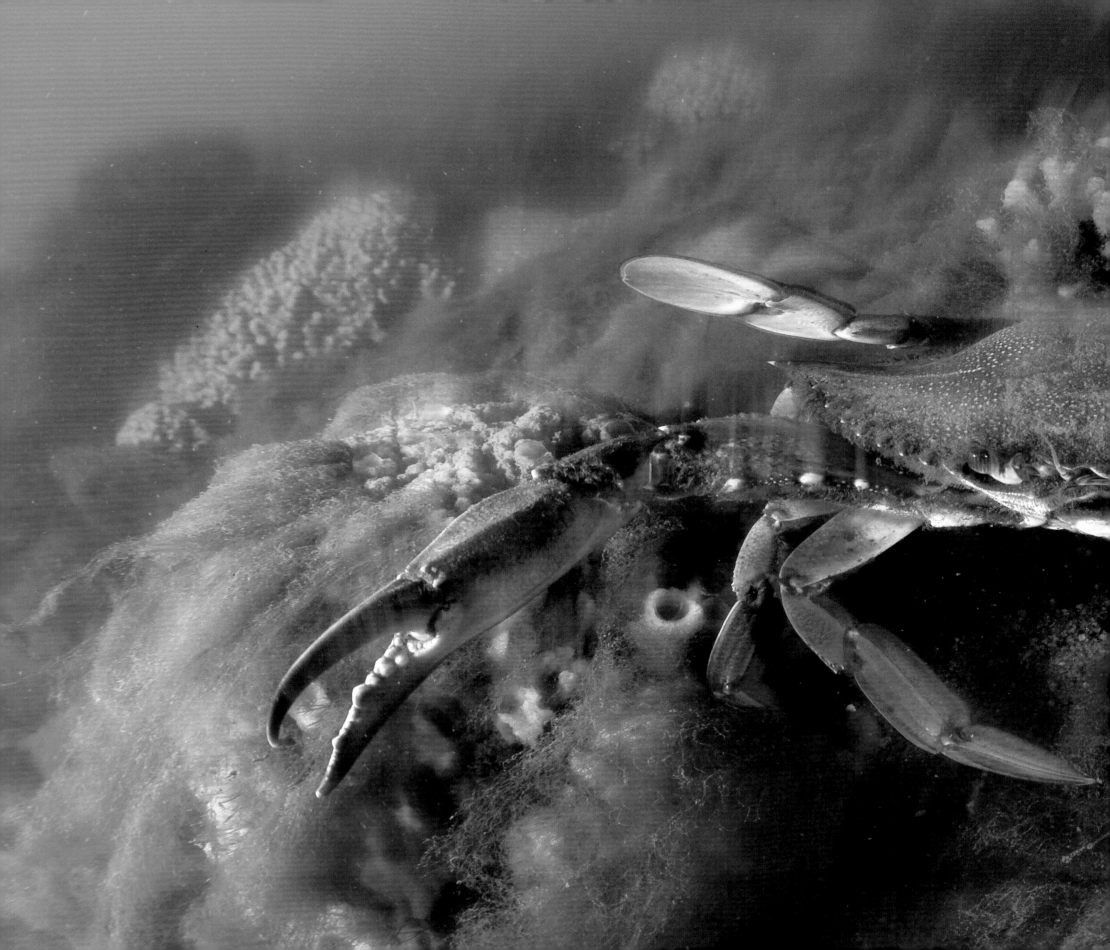

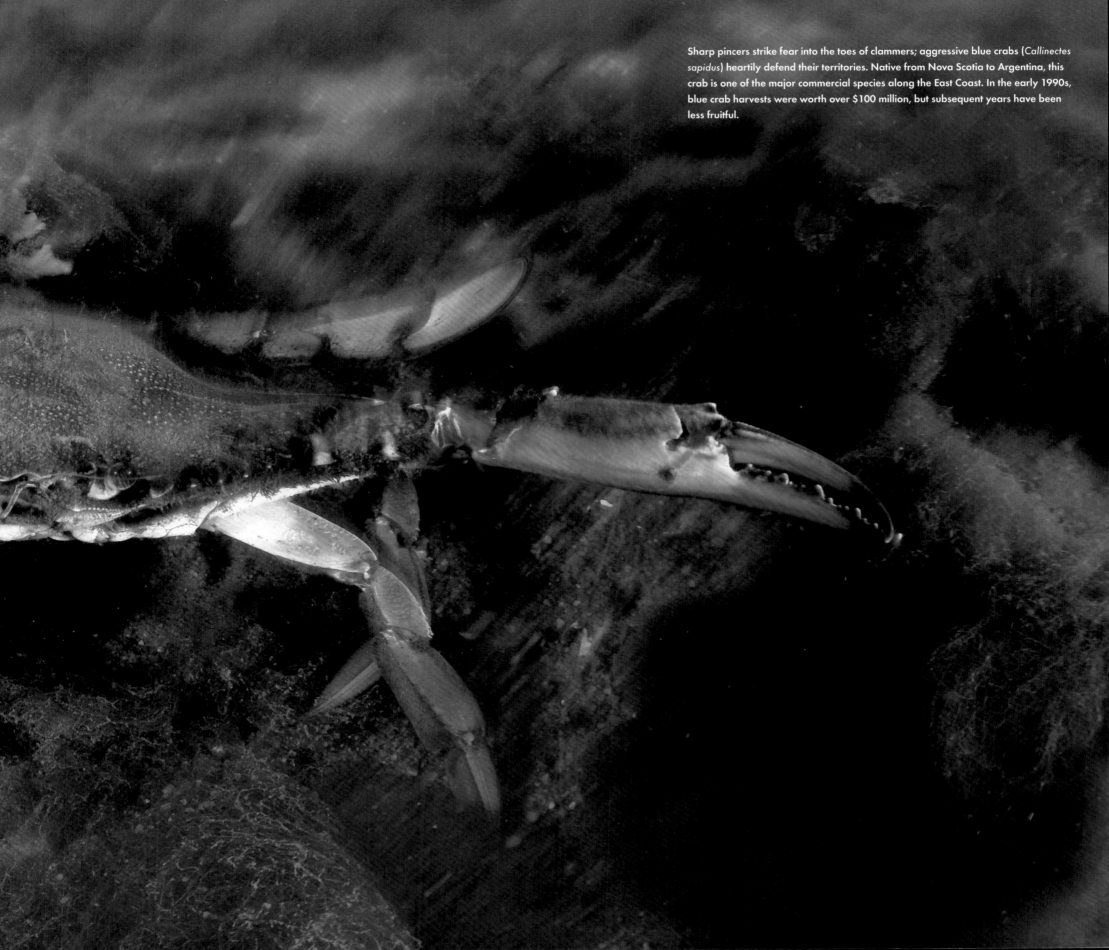

Sharp pincers strike fear into the toes of clammers; aggressive blue crabs (*Callinectes sapidus*) heartily defend their territories. Native from Nova Scotia to Argentina, this crab is one of the major commercial species along the East Coast. In the early 1990s, blue crab harvests were worth over $100 million, but subsequent years have been less fruitful.

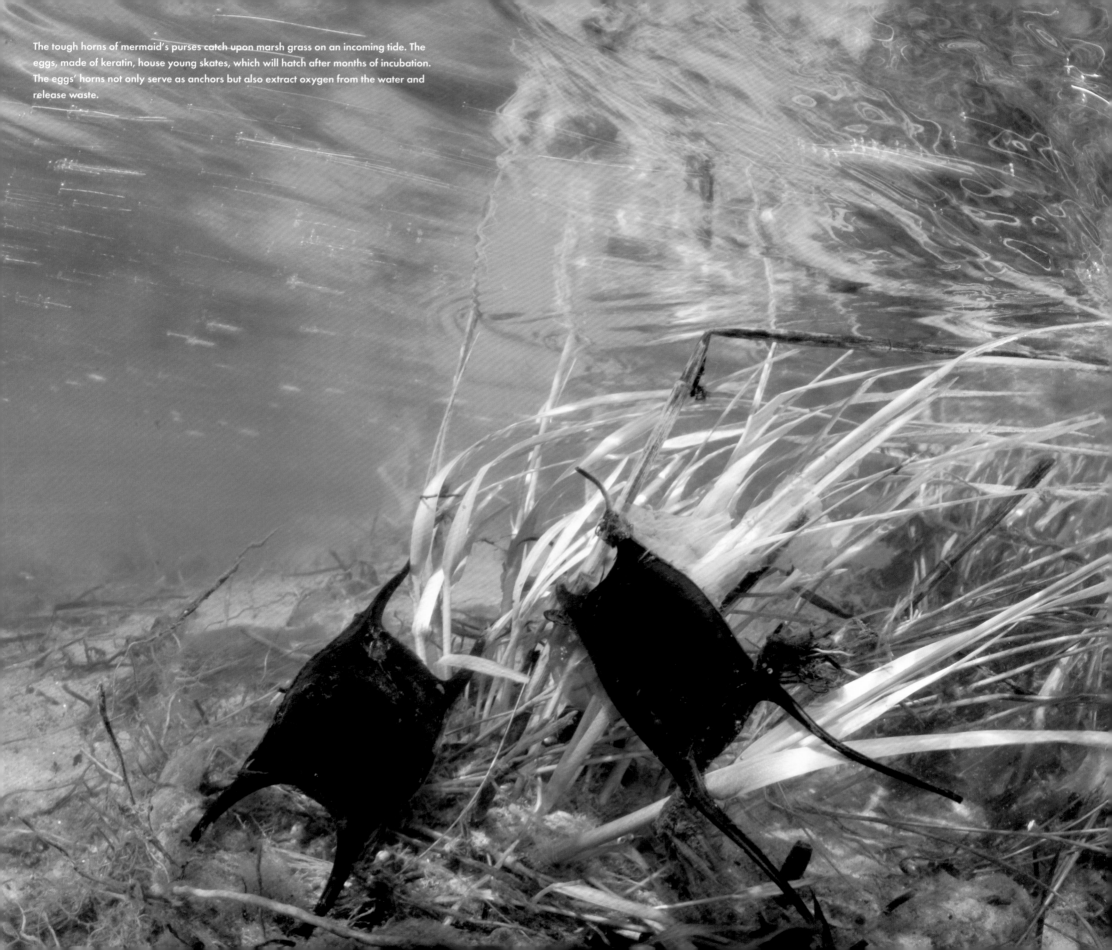

The tough horns of mermaid's purses catch upon marsh grass on an incoming tide. The eggs, made of keratin, house young skates, which will hatch after months of incubation. The eggs' horns not only serve as anchors but also extract oxygen from the water and release waste.

Juvenile horseshoe crabs live just under the soft mud and sand near the marsh. They are found by noting their wandering trails. If this particular individual matures to adulthood, around ten years of age, it may live up to twenty years.

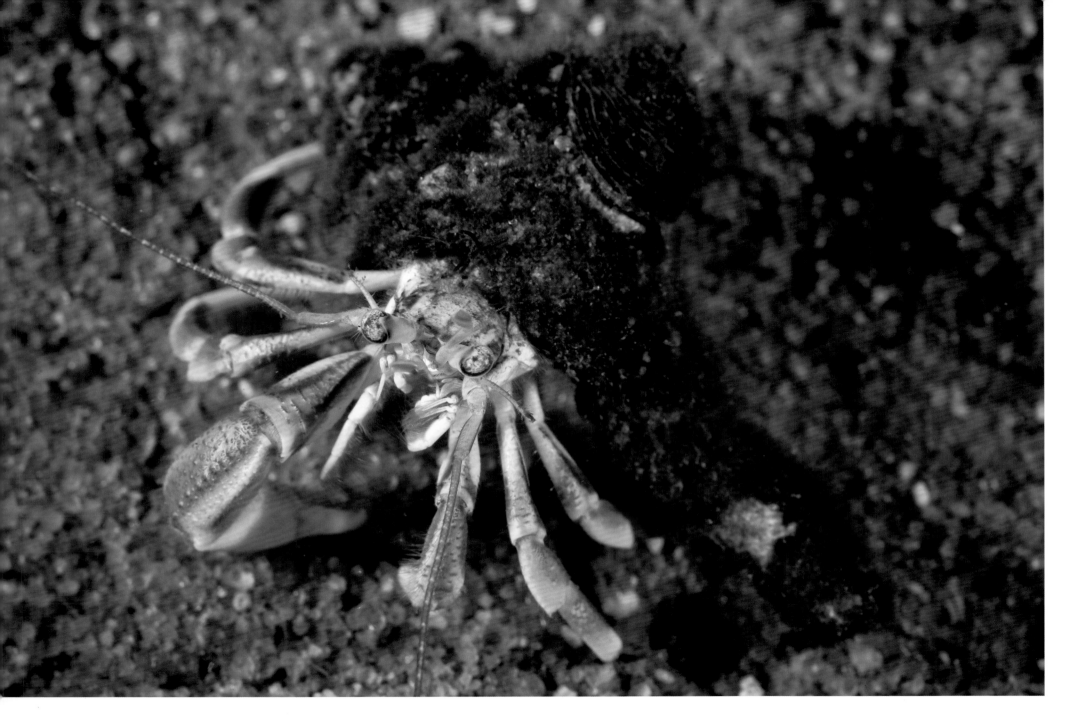

Hermit crabs are especially common in marsh areas but can be found
anywhere from the beach to over one hundred and fifty feet deep.

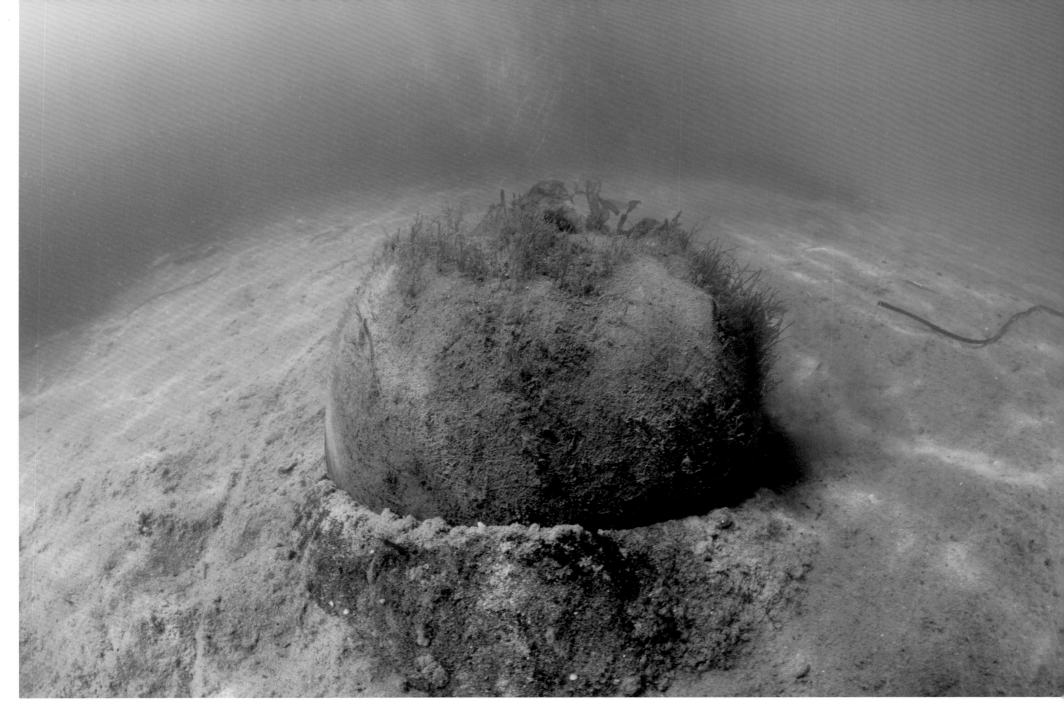

Plowing through the sandy soil of the marsh, a well-armored horseshoe crab assists in turning over and oxygenating the substrate. Horseshoe crabs search for food, including mollusks and annelids, throughout salt marsh areas, grinding up their prey and scavenged tidbits of organic material with bristles on their legs. Distant relations of spiders and scorpions, relatives of these living fossils roamed Earth's seas over 400 million years ago. Four species of horseshoe crab currently exist, though only one, *Limulus polyphemus*, inhabits the Atlantic coast of North America.

47

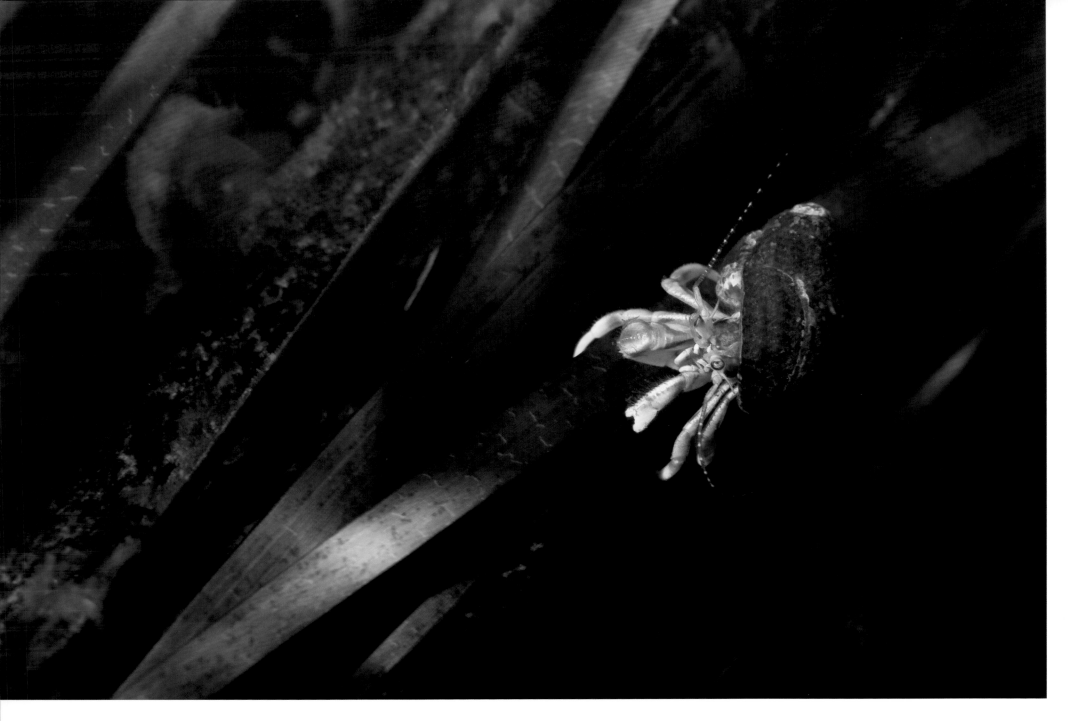

Inhabiting shorelines, muddy bottoms, and marshes, hermit crabs (*Pagurus longicarpus*) use borrowed shells to protect their soft abdomens, which lack an exoskeleton. Armies of these little beasts clean the bottom of just about anything organic.

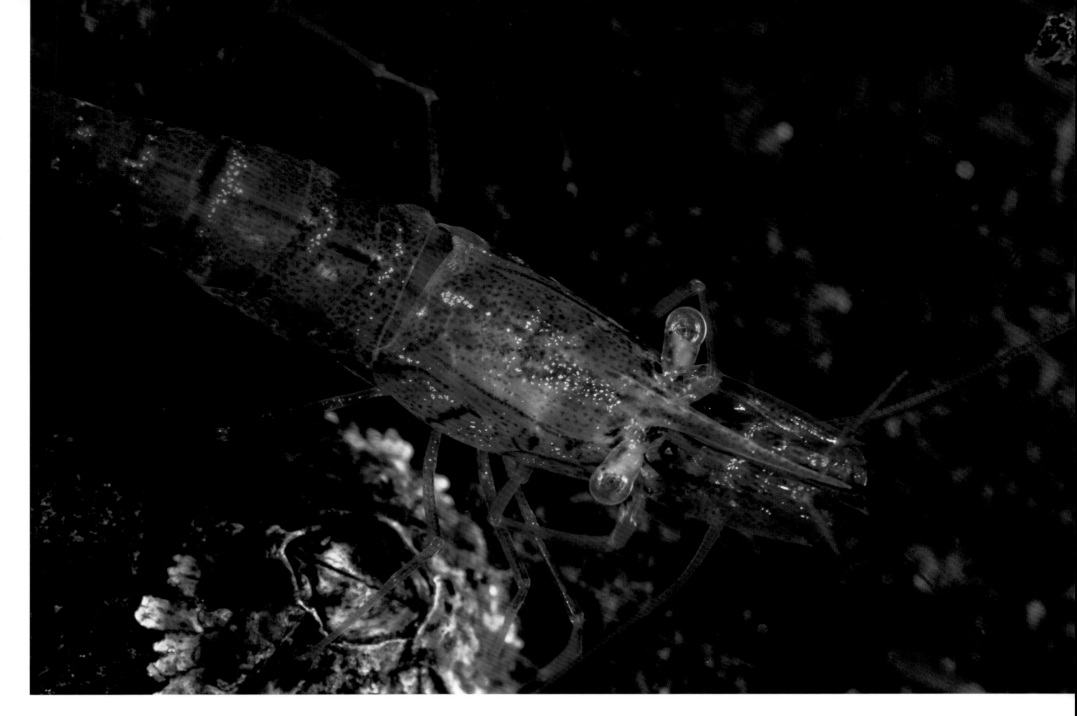

Virtually translucent, sevenspine bay shrimp (*Crangon septemspinosa*) blend into the sand and mud of marsh areas. These hard-to-spot crustaceans have adapted to varying salinities.

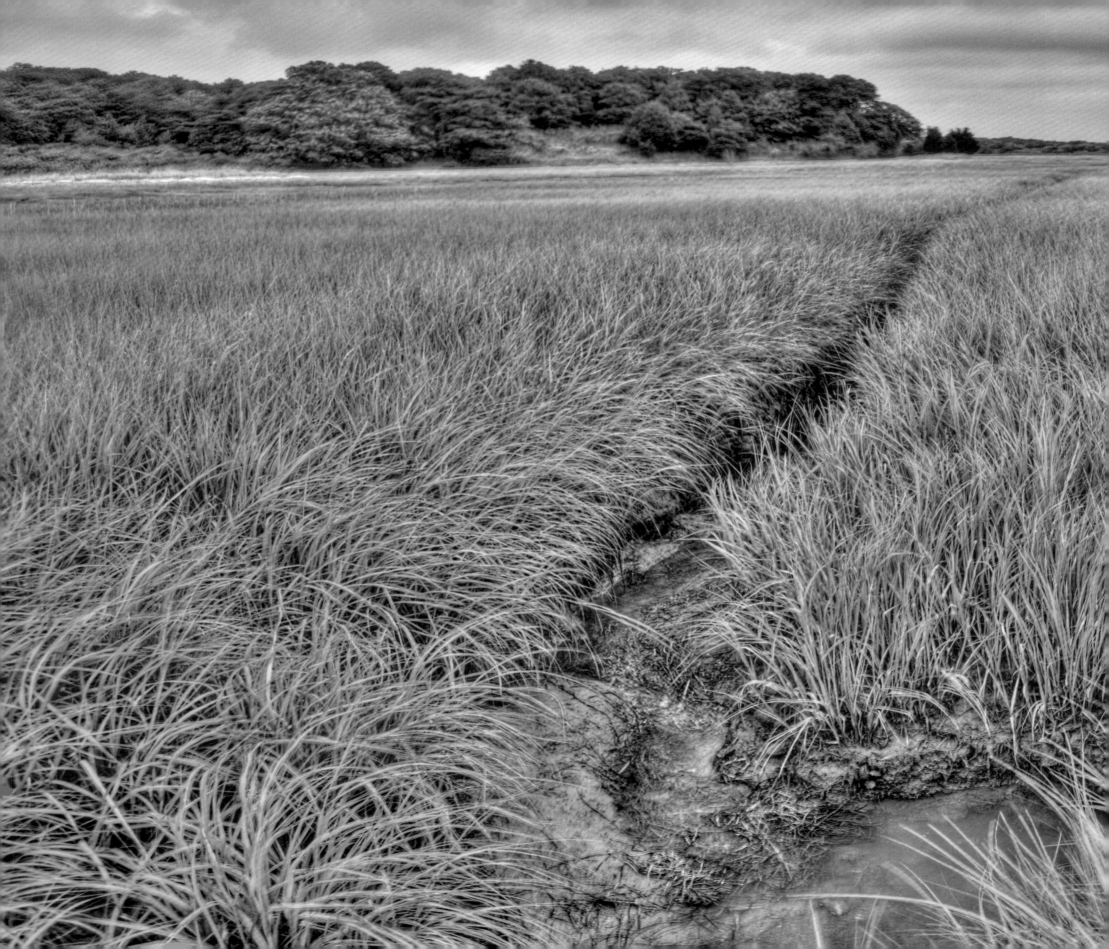

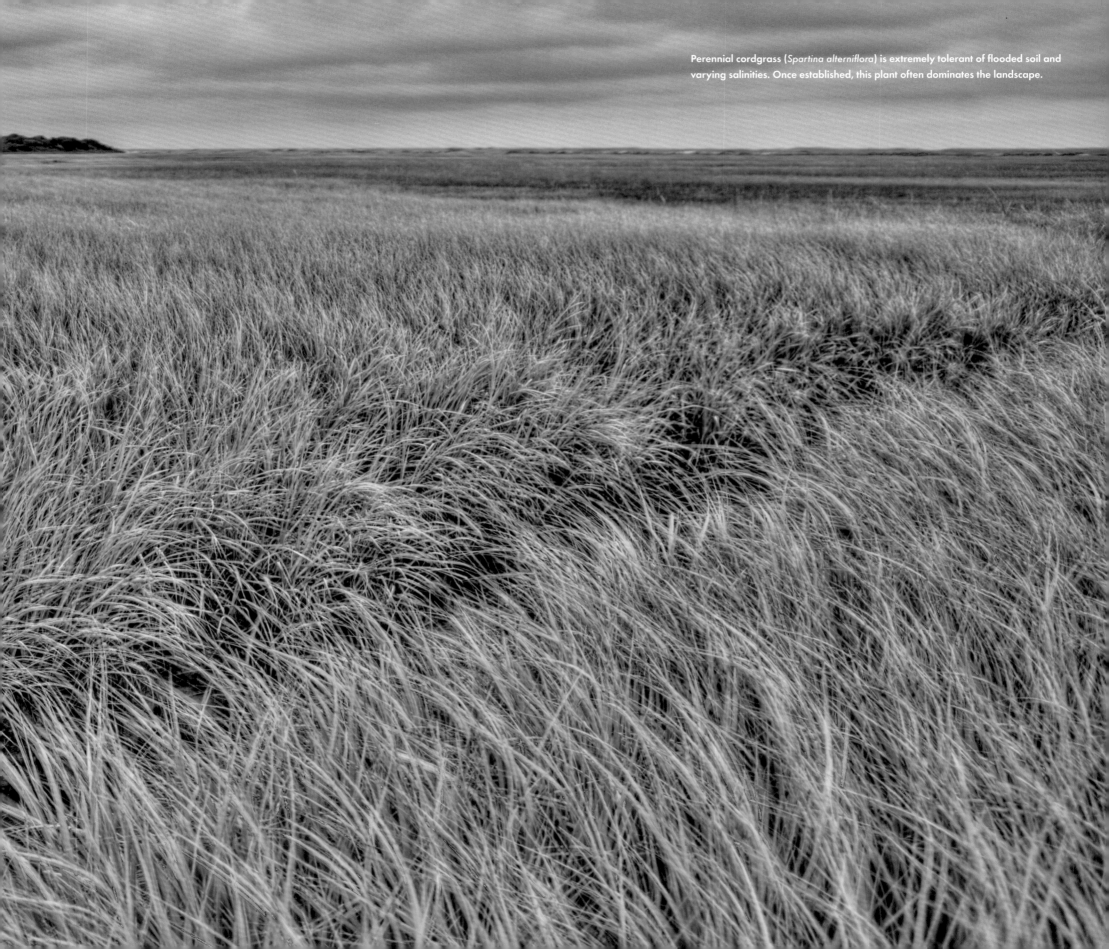

Perennial cordgrass (*Spartina alterniflora*) is extremely tolerant of flooded soil and varying salinities. Once established, this plant often dominates the landscape.

CHAPTER 3 · THE BENEVOLENT BAY

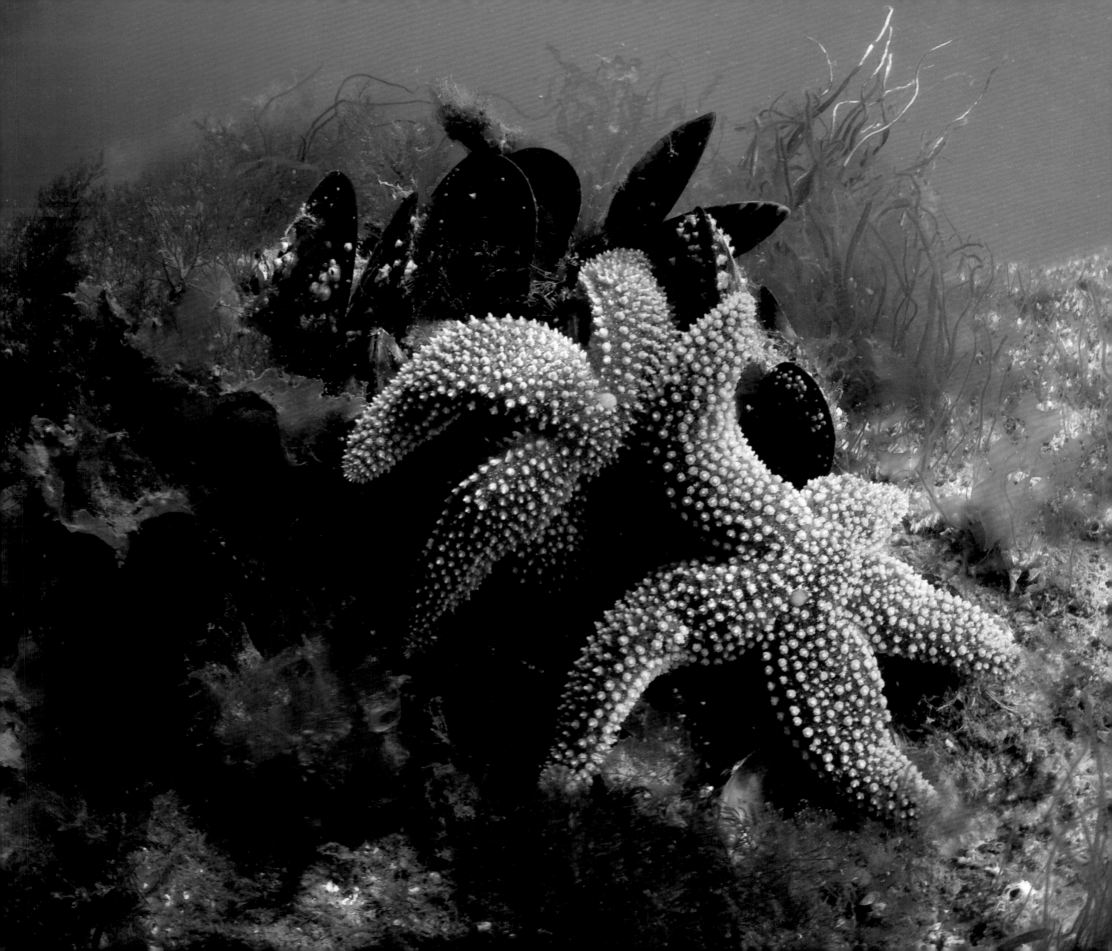

CHAPTER 3: THE BENEVOLENT BAY

An impossibly blue sky envelops the land and sea. It is another dazzling day on the outer Cape's protective, dynamic dunes. The leeward side of the dunes that make up Nauset Beach provides shelter for the hardy flora that prospers in such sandy soils—beach grass, wild rose, goldenrod, and poverty grass. To the west lie the typically tranquil waters of Pleasant Bay, approximately ninety-two hundred square acres of all that is the essence of Cape Cod. The bay's saltwater ponds, rivers, narrow creeks, islands, marshes, and inlets are the consequence of an ice age long ago and now act as nurseries and fertile feeding grounds. Marine life within Pleasant Bay represents a variety of flora and fauna that appear throughout much of New England's coastline.

The waters here, though calm and rarely deeper than fifteen feet, are not static. Incoming and outgoing tides play a dominant role in the bay's ecological web. The tides are not only influenced by the gravitational pull of the moon and sun but also by the growth and retreat of Nauset Beach, the narrow stretch of shifting sand to the east. A broth of planktonic organisms, including photosynthetic diatoms and dinoflagellates, larval fish, mollusks, and crustaceans are swept into the bay each rising tide, forming the foundation of the local food chain.

North Atlantic winds and currents churn cold nutrient-rich water at the two mouths of Pleasant Bay, where gray and harbor seals bob near fishermen who cast for bluefish and striped bass. These entrances to the bay are in constant flux, opening and closing roughly every one hundred and forty years with the continual movement of sand. The entrances, also known as breaks, slowly migrate south along the beach, a source of continual frustration, especially to the township of Chatham, due to the erosive effects of higher and lower tides on the mainland. Though new breaks tend to disgruntle people who lose their land to the sea, the bay's overall health generally benefits. With a new break comes the nourishing water from the Atlantic, which transports in new plankton and their predators; meanwhile, the bay's accumulated nutrients, such as nitrates and phosphates, are more easily whisked out to sea.

Rocky beaches, dotted with huge glacial boulders, line Pleasant Bay's shore, along with tracts of *Spartina* grass. High tides leave a wealth of washed-up eelgrass and rockweed, fascinating crab carapaces, empty scallop shells, skate egg cases, buoys, and sometimes a dilapidated lobster trap amongst the rocks and grasses. Walking along the shore, especially at low tide, allows a firsthand look at some of the animals that thrive in nearby waters. Just a few feet away, below the low-tide line, a menagerie of marine life thrives.

One of the bay's crucial primary producers is a jade-tinted perennial angiosperm that lives underwater in giant swathes of olive green: eelgrass (*Zostera marina*). The prolific eelgrass beds not only serve as food for browsing animals but also are home to a tapestry of

countless epiphytic organisms, bacteria, algae, worms, crustaceans, mollusks, and echinoderms. Bright red and orange sponges and tiny colonial tunicates cling to the thin grass blades, continually filtering the water for sustenance. Other epiphytic life catches the eye amongst small glittering bubbles of oxygen, delicate white star-shaped ascidians surrounded by minute corkscrews of *Spirorbis* worm shells. Eelgrass beds have long provided habitats and ecological processes very different from those of deeper waters offshore.

From a vantage point below the surface, the fluid movements of eelgrass are spellbinding. Currents move through the thick grasses like wind across a vast prairie. The roots, or rhizomes, of the grass stabilize the soft sediments and provide a food source for many animals. The currents bring food in the form of minute phyto- and zooplankton to the many passive, filter feeders that exist here. Bay scallops, razor clams, and soft-shelled and hard-shelled clams or quahogs are among the many mollusks that depend upon plankton for their wellbeing. Cape Cod is the northern boundary of both highly prized bay scallops and quahogs, which generally live in warmer regions. Also burrowed in the sand, along with many polychaetes, are infinitesimal gemma clams, which though small in size, are by far the most numerous of mollusks and serve as a vital food source for many of the bay's inhabitants.

At the base of the grasses, amongst narrow sandy pathways, crawl several spindly legged arthropod species. The smallest are the timid hermit crabs, carrying ungainly but protective periwinkle or mud snail shells on their backs. More difficult to see, while much larger, are the well-camouflaged decorator crabs. They can barely be discerned from their surroundings due to the amount of sponge and algal growth hooked onto their ten articulated limbs. Scampering across the bottom, stirring up a cloud of sand in its wake, a large male blue crab disappears into the underwater forest. These days, blue crabs are relatively rare, probably due to the changes in where seawater and crab larvae enter Pleasant Bay, as well as over-harvesting. Back when the crabs were prevalent, their larvae flowed in from the warmer waters of Buzzards Bay. Now, water exchange in the bay flows through the two breaks along the barrier beach off Chatham. This inevitable, natural progression merely alters the bay's food web.

Submerged portions of glacial rocks are carpeted with filter-feeding barnacles and yellow sponges. Sprouting from the sand nearby, delicate branch-like arms of a sea cucumber patiently feed on passing zooplankton, continuously stuffing the minute animals into its stationary gullet. Buried lugworms aerate the soil, much like terrestrial worms, digesting organics from surrounding sand, then depositing small mounds of sand nearby. Black mud snails slime their way between the cones

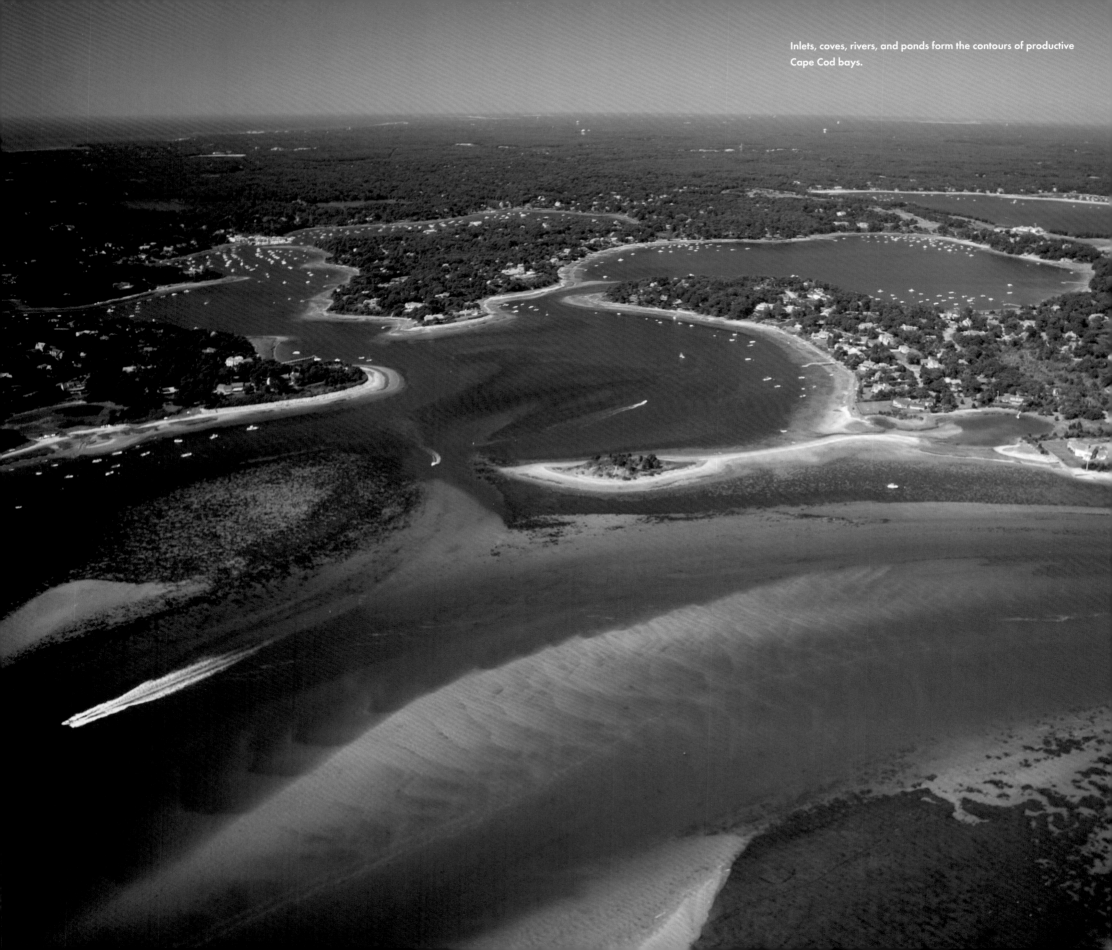

Inlets, coves, rivers, and ponds form the contours of productive Cape Cod bays.

of sand, searching for algae on which to graze. A pair of russet-colored horseshoe crabs bulldoze through the scene, the smaller male clasping the massive female from behind. These prehistoric crabs, relatives of the scorpion, are quintessential Cape Cod and certainly one of the keystone species of the bay.

Horseshoe crabs feed on small worms and bivalves, grinding up whatever they can. Now in late summer, it is toward the end of their mating cycle, but a few pairs are still found scattered about the eelgrass. May through July, female crabs head into the shallows of Pleasant Bay to lay as many as twenty thousand bluish-green eggs in multiple clusters in just one night. Another generation of tiny horseshoe crabs, beginning as swimming larvae, will hatch in coming months, renewing life in the bay. How successful horseshoe crabs have been over time! They have changed little since evolving almost 350 million years ago.

Above the crabs and amidst the vivid kaleidoscope of ectosymbionts living on the eelgrass live dozens of species of vertebrates. A slender relative to the seahorse appears from out of the grass mélange. It is a giant northern pipefish blending into the habitat with drab patterns. The strange, flattened profile of a summer flounder seems to glide across the sand, searching for small fish or crustaceans on which to feed. Schools of small mummichog and translucent silversides dart through the jungle of grass blades, avoiding deeper waters where predatory bluefish and striped bass patrol. Winter flounder, scup, blueback herring, menhaden, butterfish, alewife, and dozens of other species are found seasonally amongst the bay's habitats.

It is not easy to discern the alterations or adaptations that have occurred within the last several decades in Pleasant Bay's marine ecosystems. But community alterations are inevitable. The new inlet that broke in Nauset Beach in April 2007 may be a boon for the water quality of the bay, sweeping out phosphorous— and nitrogen-laden waters that had been stagnating for years. But for landowners, especially near the cut, the new extreme tidal exchanges are not a welcome sign. Time progresses regardless of human desires, however, and the bay will evolve to make the most of its influences from both sea and land.

A slender relative to the seahorse appears from out of the grass mélange

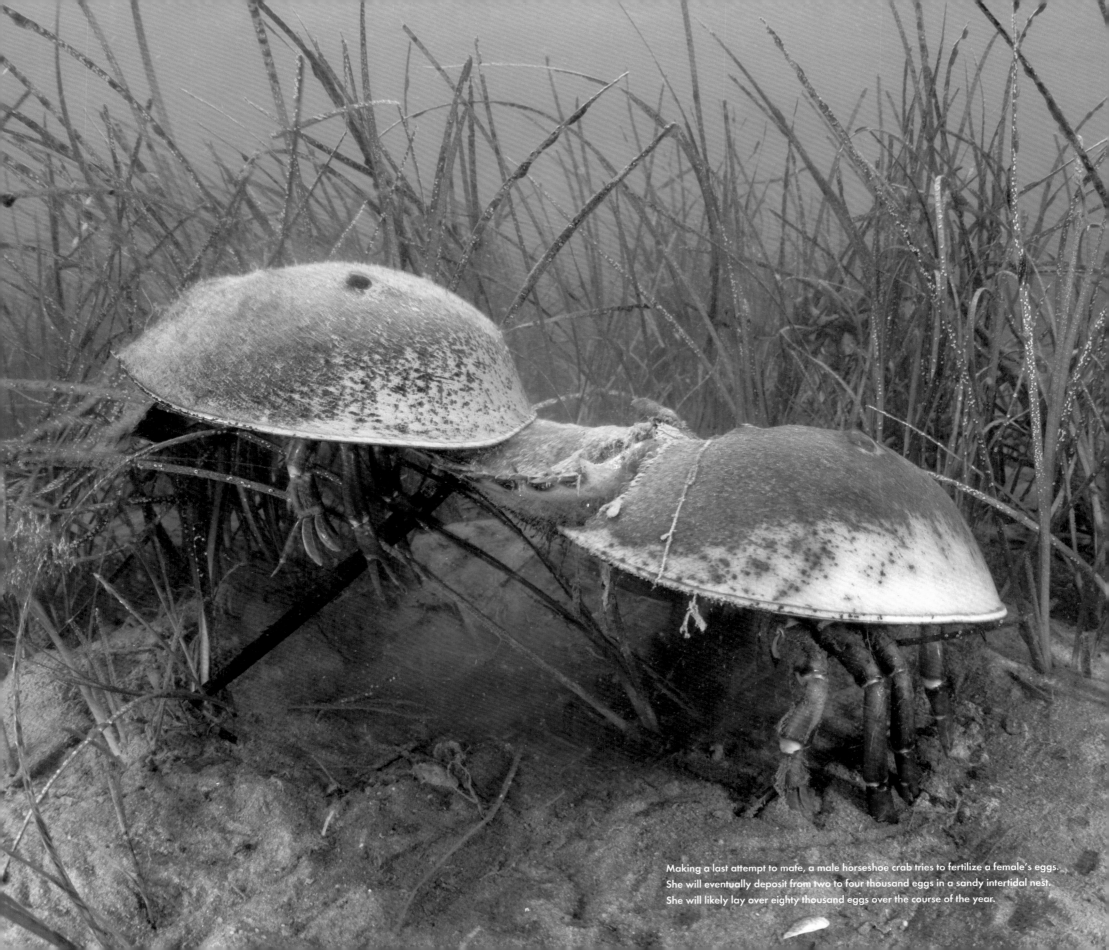

Making a last attempt to mate, a male horseshoe crab tries to fertilize a female's eggs.
She will eventually deposit from two to four thousand eggs in a sandy intertidal nest.
She will likely lay over eighty thousand eggs over the course of the year.

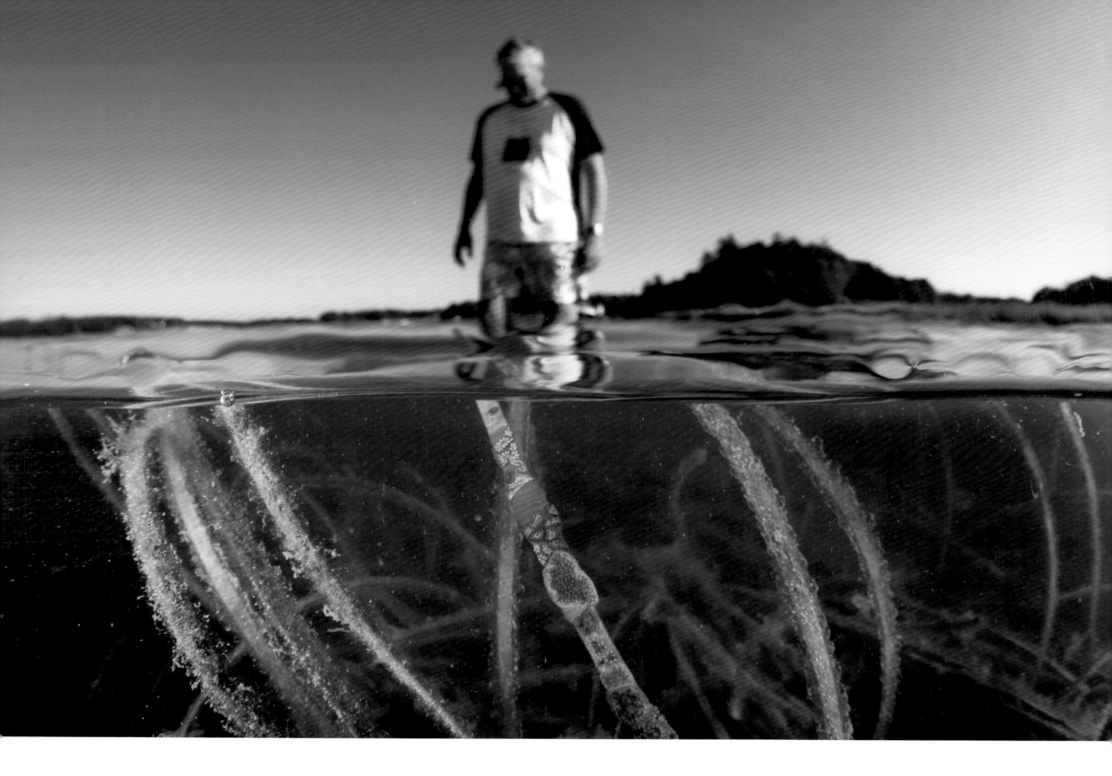

Sponges, tunicates, and algae live as epiphytes on eelgrass (*Zostera marina*);
many fish and shellfish also depend on the considerable acres of eelgrass beds
found throughout the Cape.

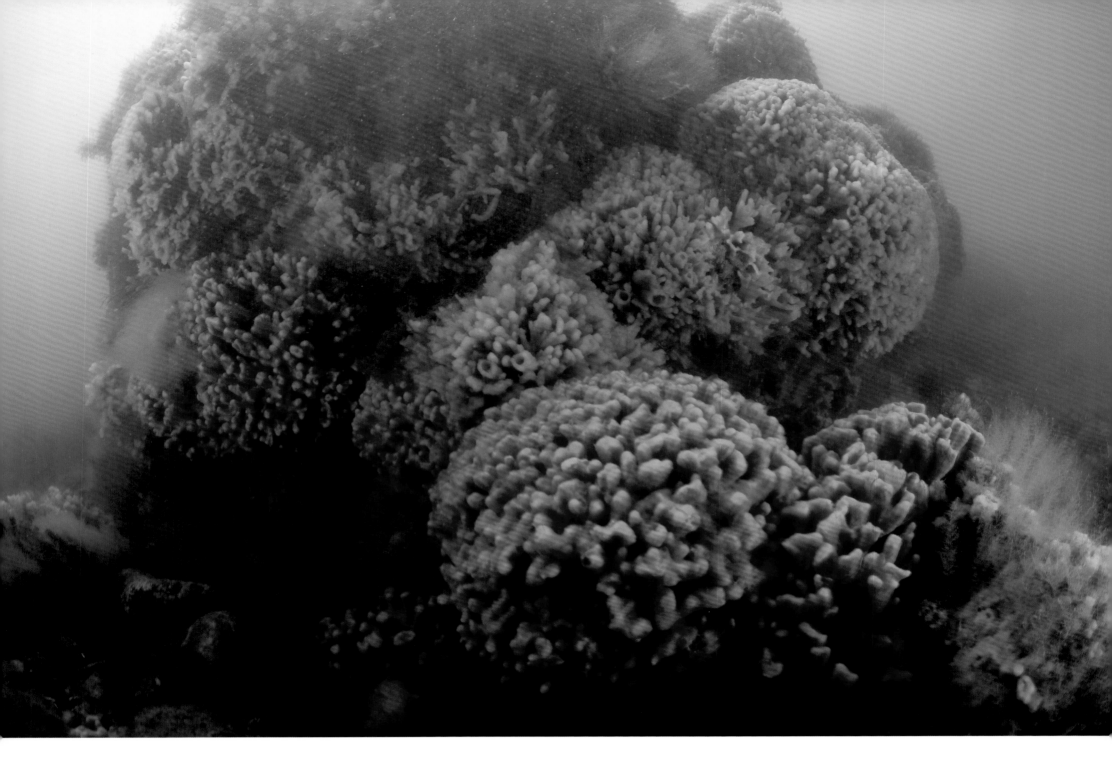

Sponges are the simplest multicellular animals on Earth. They have colonized virtually every habitat where there is water. Many colorful species are found along the coasts of New England, from the shallows to the deepest depths.

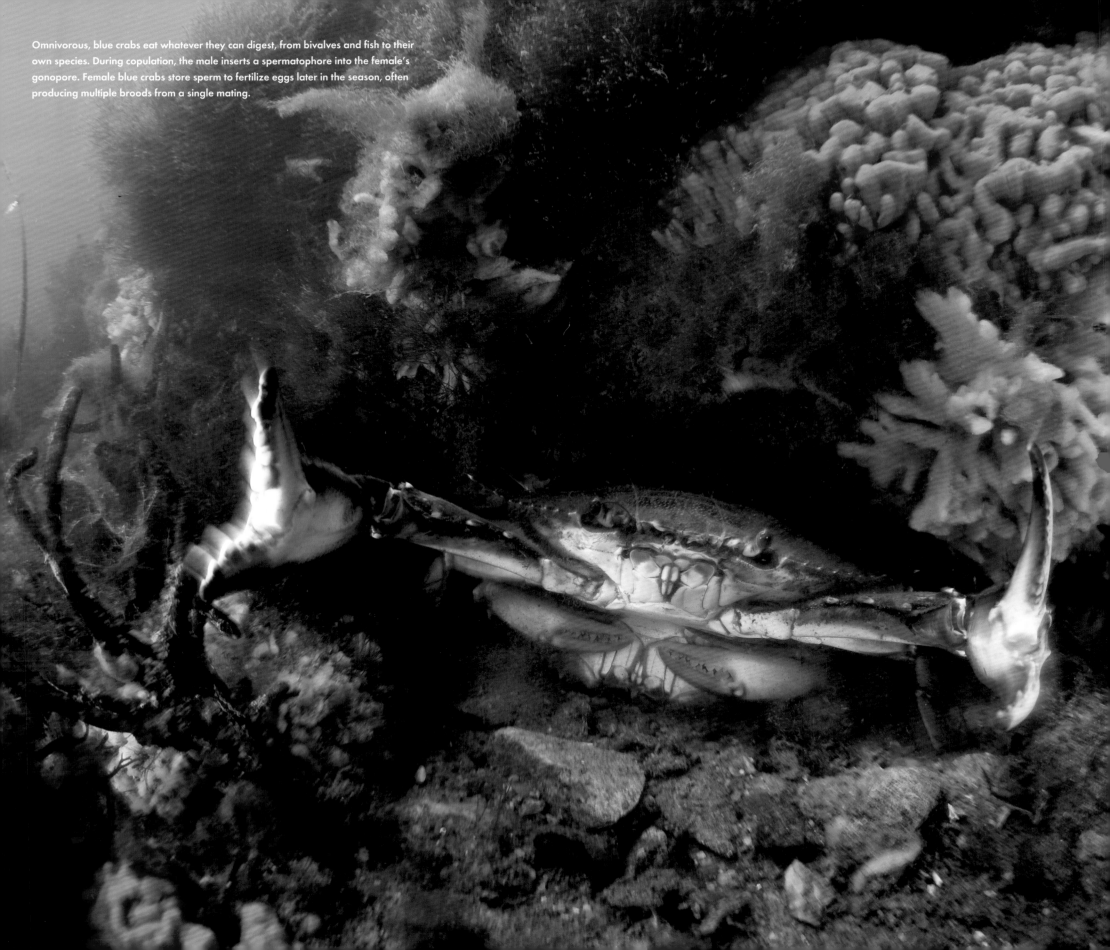

Omnivorous, blue crabs eat whatever they can digest, from bivalves and fish to their own species. During copulation, the male inserts a spermatophore into the female's gonopore. Female blue crabs store sperm to fertilize eggs later in the season, often producing multiple broods from a single mating.

Northern pipefish slither and dart through the underwater jungles of eelgrass.
Their long jaws are similar to their relatives'—seahorses.

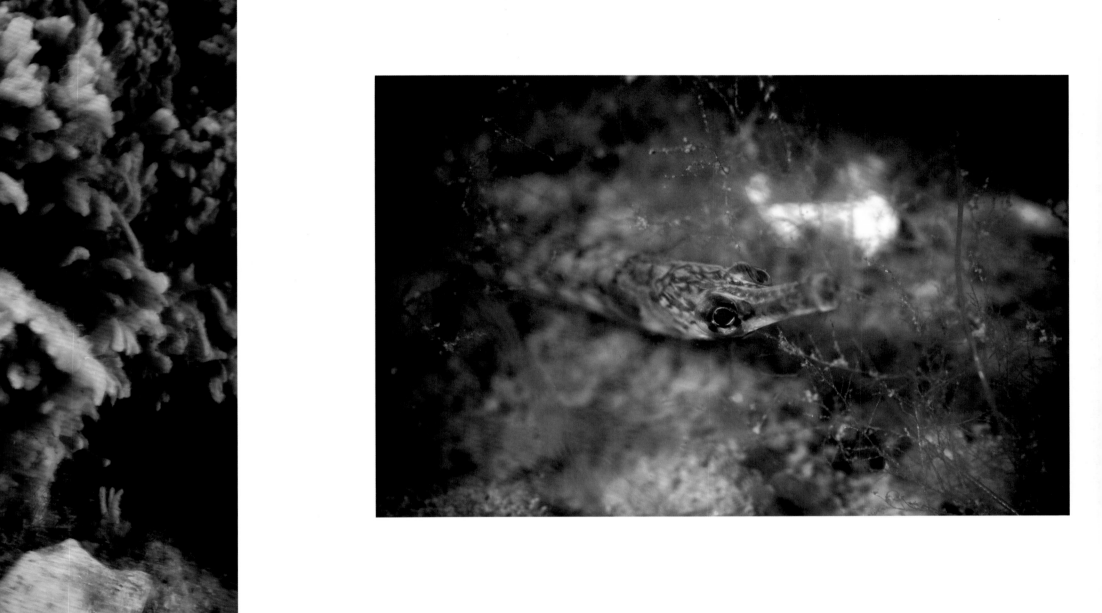

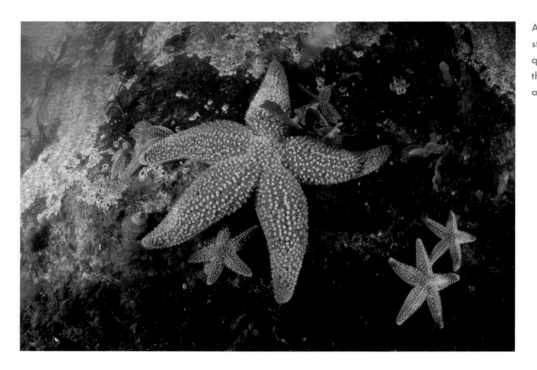

An integral part of the ecosystem, sea stars can feed on up to fifty young quahogs or mussels in a week and therefore compete with commercial and recreational fishermen.

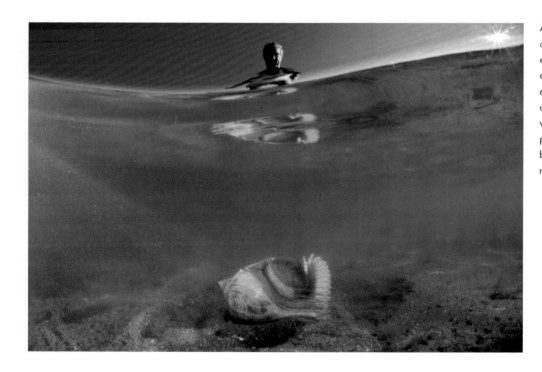

A predatory knobbed whelk (*Busycon carica*) lays a string of translucent egg capsules on the shallow bottom of the bay. Each circular capsule, about an inch in diameter, can harbor up to ninety-nine eggs. Once the tiny whelks mature, they will begin to prey upon oysters, clams, and bivalves found within the bay's muddy habitats.

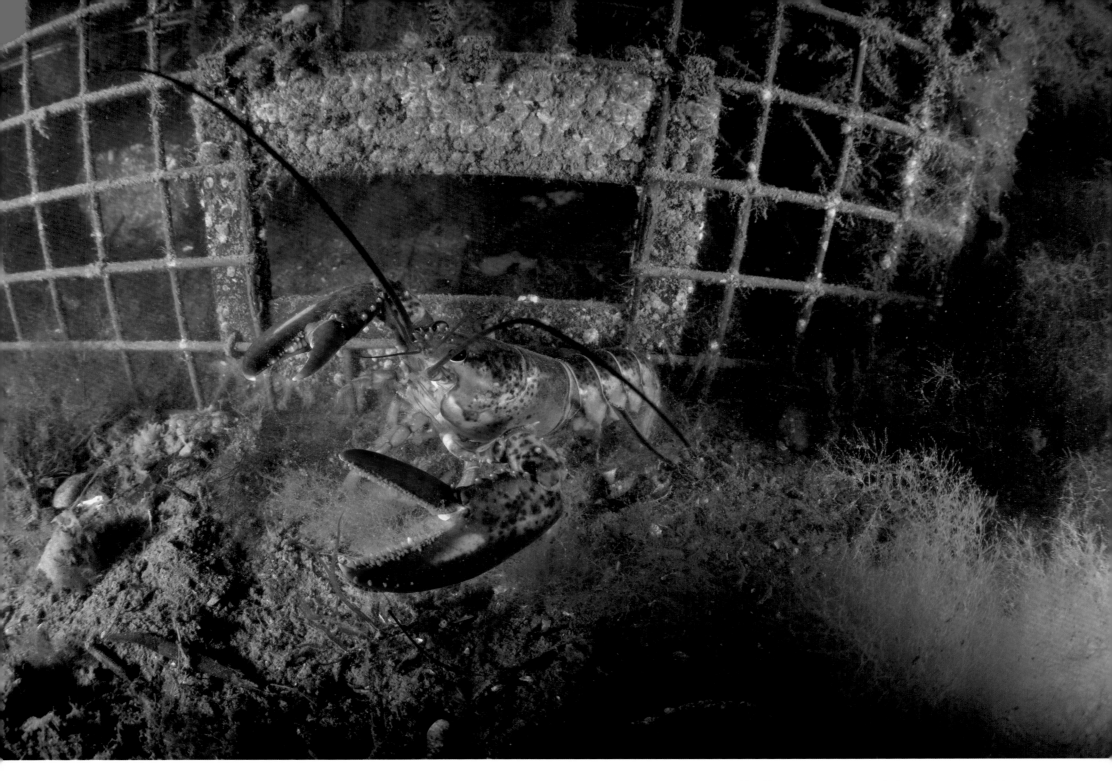

Capable of living over a century, a relatively young northern lobster (*Homarus americanus*) ponders entering a trap. The lobster fishery is heavily managed all throughout New England for good reason. It would be very easy to over-harvest this highly valued and slow-growing decapod.

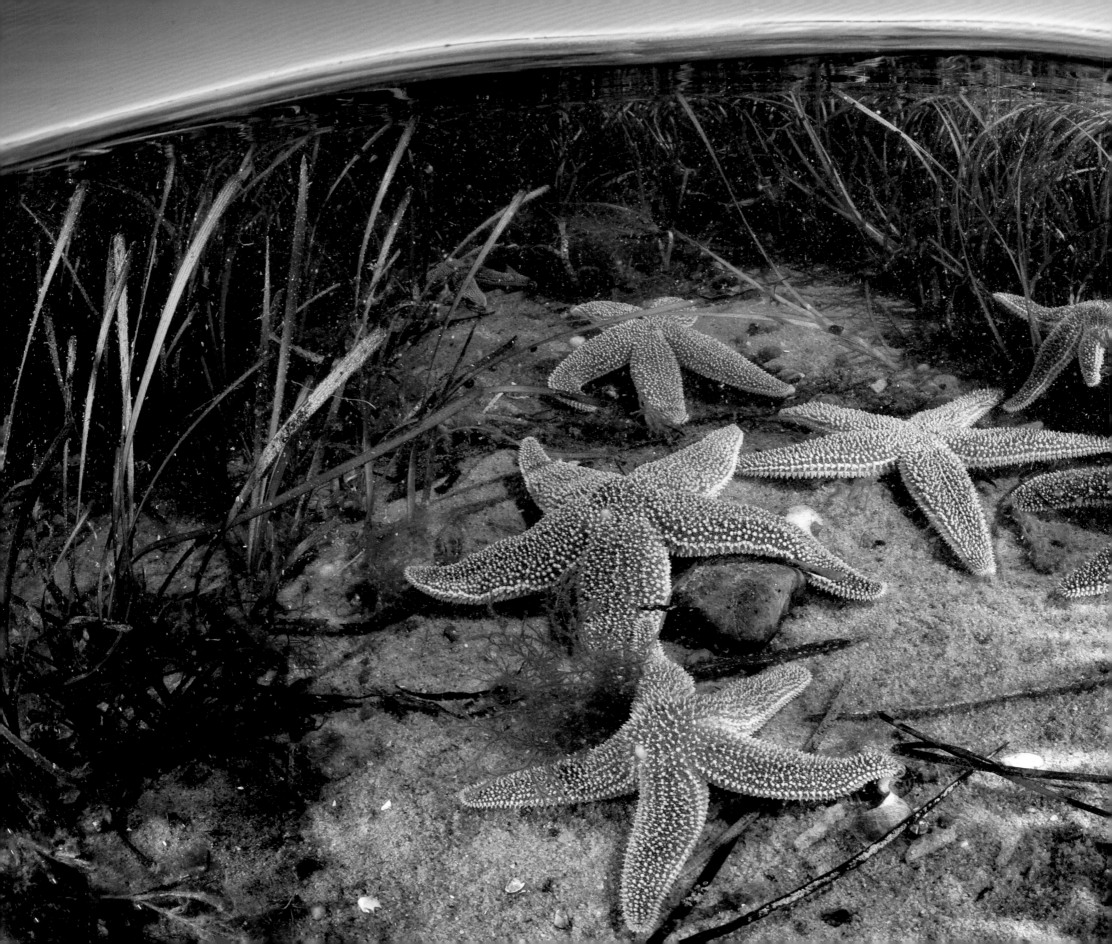

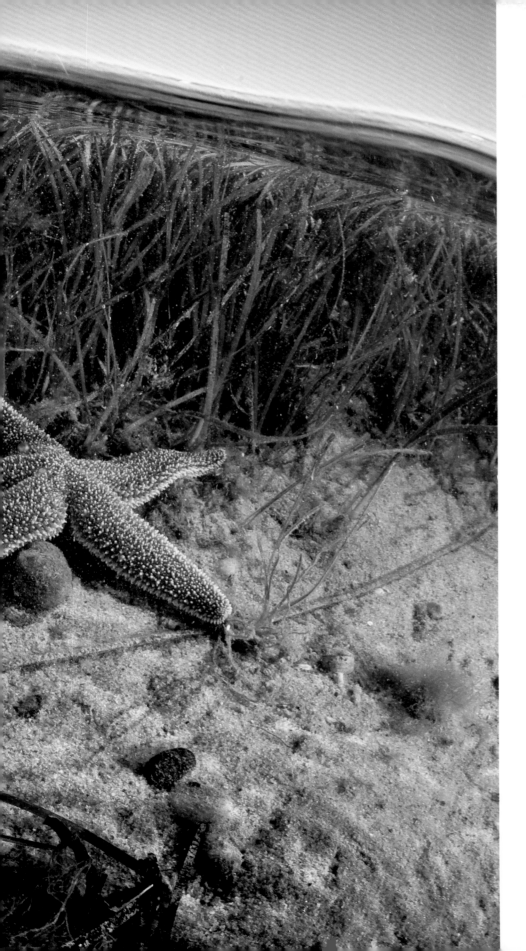

Littering the bottom near the shore of the bay, sea stars are one of the most recognized marine animals in New England.

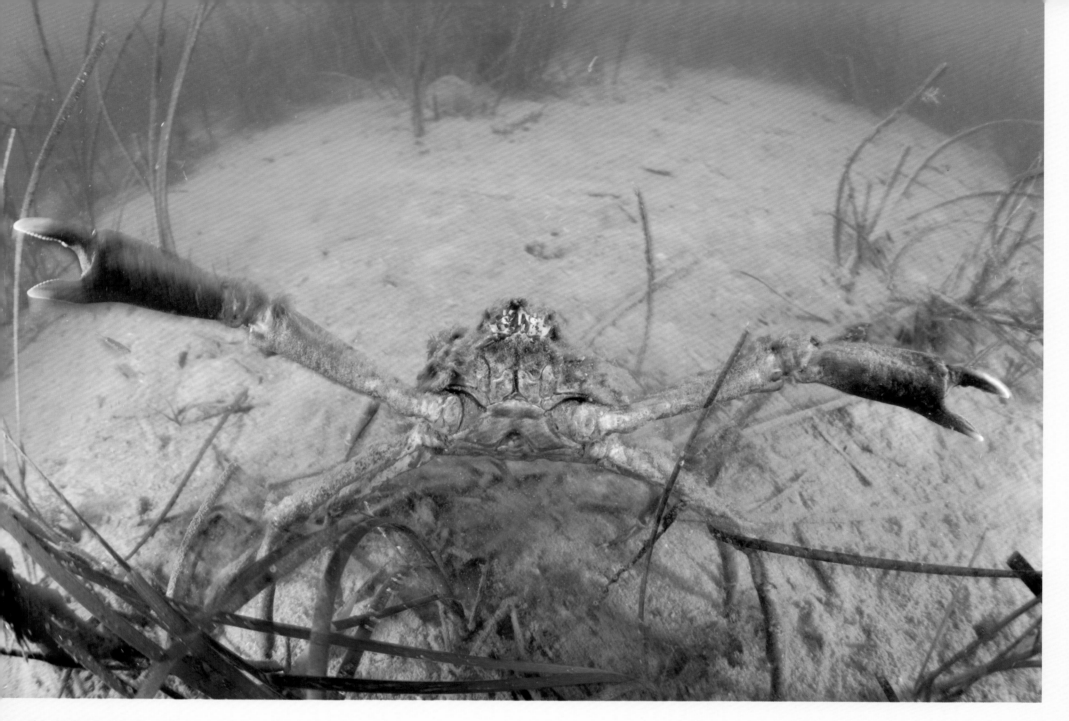

Though ubiquitous, toad crabs (*Hyas araneus*) are usually hard to spot amongst
eelgrass beds, as they grow algae, sponges, and other invertebrates on their
carapaces. These crabs are often by-catch of lobster fisheries.

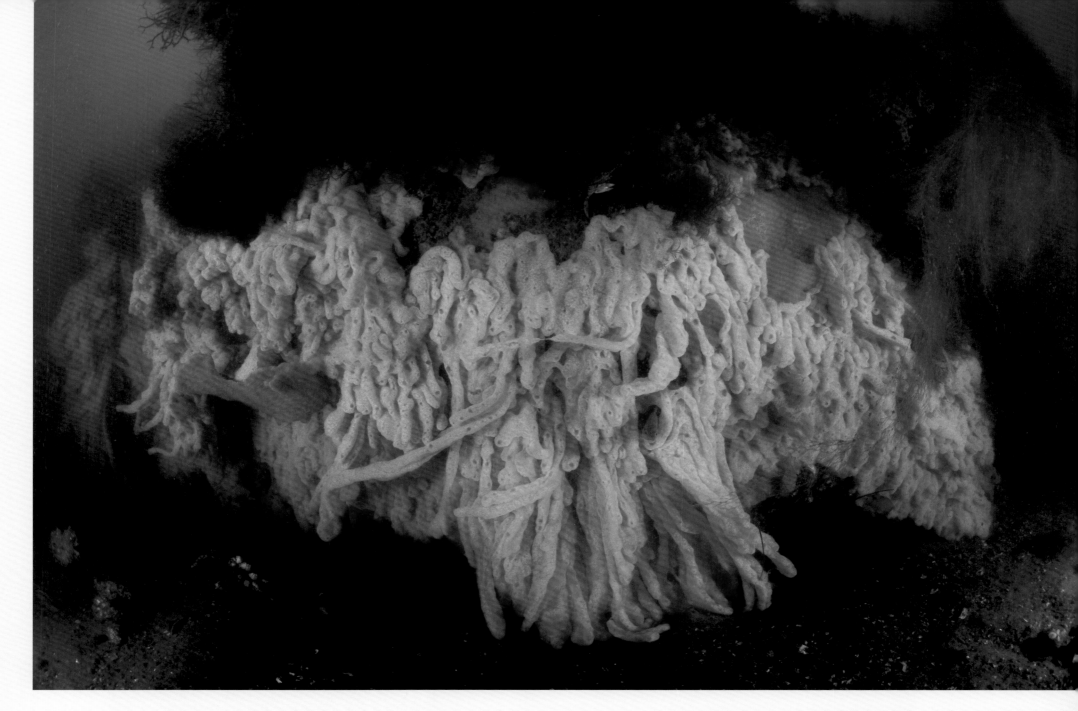

Drooping sponges encrust a submerged boulder, decorating the shallows with brilliant hues. Sponges are filter feeders that clean bay waters, improving visibility and removing toxins.

Barnacles cover a large colony of edible blue mussels (*Mytilus edulis*) in the intertidal zone of a bay. The mussels hold to rocks within the bay with incredibly strong, hair-like threads.

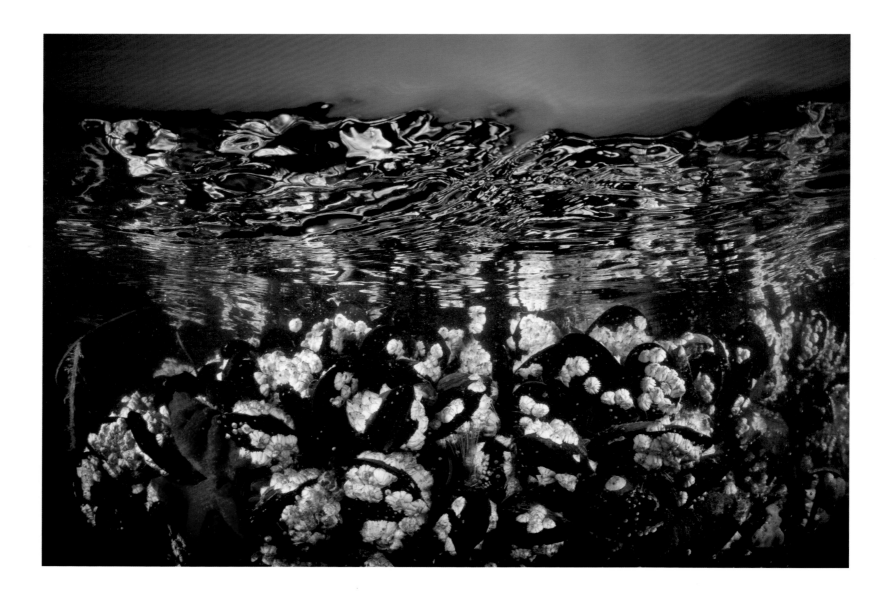

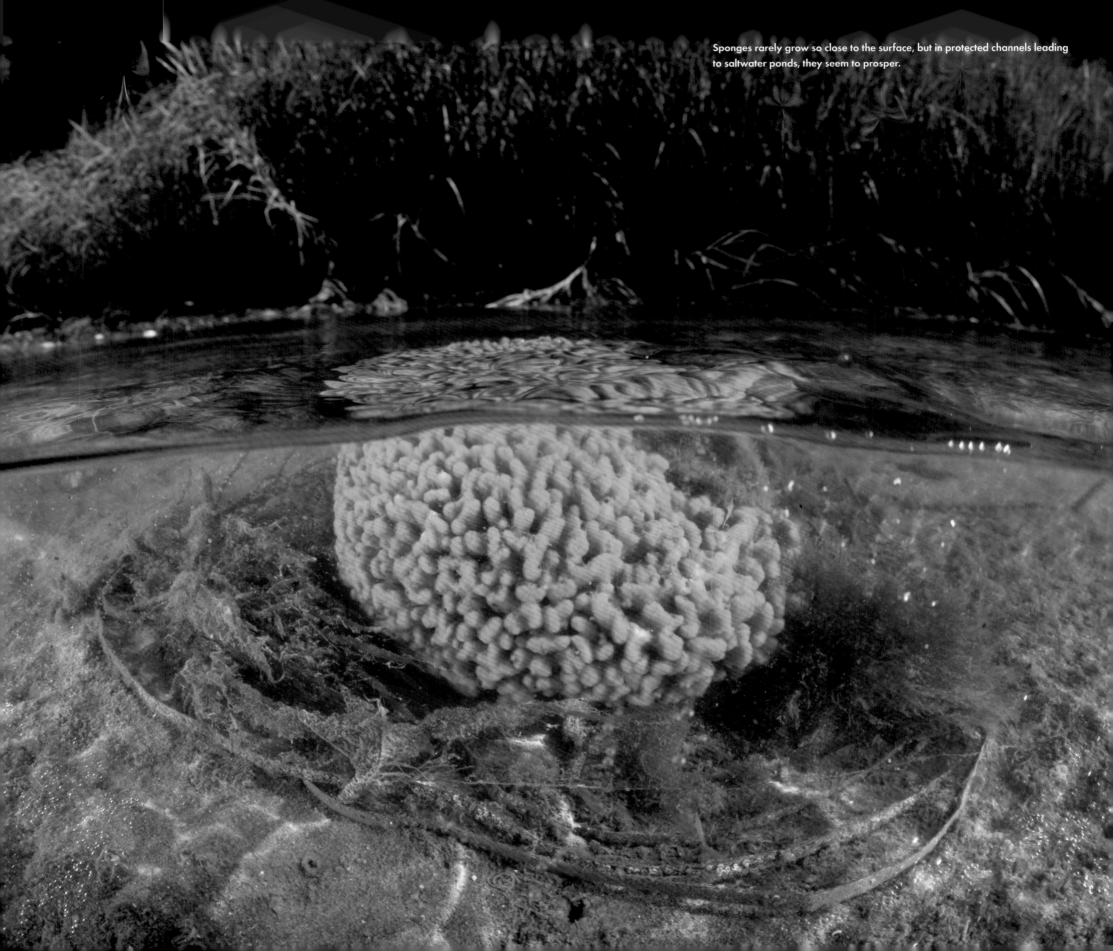

Sponges rarely grow so close to the surface, but in protected channels leading to saltwater ponds, they seem to prosper.

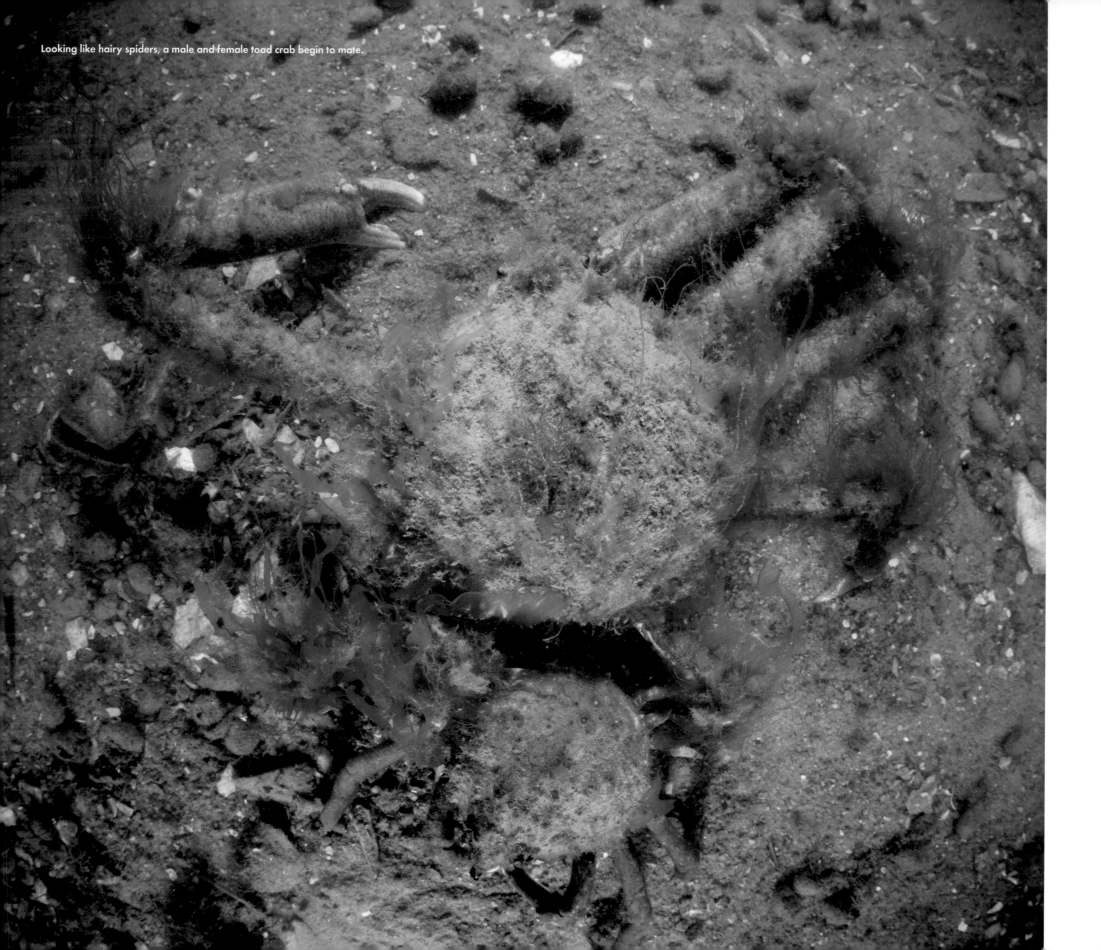

Looking like hairy spiders, a male and female toad crab begin to mate.

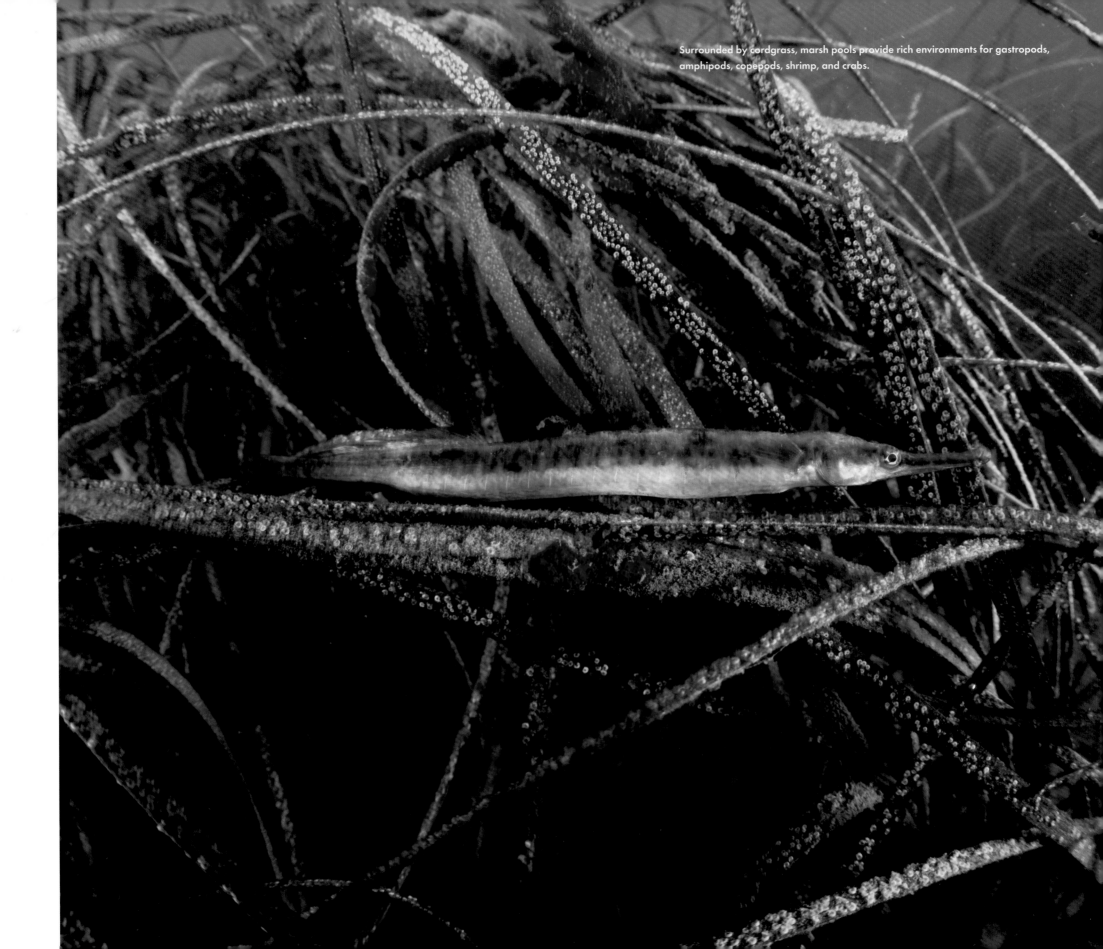

Surrounded by cordgrass, marsh pools provide rich environments for gastropods, amphipods, copepods, shrimp, and crabs.

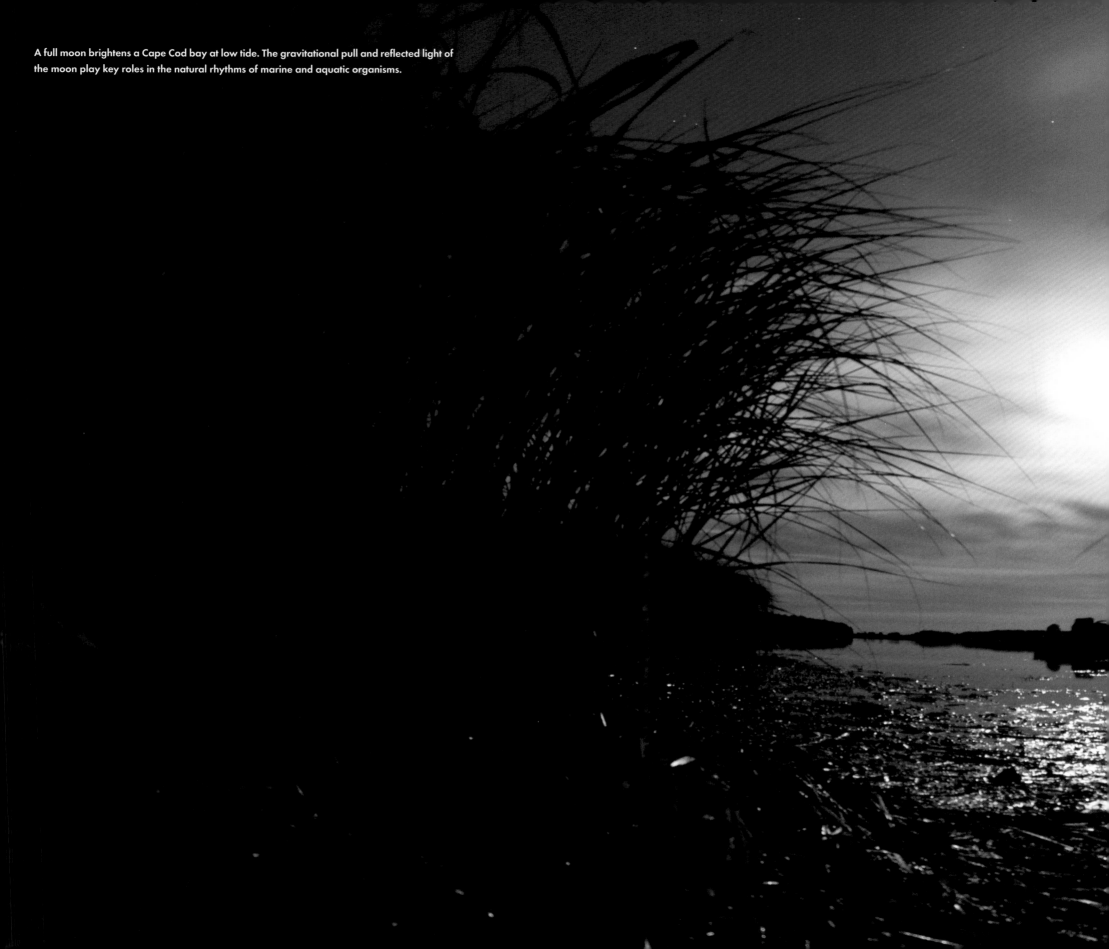

A full moon brightens a Cape Cod bay at low tide. The gravitational pull and reflected light of the moon play key roles in the natural rhythms of marine and aquatic organisms.

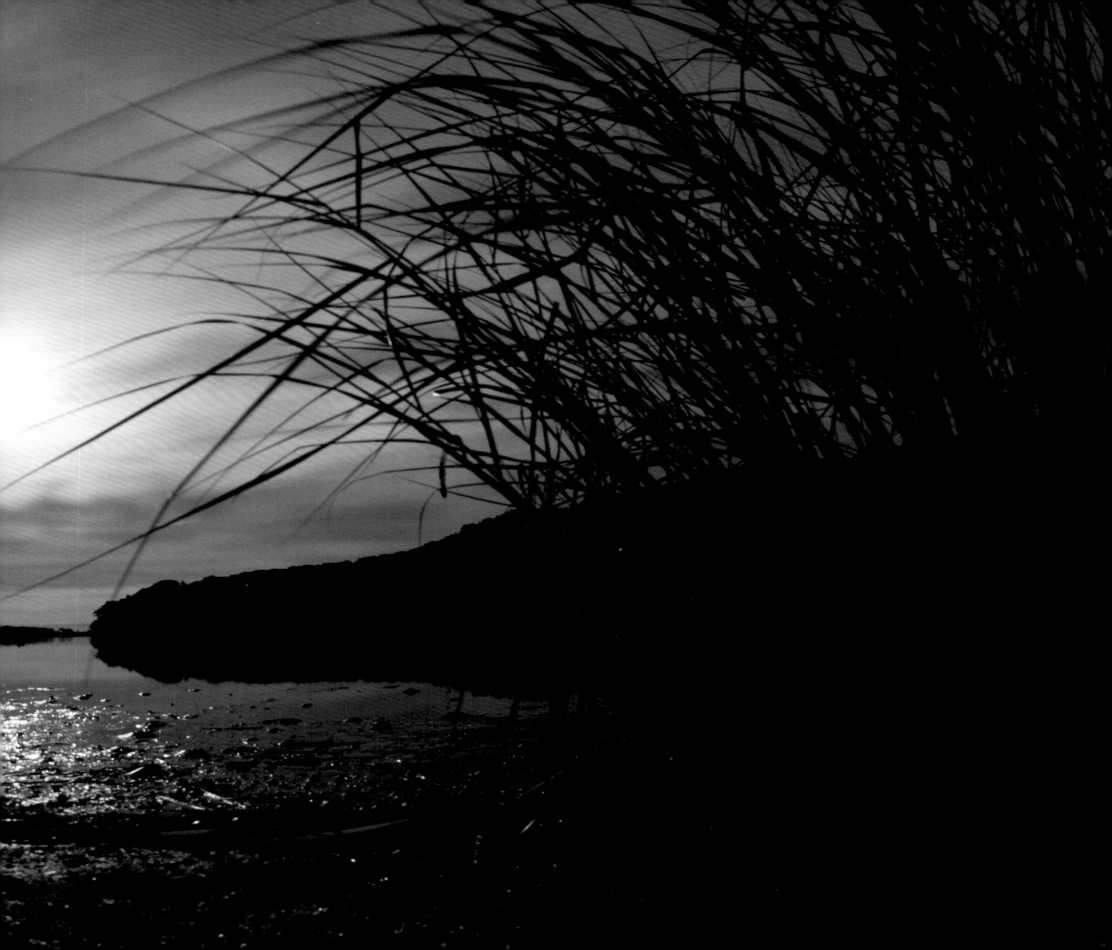

CHAPTER 4 | THE OCEAN'S AMBIANCE

Gray seals are now found in large numbers along the outer Cape, where food is prevalent—including sand eels, flatfish, herring, and lobster—and plenty of beaches provide spots to haul out.

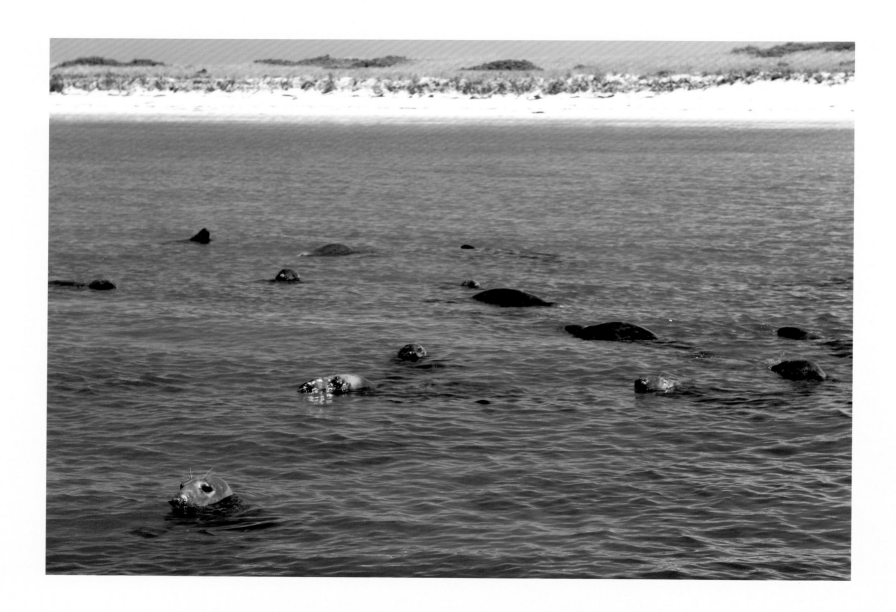

CHAPTER 4: THE OCEAN'S AMBIANCE

Just a stone's throw from the bay, the ocean seethes. Cold ocean currents bustle with life along the long arm of Cape Cod. The ocean defines Cape Cod—its history, its climate, its dramatic moods and allure. Additionally, the ocean's role in the Cape's ever-changing coastline and the overall health of its fisheries and wildlife cannot be overstated.

Consciously or unconsciously, deep in our genetic makeup, all of us are related to the sea

First light sparkles on the ocean's white caps, silhouetting the head of a male gray seal as it peeks up from the green waters. The plump eight-foot-long seal takes in its surroundings and pauses to consider several amusing people on surfboards waiting for a set of waves to roll in. To the east, beyond the seal and the surfers, churns the North Atlantic Ocean, an expanse of chilly, salty water whose magnetism, resources, ferocity, and monsters have long held people's imaginations. Heedless of the mysteries of the sea, the seal sinks beneath the waves, disappearing into the dark underwater world where it was born to thrive.

The distinctive smell of the sea is what most people first notice upon the approach to Cape Cod. A sense of relaxation and comfort derives from the aromatic salty air, cracking open the doors to their lost thoughts. Consciously or unconsciously, deep in our genetic makeup, all of us are related to the sea. Here on Cape Cod, we all possess a stake in the ocean's wellbeing.

The open ocean is alive with movement. It swells and subsides, endlessly rolls and rocks according to earthly, solar, and lunar rhythms. The major currents of the North Atlantic originate from thermohaline circulation and are the basis for an extremely large and diverse food web. For centuries, anglers have known that New England's plankton-rich waters are among the best in the world for food-fish production. Its cold waves, which can range from 53.6°F in the early spring to 71°F in the late summer, act as a nursery and provide essential food sources for both native fauna and local communities.

What makes Cape Cod's pelagic waters so fruitful are microscopic photosynthesizing one-celled diatoms and other algae (phytoplankton) invisible to the naked eye. The shallow photic zone of the North Atlantic is like a colossal farm, producing immeasurable amounts of phytoplankton. Stellwagen Bank and Georges Bank, where nutrient-rich water blends with sunlight, are especially productive due to deepwater upwelling. Blooms of phytoplankton then feed the slightly larger planktonic animals (zooplankton), including protozoa, larval crustaceans, and fish, like sand lance, which in turn attracts planktivorous marine mammals and larger fish. Some of the most extraordinary and rare mammals on Earth feed and raise young here, including northern right whales, fin, minke, and humpback whales. In many cases, whales travel thousands of miles in order to be off the Cape's coast during summer months. Once there, they strain enormous quantities of plankton through their baleen, fattening themselves for the long

migration south before winter. Fish- and squid-eating toothed whales, like pilot whales, orcas, and a number of dolphin species, also inhabit the Cape's offshore sea, seasonally drawn to the protein-rich area.

Most common to spot, for locals and visitors alike, are harbor and gray seals, which are now re-inhabiting many of their haunts and breeding grounds of old around the Cape. Recent legislation protects these species from being hunted, and their numbers have rebounded dramatically. Retaining their ties to land, seals haul their ungainly bulks onto beaches and rocks at low tide and bask in the warm sun. As the tide rises, the seals re-enter the water, graceful in their movements once more. Slowing their heart rate in order to conserve oxygen, gray seals often swim submerged for over twenty minutes. Using excellent underwater vision, acute hearing, and possibly echolocation, they hunt sand eels, crabs, shellfish, squid, herring, alewife, flounder, hake, or whatever comes across their path.

The outer Cape now hosts one of the largest colonies of gray seals in New England. The return of seal populations signals another stirring comeback—the food web's supreme predator, the great white shark. The great white has been the stuff of legends and nightmares for good reason. Growing over twenty feet long, weighing several thousand pounds, with a never-ending supply of saw-like teeth, the great white is one of the few predators remaining on the planet capable of hunting and consuming a human. Over the past few years, several documented attacks on seals just off the outer beach signal where great white sharks patrol. The waters here have always been home to sharks, but with the return of their favored prey—portly pinnipeds—the great white shark population should grow locally.

Another large beast that seasonally visits the coastal waters of Cape Cod is the grayish brown basking shark. Growing to massive sizes, usually around twenty to twenty-five feet in length, this species is often mistaken for the great white, but there is little to fear from basking sharks. Their gigantic mouths are adapted to gorge on microscopic zooplankton, not mammals. Other sizeable sharks found off the coast include blue porbeagle, shortfin mako, and thresher sharks. More widespread in coastal waters, where fishermen often reel them in, are the spiny and smooth dogfish, both slender sharks that grow to a less-intimidating size of about three feet. Smooth dogfish are voracious hunters of lobster and have a bad reputation amongst fishermen as a result. Spiny dogfish regularly swim in packs, seasonally migrating with their prey: herring and mackerel.

Notable swimmers that contribute to Cape Cod's vital fishing industry include flatfish—flounder, sole,

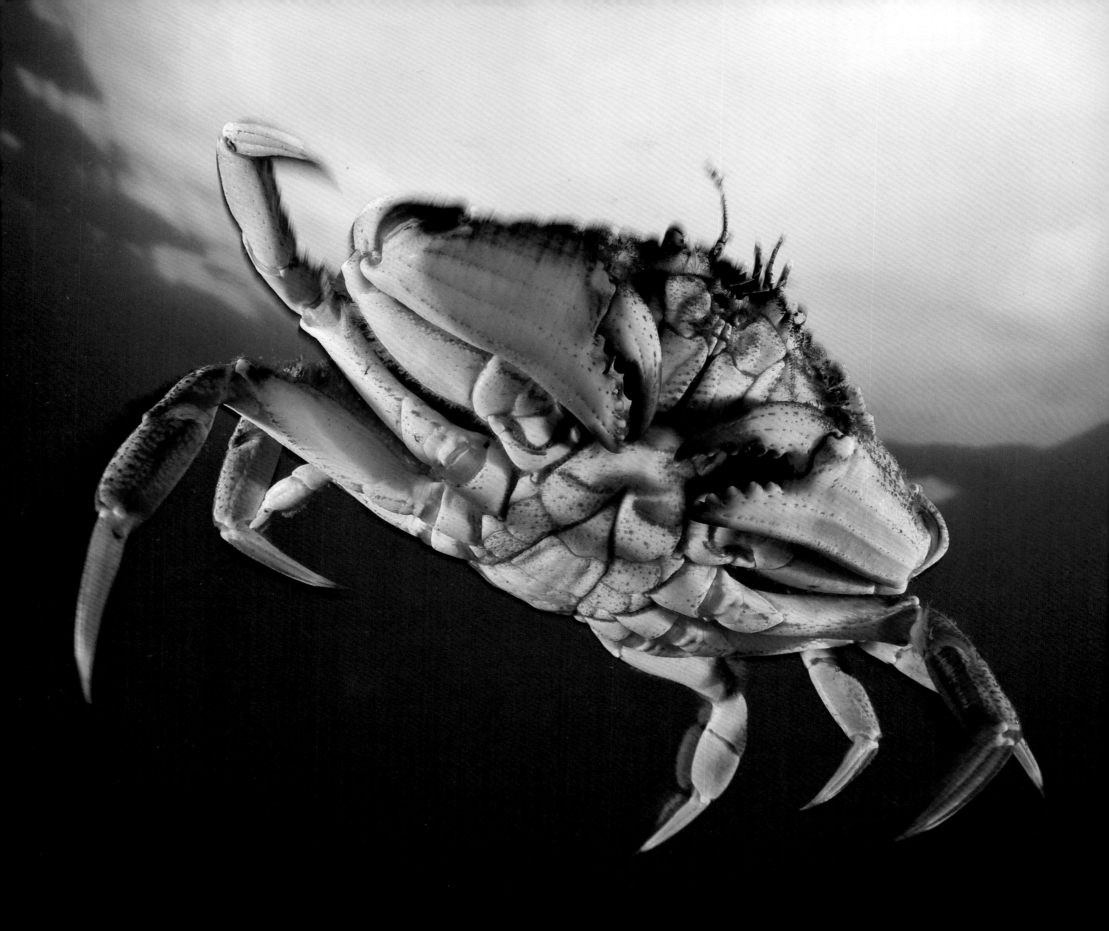

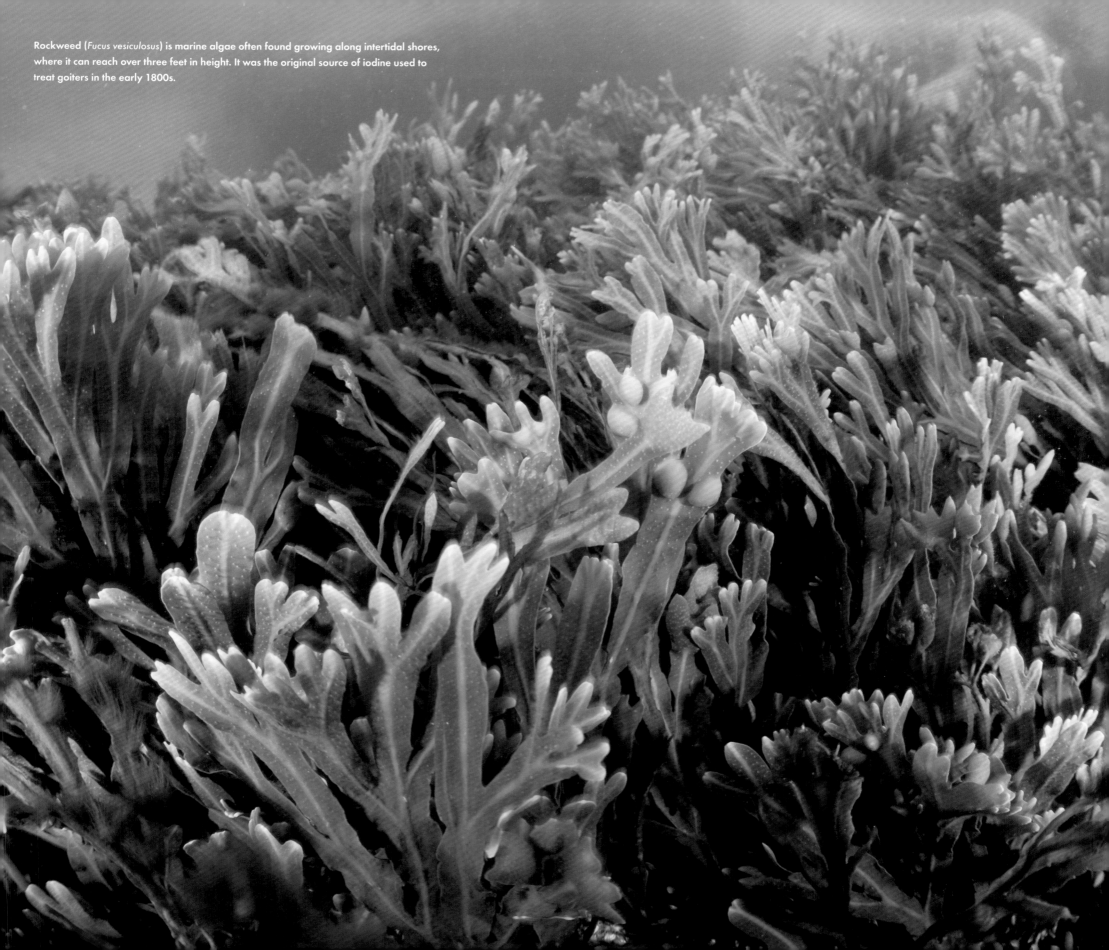

Rockweed (*Fucus vesiculosus*) is marine algae often found growing along intertidal shores, where it can reach over three feet in height. It was the original source of iodine used to treat goiters in the early 1800s.

halibut—striped bass, bluefish, bluefin tuna, mackerel, thorny skate, Atlantic herring, spiny dogfish, haddock, hake, and the legendary cod. It is amazing how such a multitude of body designs can thrive in such austere conditions, yet fish adapted to this environment millions of years ago.

After what seems like an eternity, the gray seal once more emerges from the murky depths. Though its life is not easy, having to compete for food while avoiding enormous sharks, it must instinctively recognize the beauty of the North Atlantic. The changing sea is secretive, sometimes ferocious and potentially cruel, but it is also habitat for a fantastic array of life, from the miniscule to the massive. It is a blue-green playground for a variety of fish, marine mammals, and other exotic life forms that have adapted in order to take advantage of its assets. This chaotic gumbo of life evokes enduring imagery of seafaring livelihoods, the salty smell of the ocean, and the erratic sounds of waves and wind.

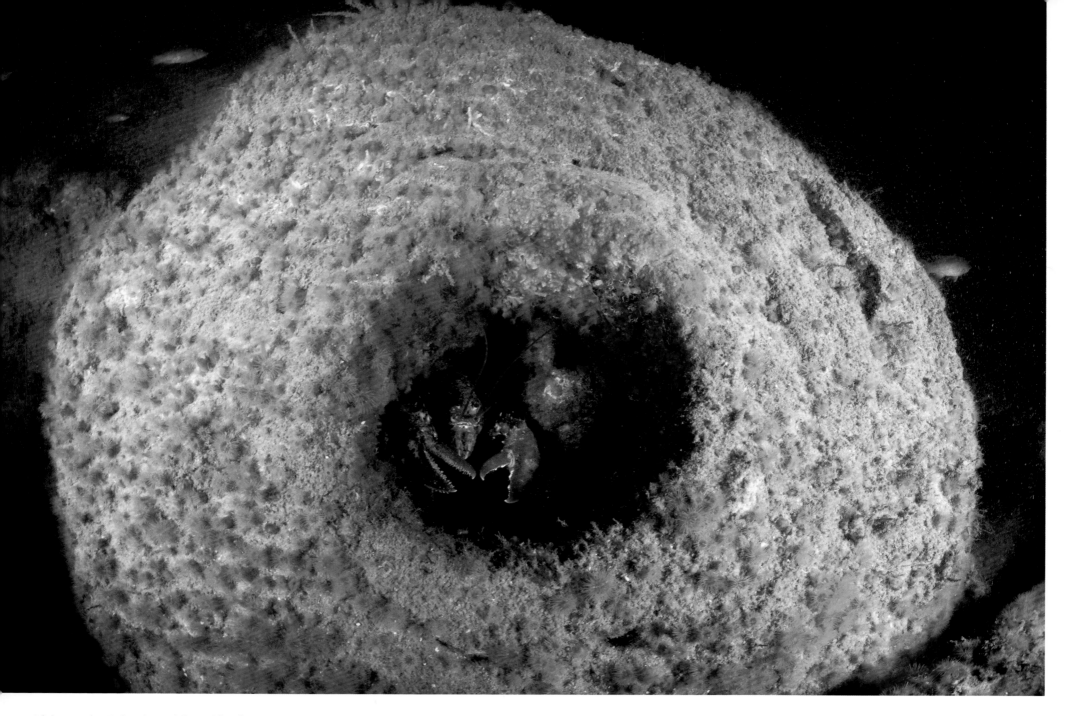

A lobster pokes its head out of the middle of a train wheel that has lain on
the bottom of the sea just south of Cape Cod since November 2, 1918. The
massive wheel, one of hundreds of freight car wheels, is now home to a host
of small anemones.

84

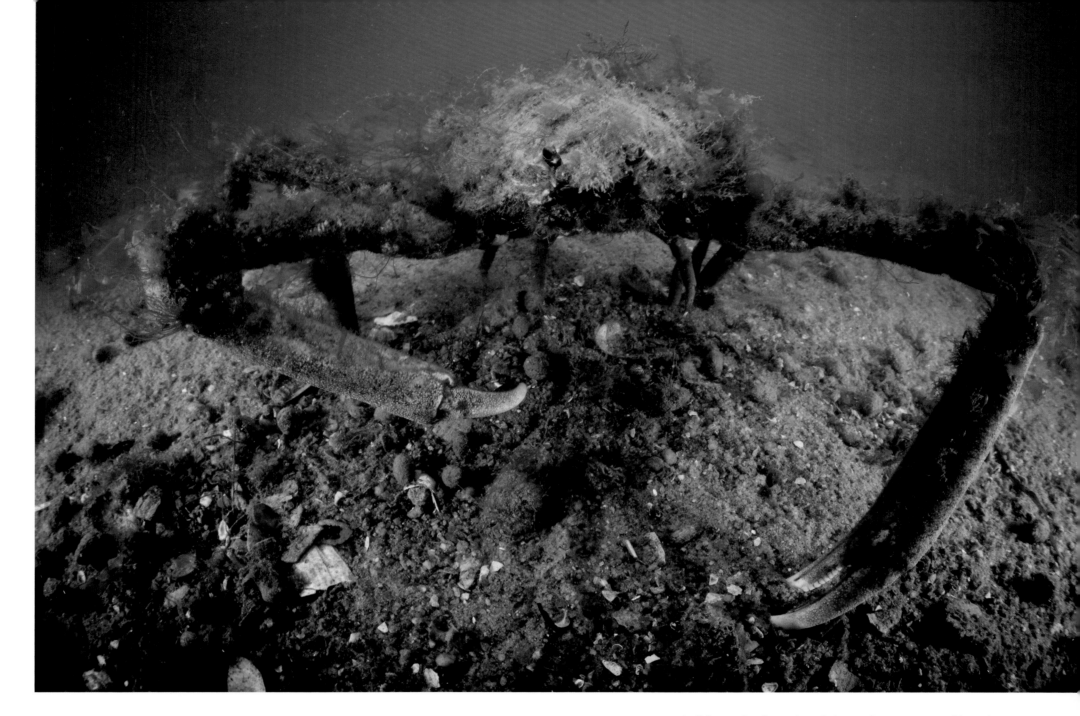

As if dreamed up for a science fiction movie, a monstrous spider crab appears from the silty water. Able to grow hydroids, bryozoans, sponges, and algae on their carapaces, spider crabs are extremely well camouflaged.

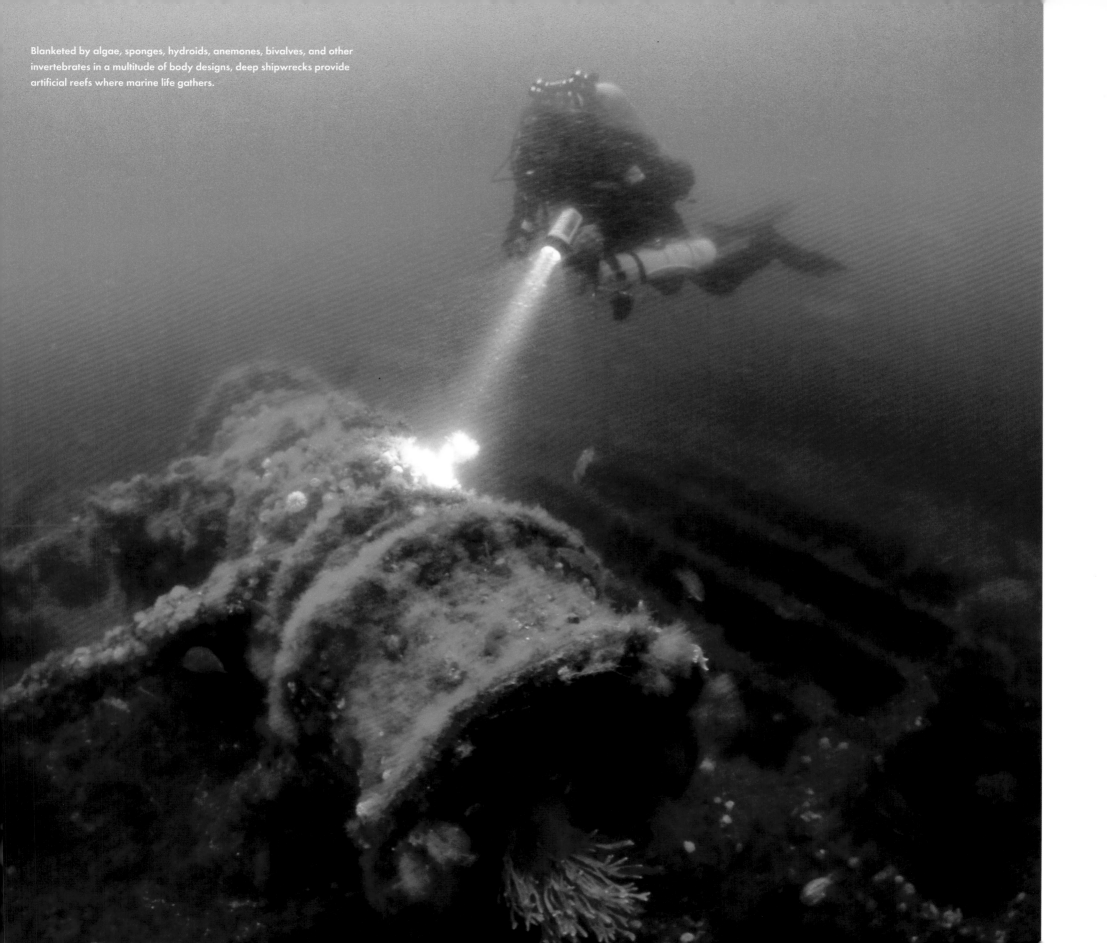

Blanketed by algae, sponges, hydroids, anemones, bivalves, and other invertebrates in a multitude of body designs, deep shipwrecks provide artificial reefs where marine life gathers.

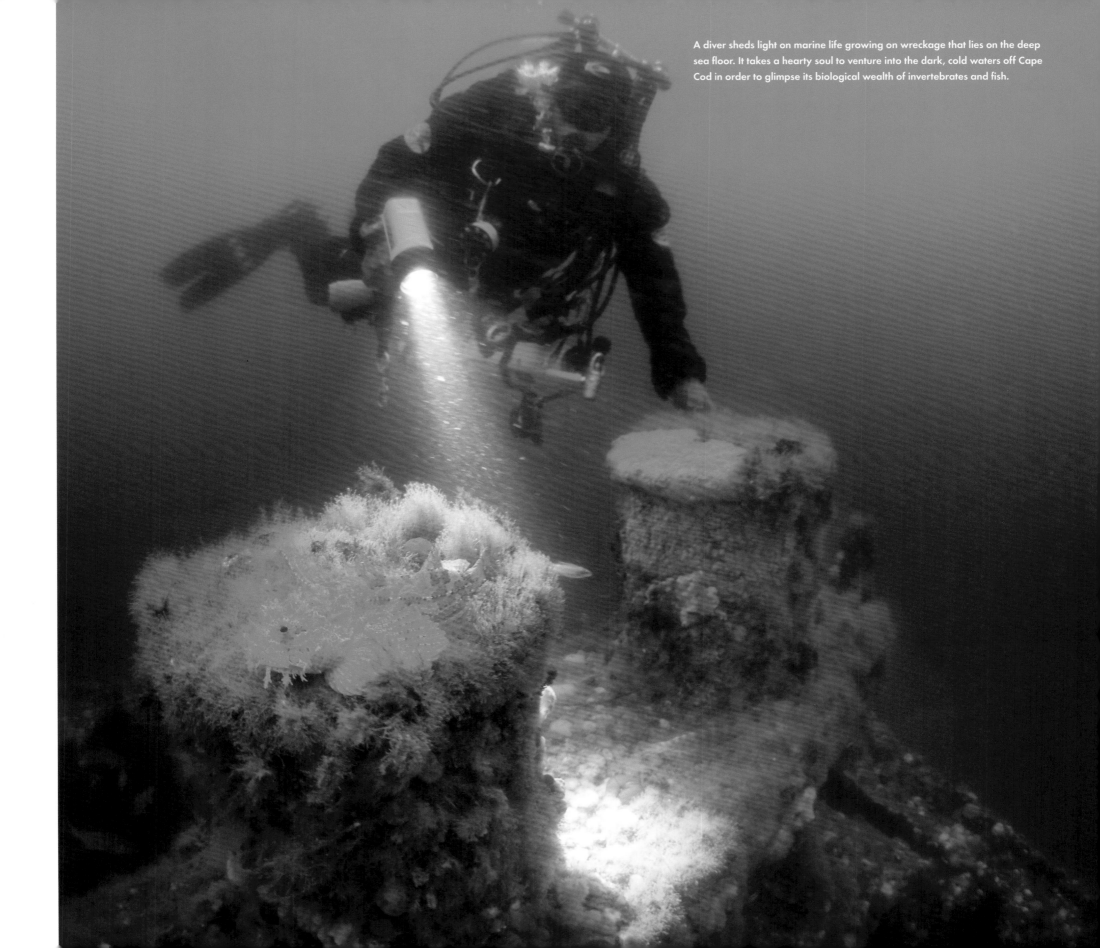

A diver sheds light on marine life growing on wreckage that lies on the deep sea floor. It takes a hearty soul to venture into the dark, cold waters off Cape Cod in order to glimpse its biological wealth of invertebrates and fish.

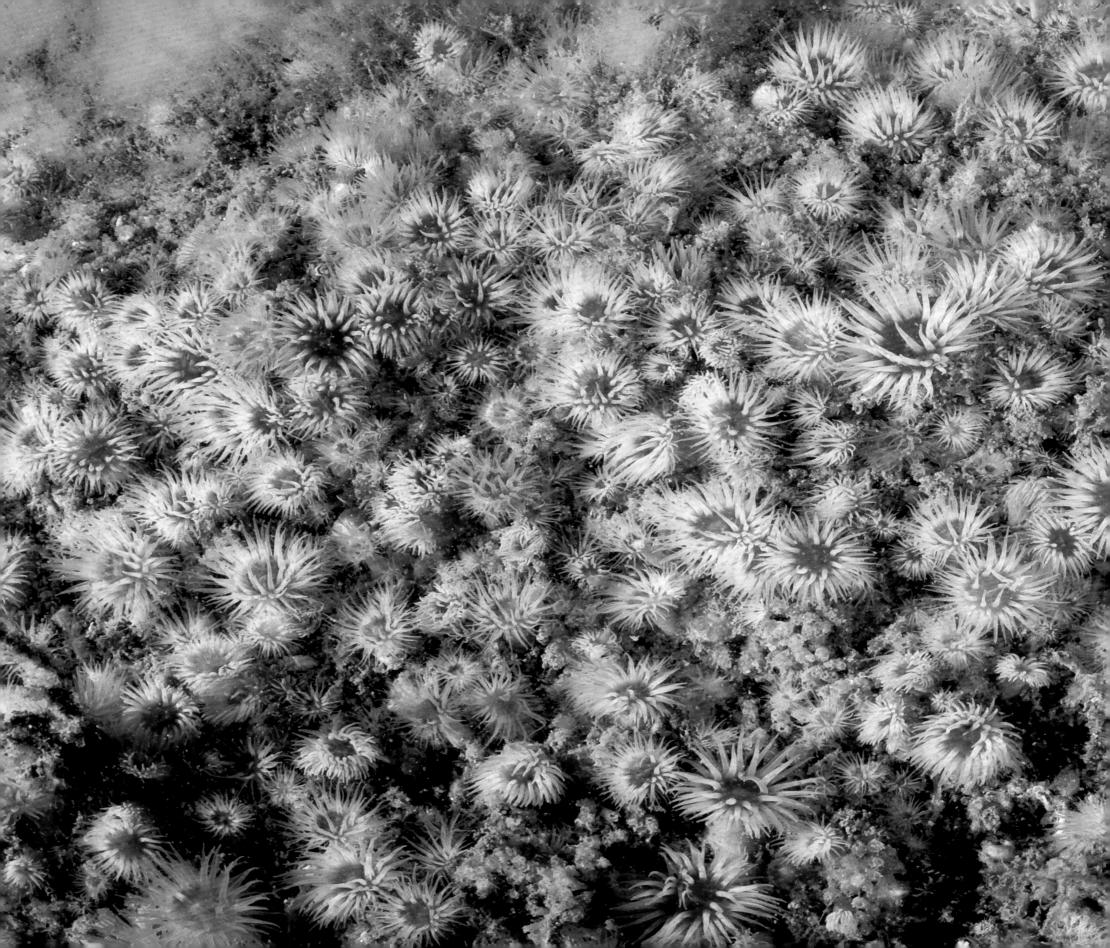

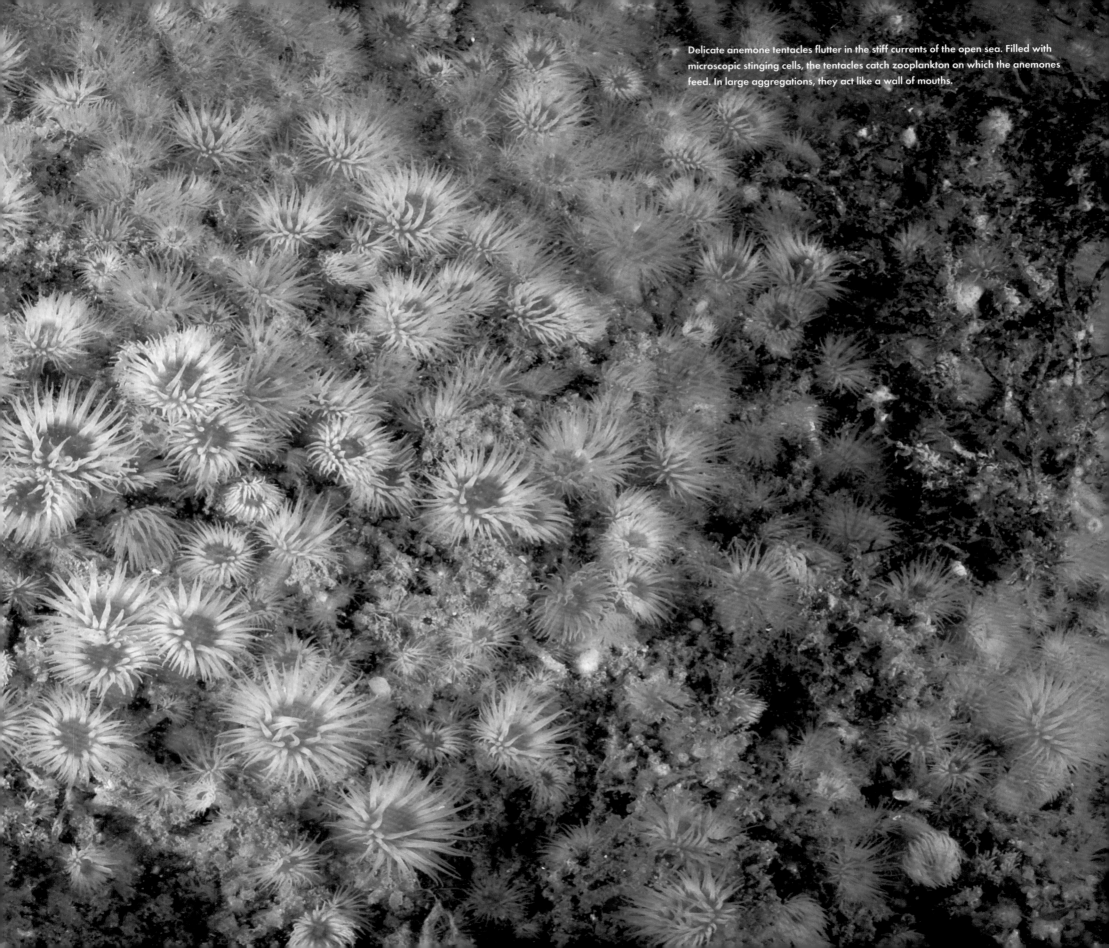

Delicate anemone tentacles flutter in the stiff currents of the open sea. Filled with microscopic stinging cells, the tentacles catch zooplankton on which the anemones feed. In large aggregations, they act like a wall of mouths.

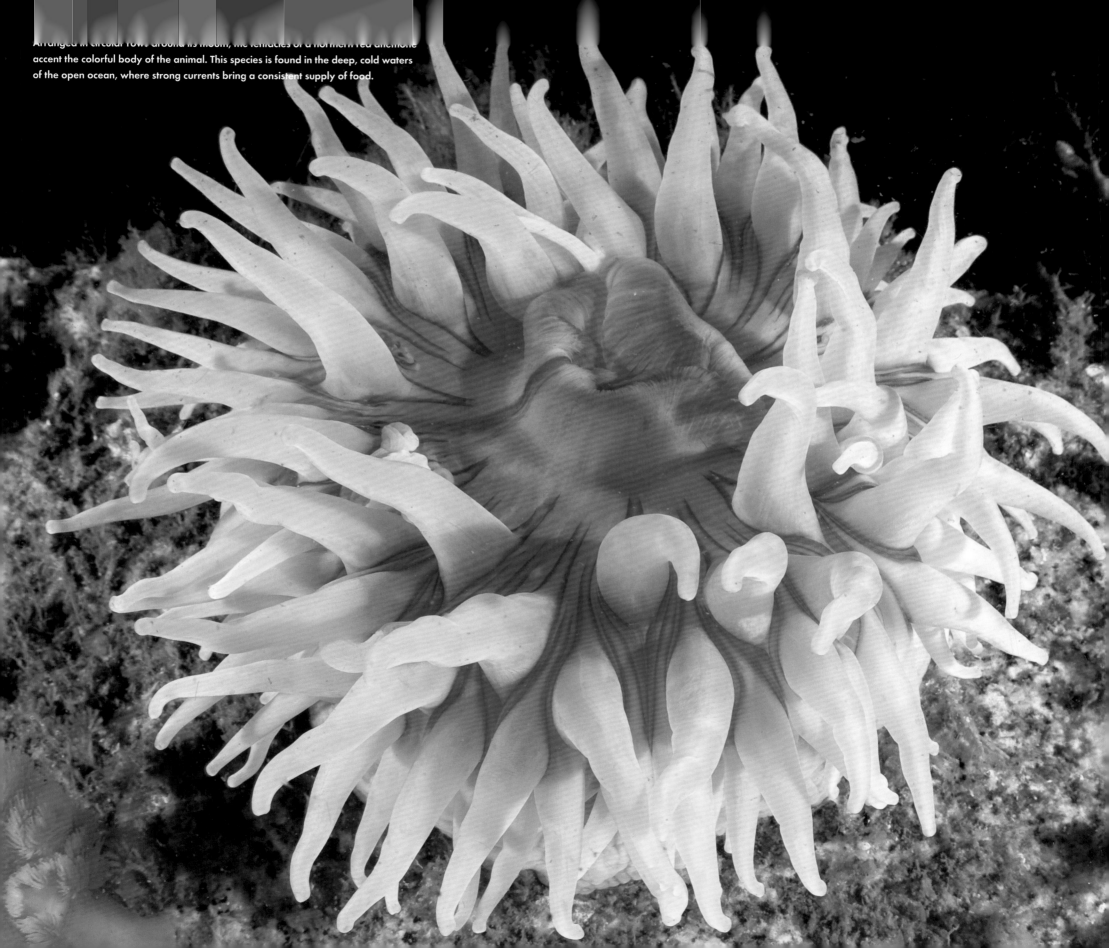

Arranged in circular rows around its mouth, the tentacles of a northern red anemone accent the colorful body of the animal. This species is found in the deep, cold waters of the open ocean, where strong currents bring a consistent supply of food.

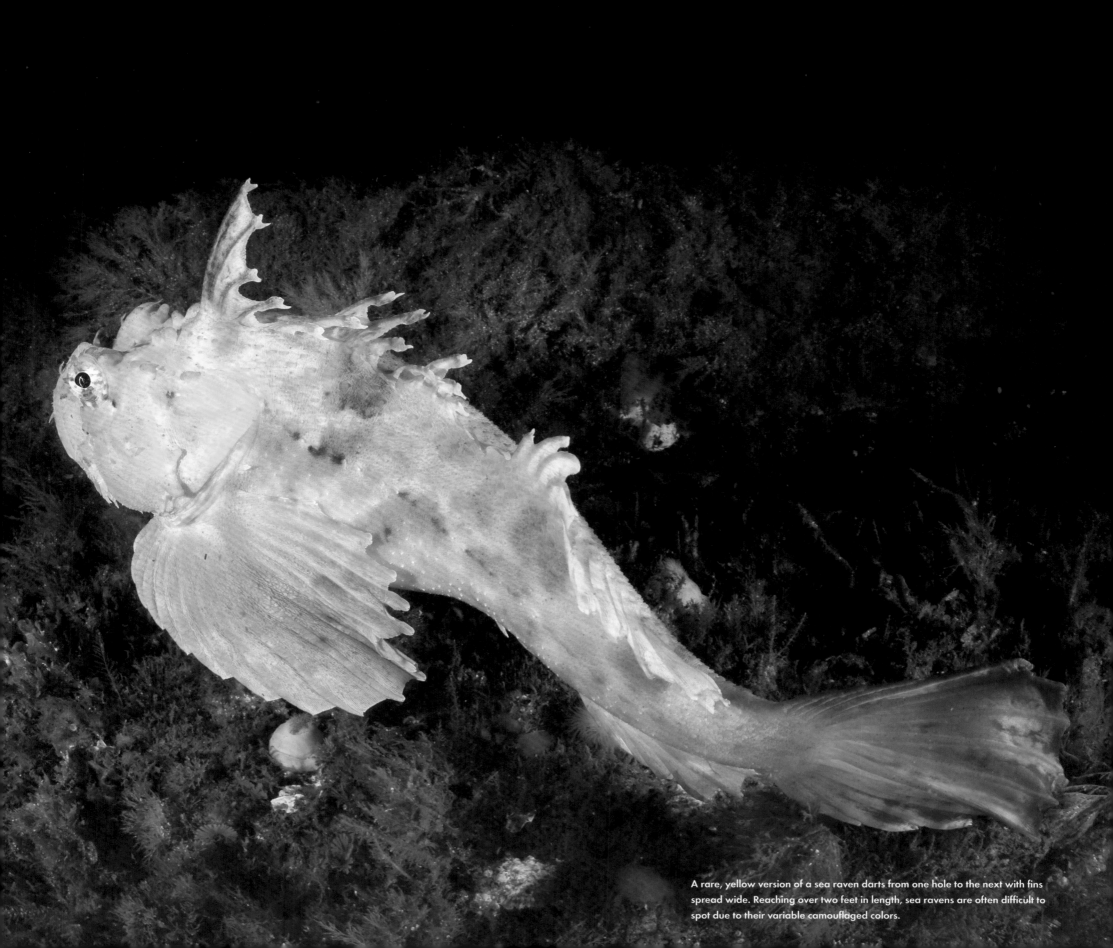

A rare, yellow version of a sea raven darts from one hole to the next with fins spread wide. Reaching over two feet in length, sea ravens are often difficult to spot due to their variable camouflaged colors.

Often found around sunken structures like shipwrecks, cunners (*Tautogolabrus adspersus*) are wrasses that feed on hard-shelled mollusks and crustaceans. The fish crush their prey with knob-like teeth located on the roof of their mouth and bottom of their pharynx.

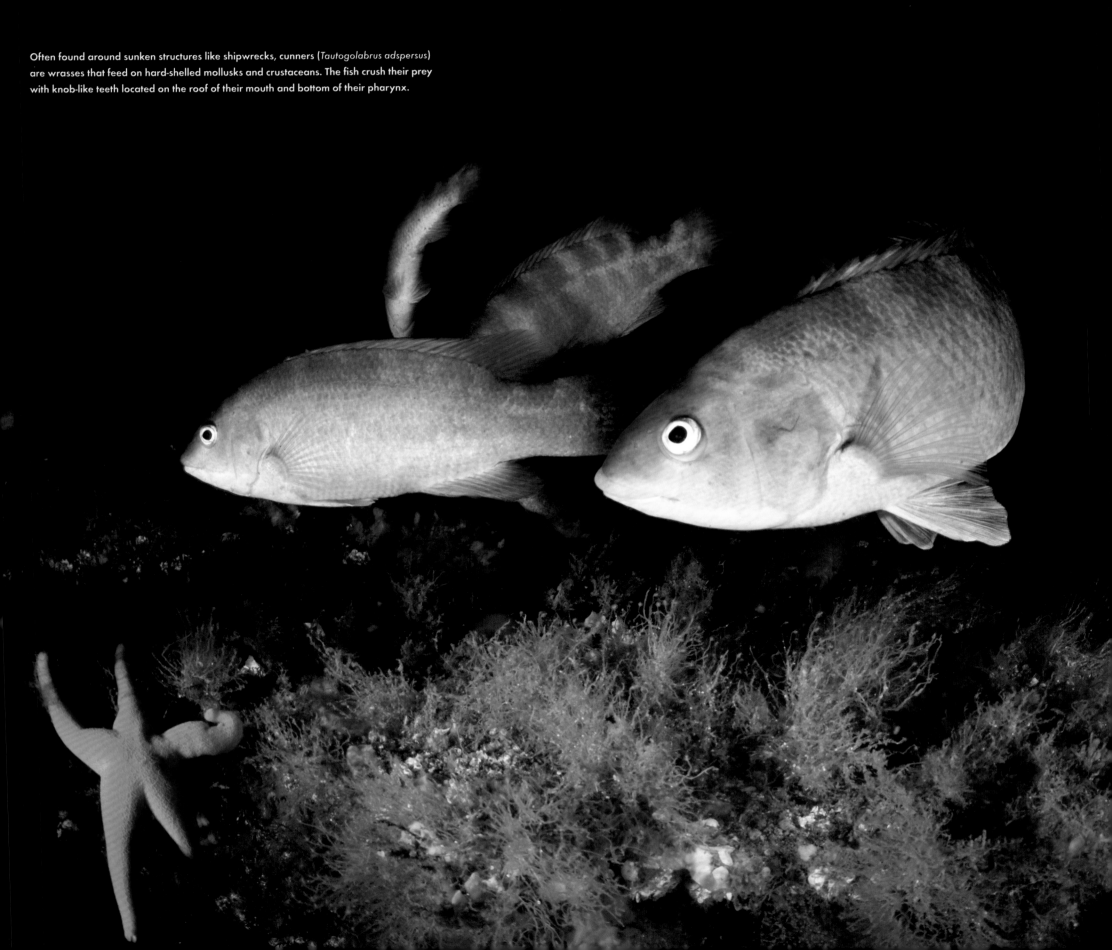

A vibrant finger sponge brightens the dull sea floor. Sponges are some of the more successful invertebrates living in the open ocean; they thrive by filtering nutrients from the surrounding currents.

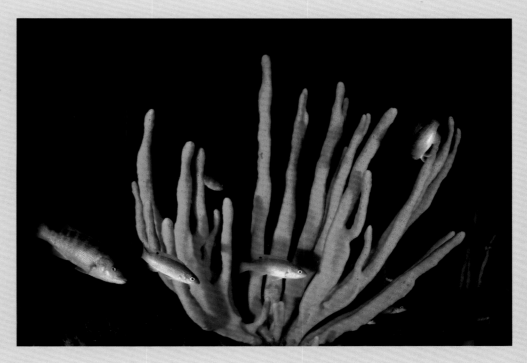

In the waters below one hundred feet, a diver lights an orange-footed sea cucumber (*Cucumaria frondosa*). A set of fine anterior tentacles are used for filter-feeding.

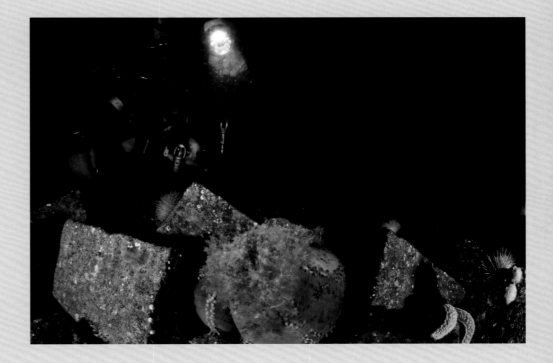

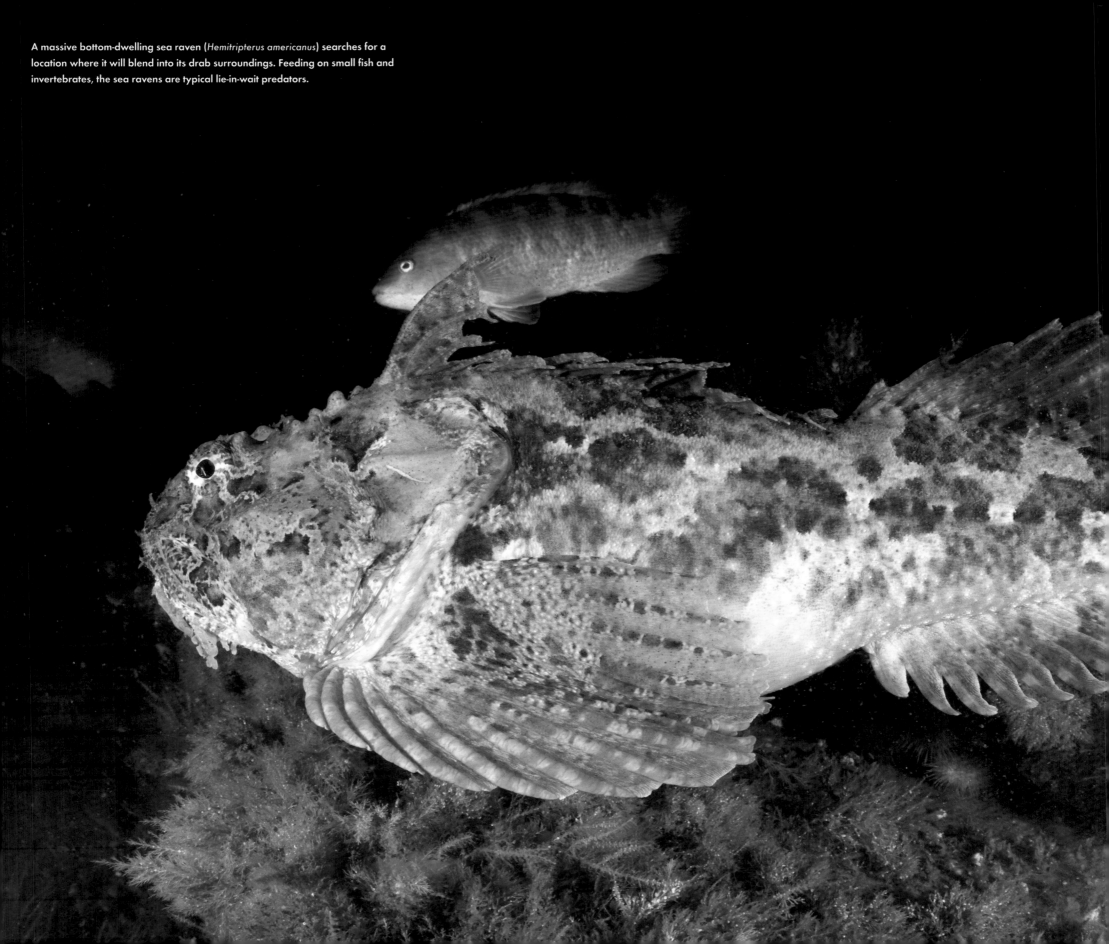

A massive bottom-dwelling sea raven (*Hemitripterus americanus*) searches for a location where it will blend into its drab surroundings. Feeding on small fish and invertebrates, the sea ravens are typical lie-in-wait predators.

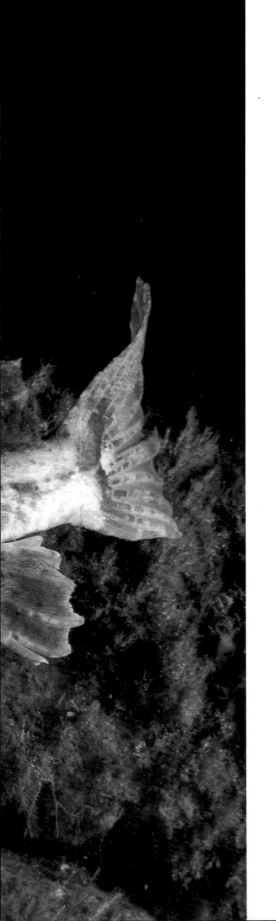

An incredible array of organisms exists where powerful tides, currents, and cold temperatures affect them. Diving off Cape Cod opens a world where fantastic creatures flourish—some elegant, some fragile, others odd or scary.

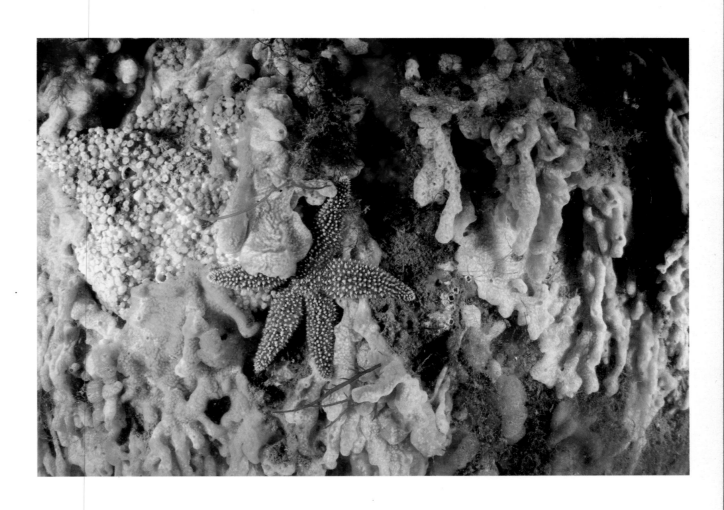

An oceanic oddity, an ocean sunfish (*Mola mola*) swims along the surface of the North Atlantic basking in the sun. Resembling a giant head with a few fins, ocean sunfish often bask on the surface, thermally recharging, after diving to depths well below six hundred feet to feed on jellyfish. Since jellyfish don't provide much in terms of nutrients and sunfish are the heaviest bony fish known on the planet, they must devour massive amounts of the cnidarians in order to generate enough energy to thrive.

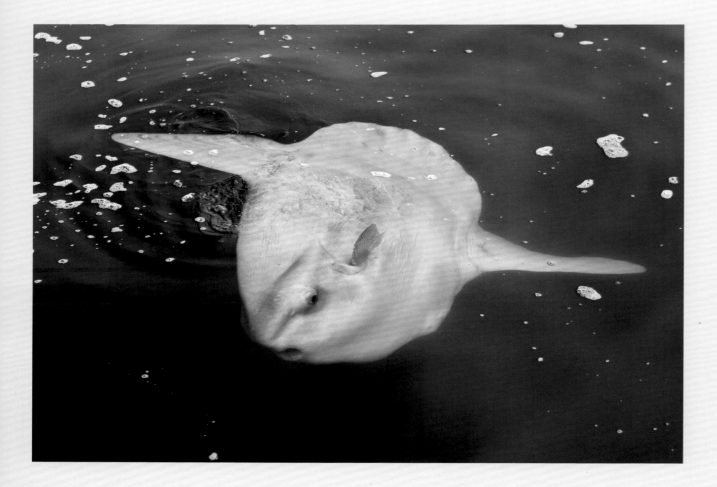

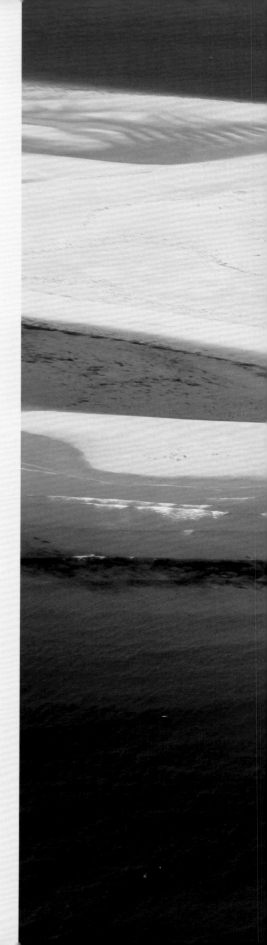

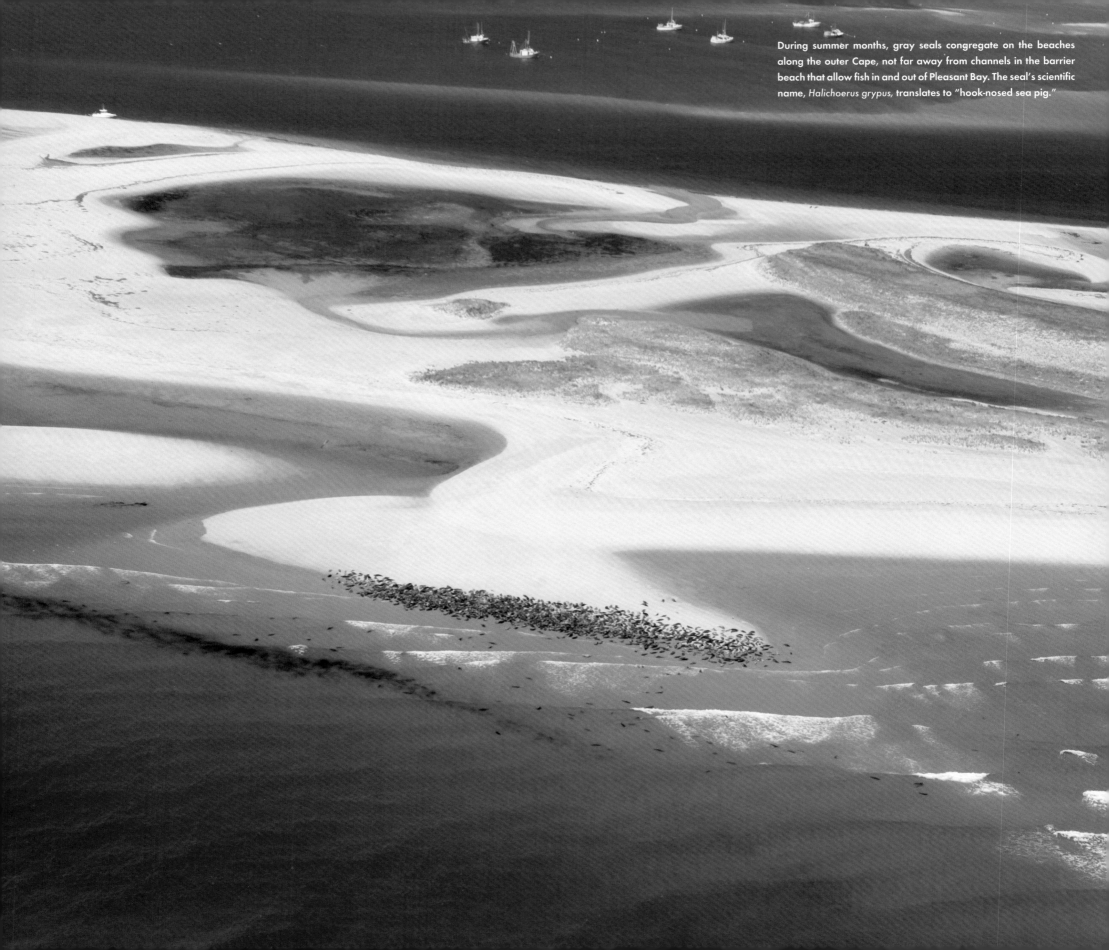

During summer months, gray seals congregate on the beaches along the outer Cape, not far away from channels in the barrier beach that allow fish in and out of Pleasant Bay. The seal's scientific name, *Halichoerus grypus,* translates to "hook-nosed sea pig."

The restless North Atlantic Ocean bounds the Cape and determines much of its natural character. Ocean currents and associated nutrients are the base of an enormous and intricate food web that the marine ecosystem relies on.

The foremost predator of the North Atlantic, the great white shark (*Carcharodon carcharias*) is a seldom seen yet consistent resident of Cape Cod. Adult great whites are attracted to the Cape due to the resurgence of seal populations. Although researchers have recently tagged several individuals off Chatham in a hope to discern where they roam, this particular shark was photographed off the coast of South Africa.

CHAPTER 5 FRESHWATER COLORS

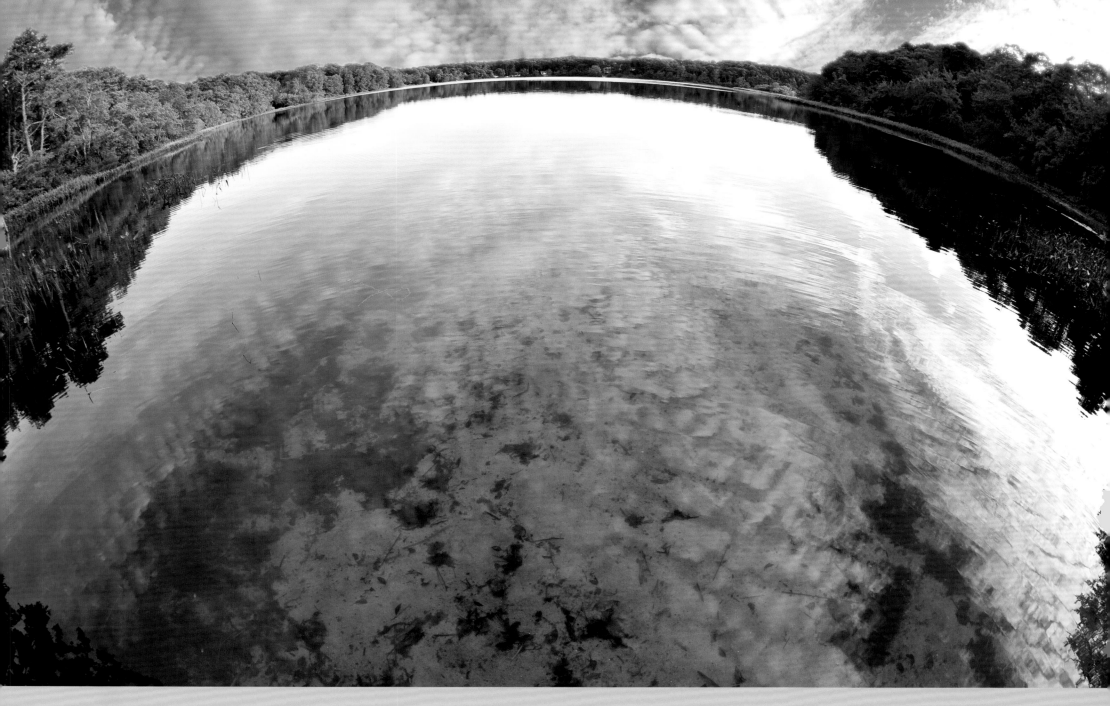

The quiet glassy surface of a lake hides a healthy aquatic world that thrives below. Vegetation, microscopic plankton, fish, amphibians, and reptiles spend their entire existence growing, feeding, reproducing, then being recycled in ponds and lakes across Cape Cod.

Within minutes of the sea, hundreds of charming freshwater ponds and lakes lie scattered across Cape Cod's landscape. These habitats are usually thought of as mere respites from saltwater and the heat of humid summer days. But, delving beneath the placid surface of a pond allows for a unique perspective where delicate beauty becomes apparent.

Each of these kettle holes is a quaint gem of natural history

A light breeze ruffles the leaves of red maple trees and sends ripples across the still water of a circular pond somewhere on the lower Cape. Stately Canada geese paddle in the distance, and late afternoon sun sparkles as the water smoothes itself. A rock along the waterline hosts two eastern painted turtles basking in the day's remaining light. Above them soar insectivorous swallows, while a pair of flycatchers flits from tree to tree along the shoreline, filling the air with faint song. An iridescent dragonfly on its way to find the day's last meal buzzes through the scene. Water striders deftly skate across the pond's surface, scattering from the predatory dragonfly. This is nature as it has always been, at least for the last several thousand years. Serenity at its peak.

Described by Thoreau, the Cape is "the bared and bended arm of Massachusetts," a rolling, pocked landscape, the product of a massive glacial retreat northward about fifteen thousand years ago. Not only did the glaciers leave behind sandy soils and rocks, they also left enormous chunks of ice embedded in the earth. As the ice chunks melted, they left round or irregular depressions called kettle holes, which filled with groundwater over time

and developed into the Cape's many ponds and lakes. For thousands of years, the ponds have been slowly wrought by almost imperceptible wind-circulated currents, which have gently smoothed most of their shores.

Peppering the Cape's countryside, hundreds of ponds and lakes range in size, shape, and setting. Many are small and shallow, while others are large and deep—some reaching over eighty feet in depth. Each of these kettle holes is a quaint gem of natural history, a pool replete with a range of remarkable amphibious and aquatic flora and fauna that are most vigorous in warm summer months. Little oases of mostly native wildlife, ponds still thrive amongst the Cape's terrestrial ecosystems, which have changed considerably over the last three hundred years.

Most of the year, these freshwater habitats are tranquil settings where a variety of natural auditory influences—birds, frogs, and insects—saturate the air with songs. The surrounding scenery is pleasing but humble; it's not quite as majestic or dramatic as the nearby sea, but the peacefulness and inspiration of the Cape's soft light hitting a glassy pond in the early morning or late afternoon is overwhelmingly serene.

Like Thoreau, I imagine ponds and lakes as "earth's eye; looking into which the beholder measures the depth of his own nature. The fluviatile trees next the shore are the eyelashes which fringe it, and the wooded hills ... are its overhanging brows." But there is more than merely

observing the happenings of the pond as it flourishes during the warm summer days. The real experience comes from being inside it, mingling with the water and its inhabitants. This is where a thoroughly detailed picture of the ecosystem comes to light.

Immersed in a virtually weightless universe, disconnected from the world spinning above, one enters another time, another space, and experiences a great discord of color. Vibrant greens and sultry reds of lilies clash in an unruly composition. Sunlight passes through a canopy of lily pads growing on the edge of the water, casting yellowish beams through the miniature underwater jungle, illuminating silvery fish below. The pond's sandy margins support a rich and colorful flora, especially in late summer when water temperatures are peaking.

There is a unique wildness to these forgotten Cape Cod waters. Looking half in and half out of the water displays the pond's gradations. Clean, cool, deeper water leads up a gentle slope to the pond's edge, where cattails, slender arrowhead, violet pickerelweed flowers, and the pinks of steeplebush mature. Just a bit deeper, white water lilies and yellow pond lilies vie for sunlight, spreading wide raft-like leaves on the surface and sending slender stems toward the bottom for anchorage. Past the lilies grows a virtually impenetrable forest of multihued reeds, where sparkling schools of small glossy minnows pulse through the twisting stems of the rising lily pads.

Obscure movements in the dimness outside the reeds signal the passage of a sizable fish and cause smaller prey to disappear. A largemouth bass, king of its aquatic domain, stares into the murky darkness of the reeds, willing the small fish to re-emerge. Along with primeval-looking snapping turtles, which can be enormous and are often found submerged in the gloomy depths, bass are the foremost predators in the pond's food web. After a few moments, the bass glides silently away, grumpy about leaving without a meal. A few perch come into view, and multihued bluegills and pumpkinseeds, otherwise known as sunfish, swim by while juvenile pickerel warily peek their heads up from the depths.

The pond's impenetrable shadows shelter not only small fish but harmless northern water snakes, painted turtles, bullfrogs and wood frogs, and tiny planktonic animals, some visible to the naked eye. It feels like gazing into a secluded petri dish, a tiny microcosm of the primal world, perfect for studying the factors influencing the Cape's freshwater habitats. What at first seems a simple freshwater ecosystem is indeed more complex: Its thriving community is pieced together through immigration and extinction since the last ice age. Life histories of many species are laid bare amongst the lily pads, reeds, and open water. The shallow depths of a pond open an intimate world where Cape Cod's wilderness is still apparent. Ponds and lakes remain potent ecosystems, rife with wildlife and beauty—beauty unique to the Cape that can often escape the casual observer.

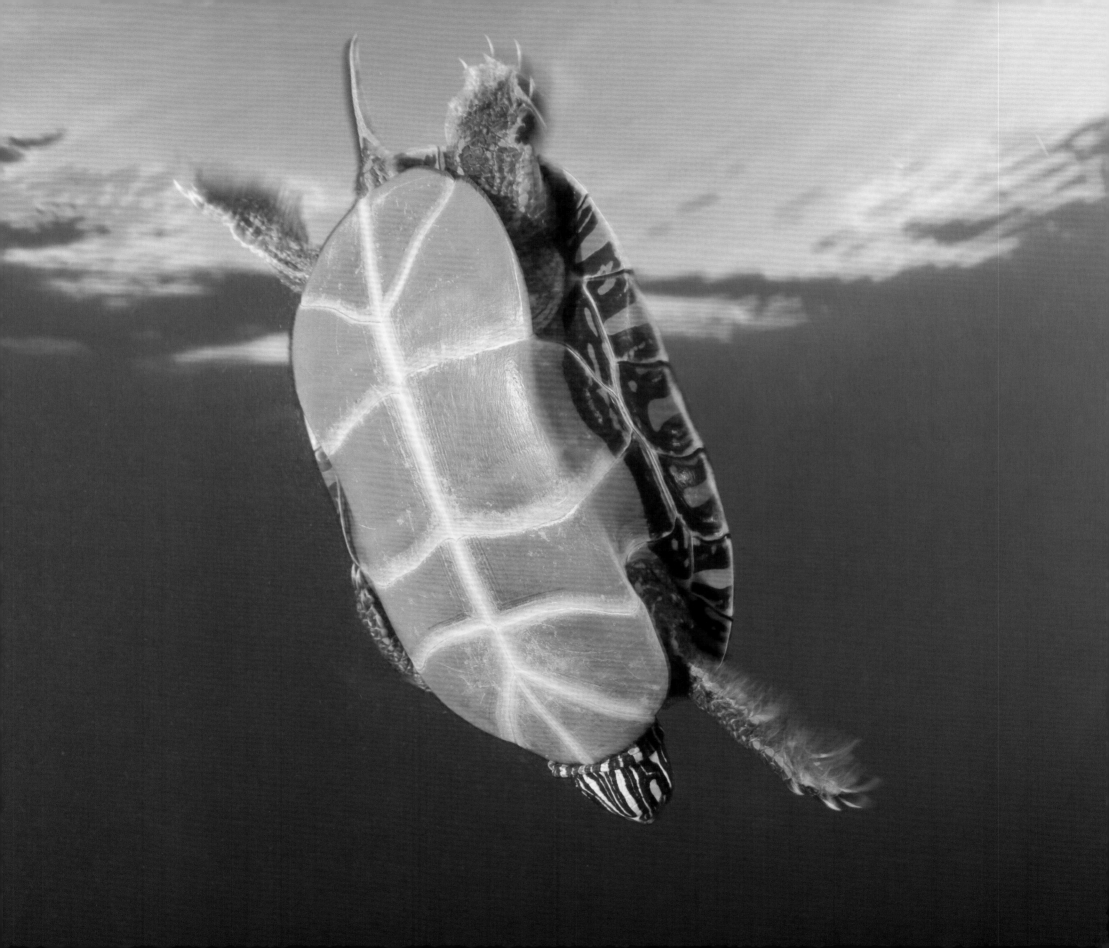

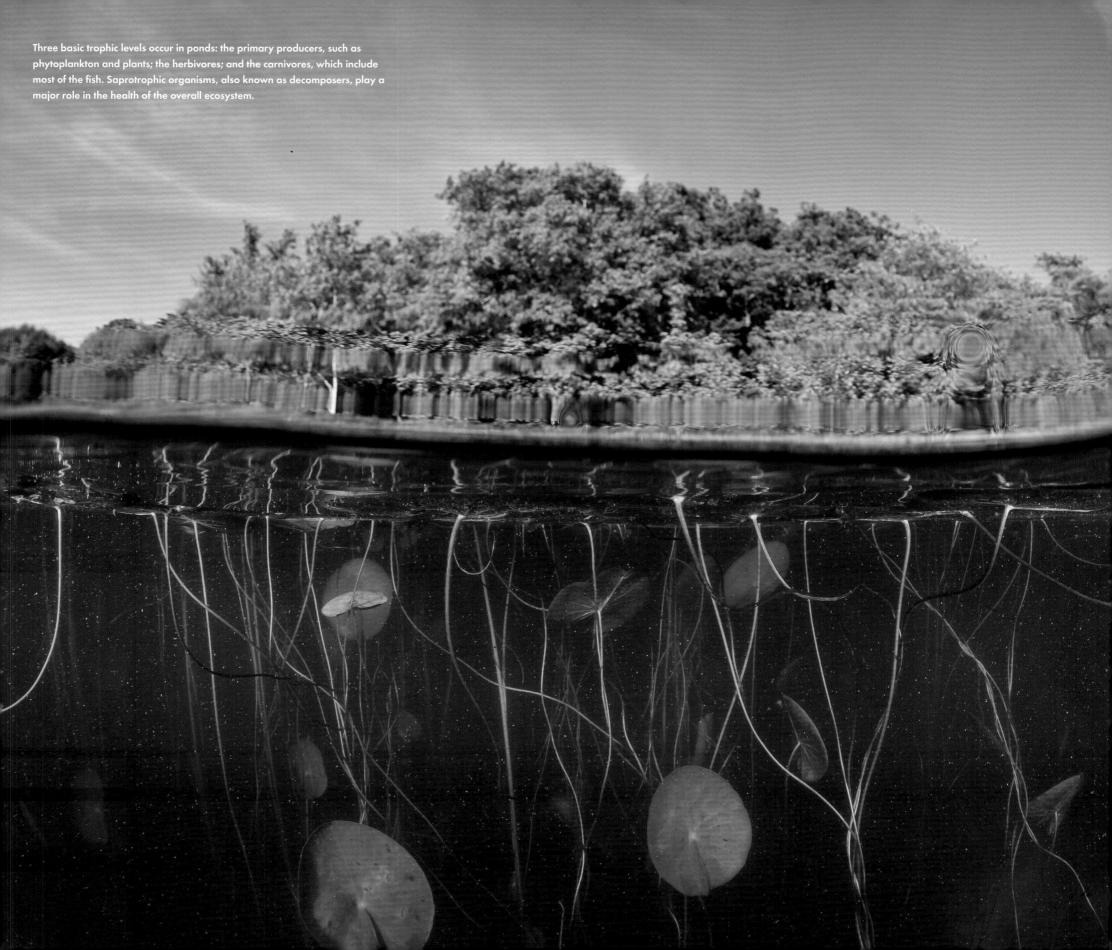

Three basic trophic levels occur in ponds: the primary producers, such as phytoplankton and plants; the herbivores; and the carnivores, which include most of the fish. Saprotrophic organisms, also known as decomposers, play a major role in the health of the overall ecosystem.

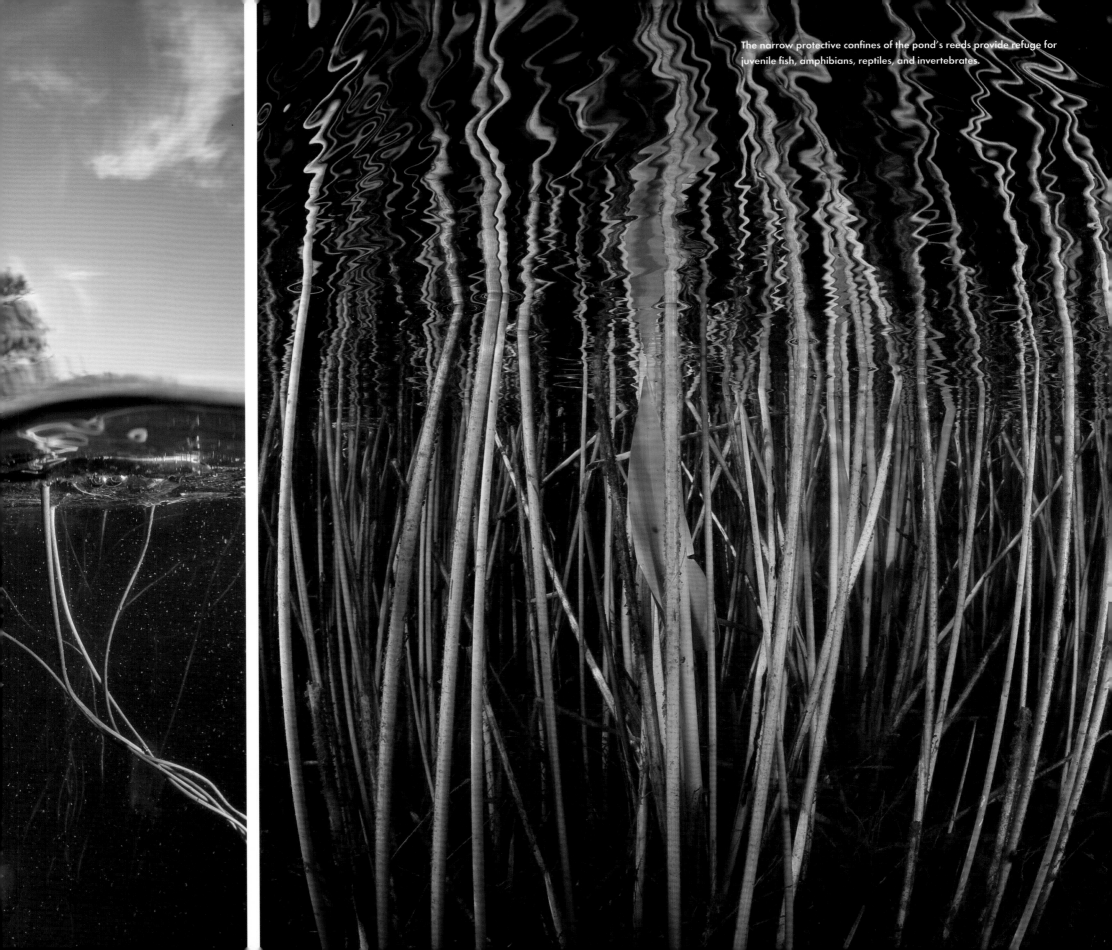

The narrow protective confines of the pond's reeds provide refuge for juvenile fish, amphibians, reptiles, and invertebrates.

An adult largemouth bass hunting amongst a tangle of lilies will eat just about anything it can get its mouth around. It plays the role of a fundamental predator in pond ecosystems.

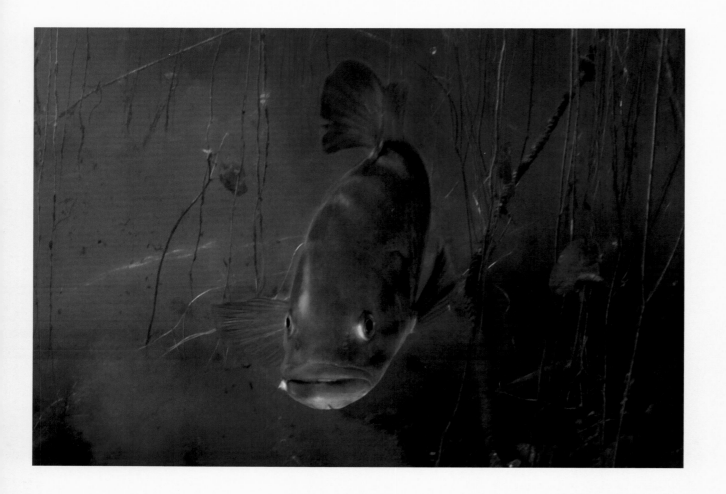

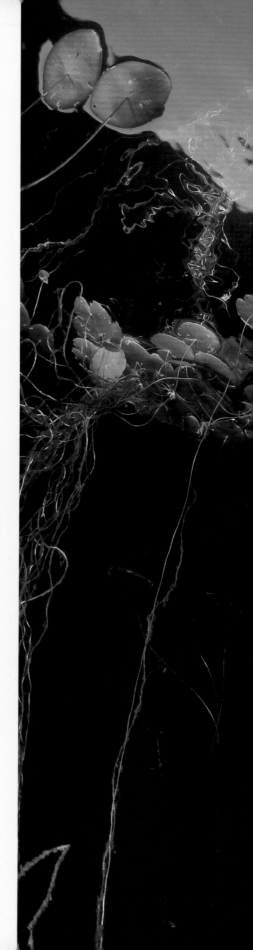

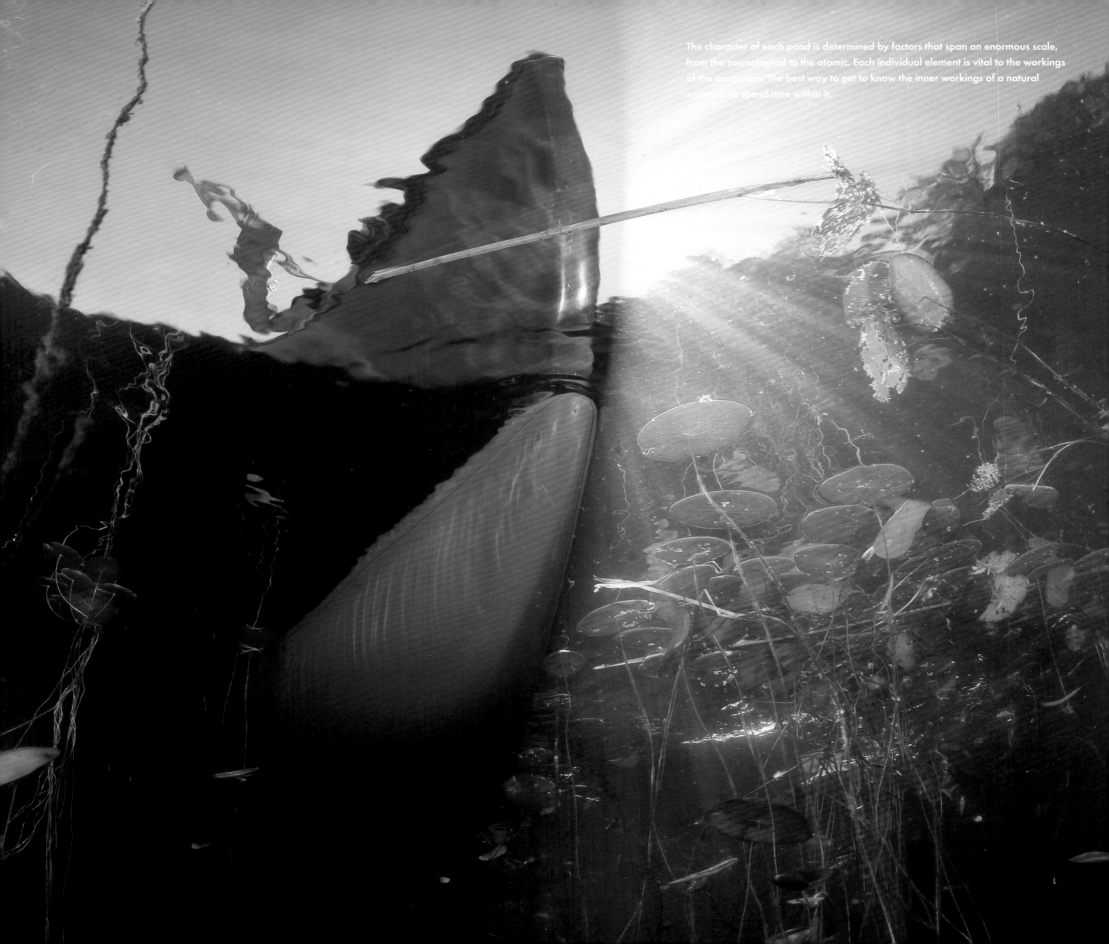

The character of each pond is determined by factors that span an enormous scale, from the cosmological to the atomic. Each individual element is vital to the workings of the ecosystem. The best way to get to know the inner workings of a natural system is to spend time within it.

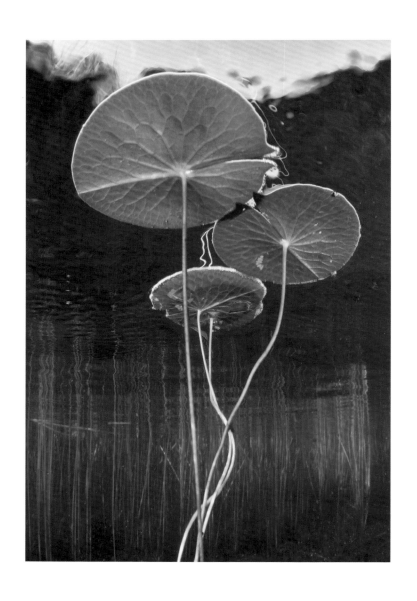
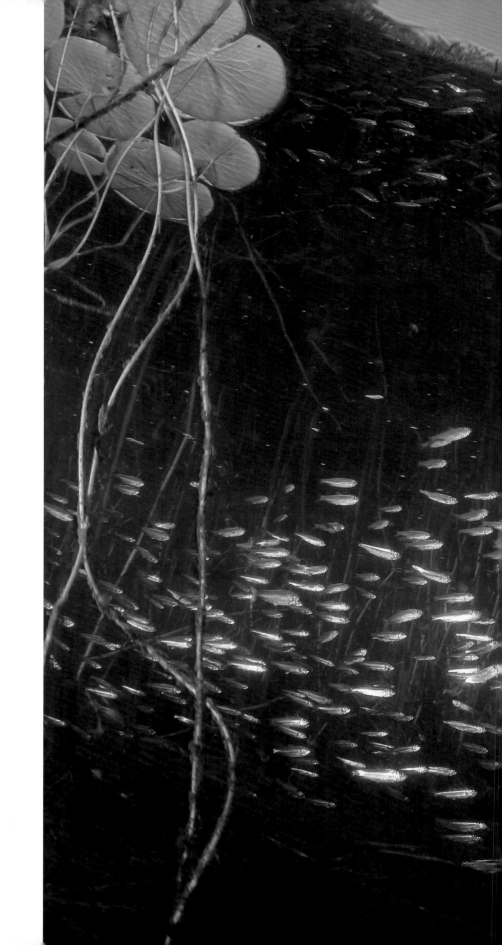

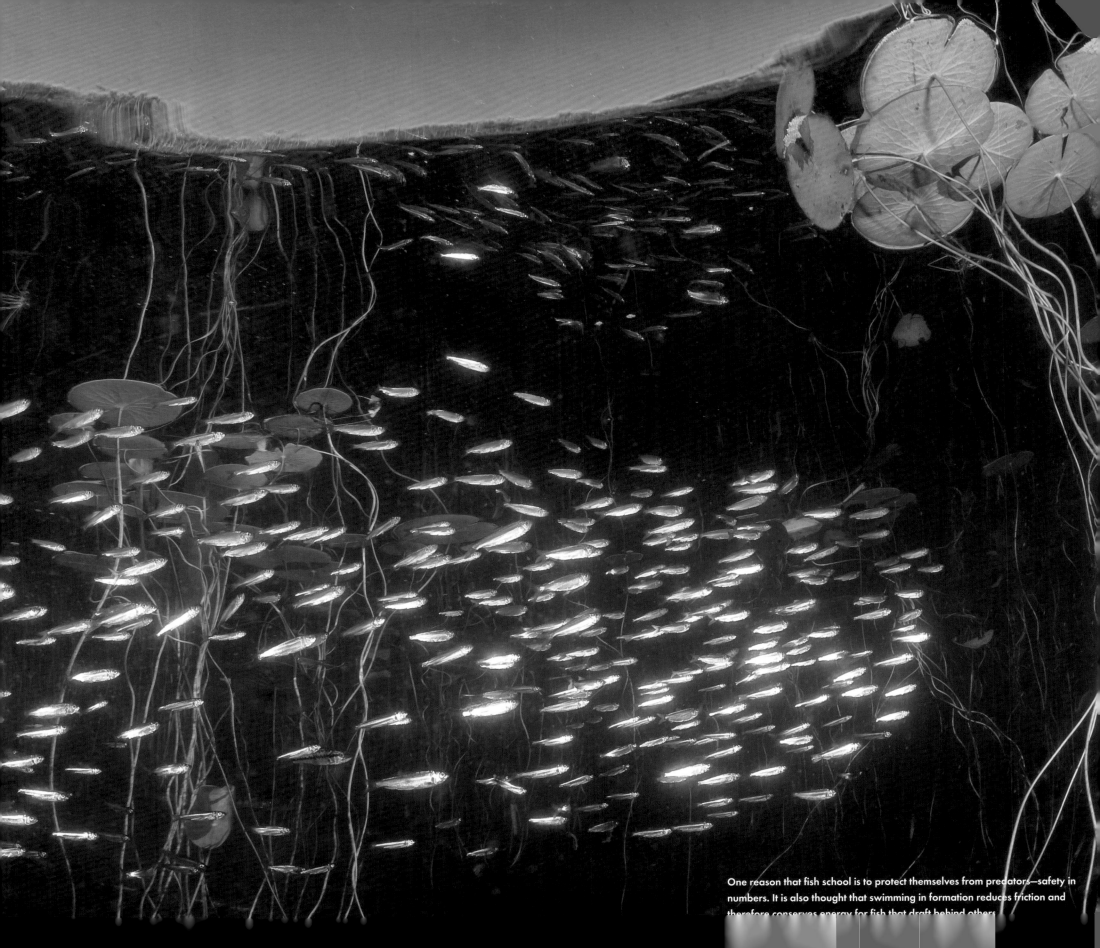

One reason that fish school is to protect themselves from predators—safety in numbers. It is also thought that swimming in formation reduces friction and therefore conserves energy for fish that draft behind others.

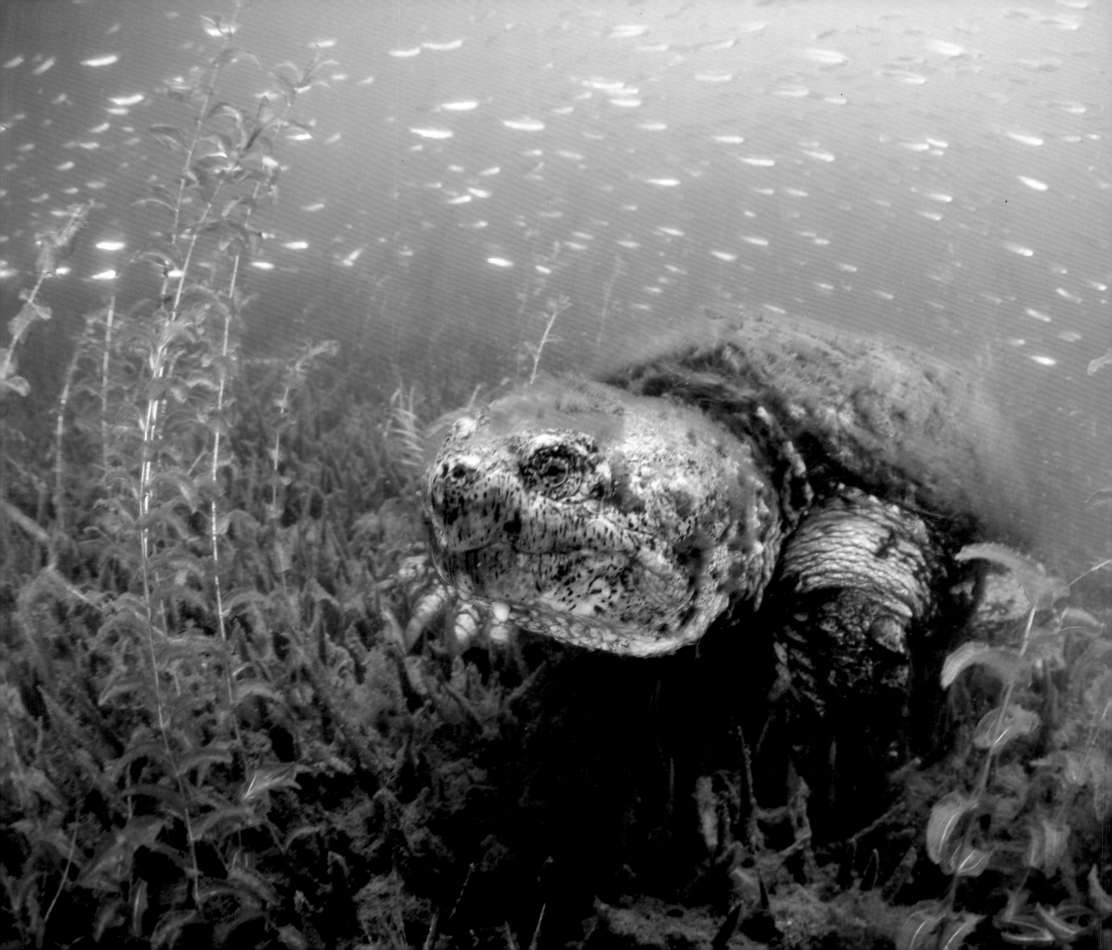

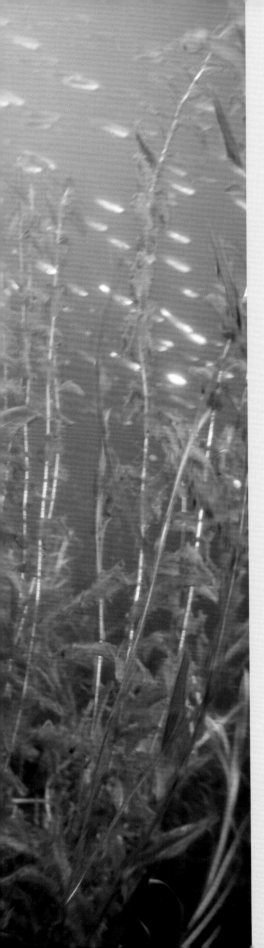

Once fully grown, snapping turtles (*Chelydra serpentina*) rule the lake or pond they live in. Rarely are they found basking in the sun; they spend much of their lives underwater.

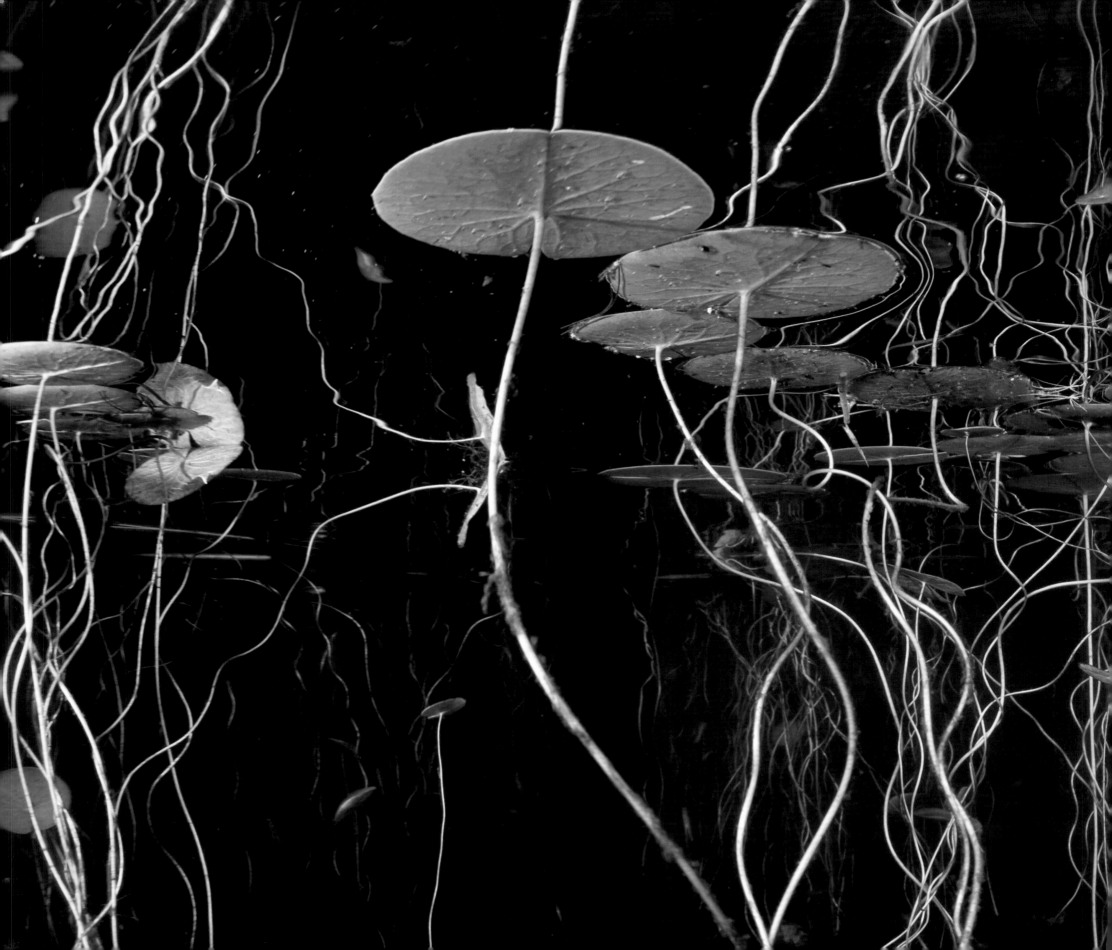

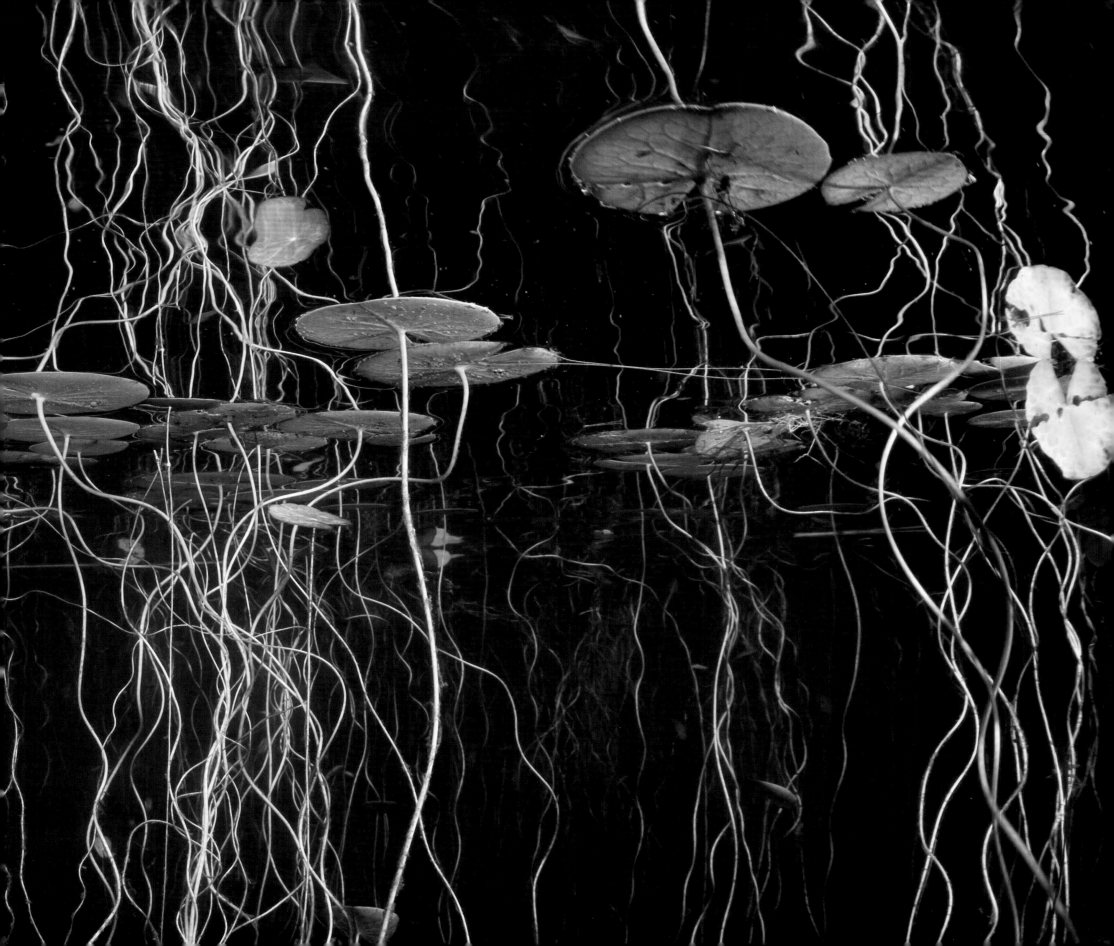

A bullfrog (*Rana catesbeiana*) breathes at the surface of a lake just before nightfall. It will feed during the night. The peninsula's largest frog, female bullfrogs can lay up to twenty thousand eggs.

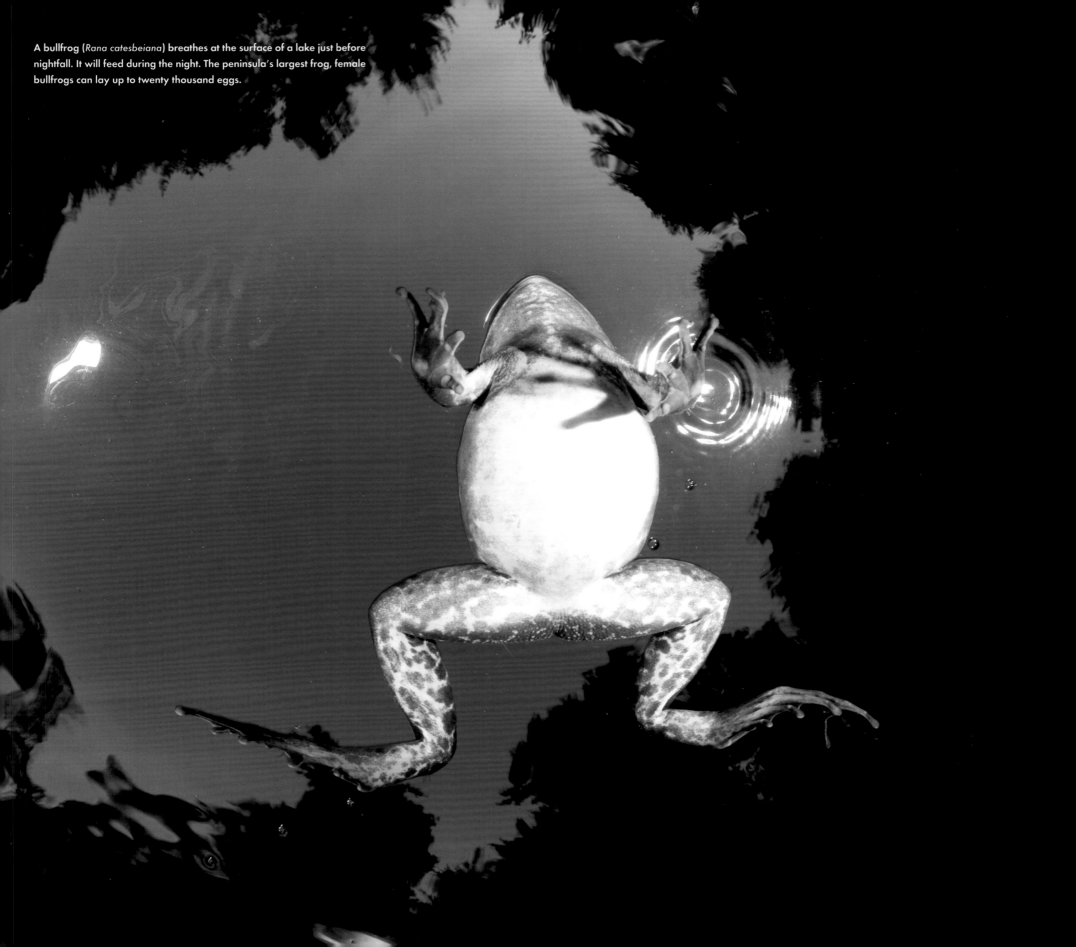

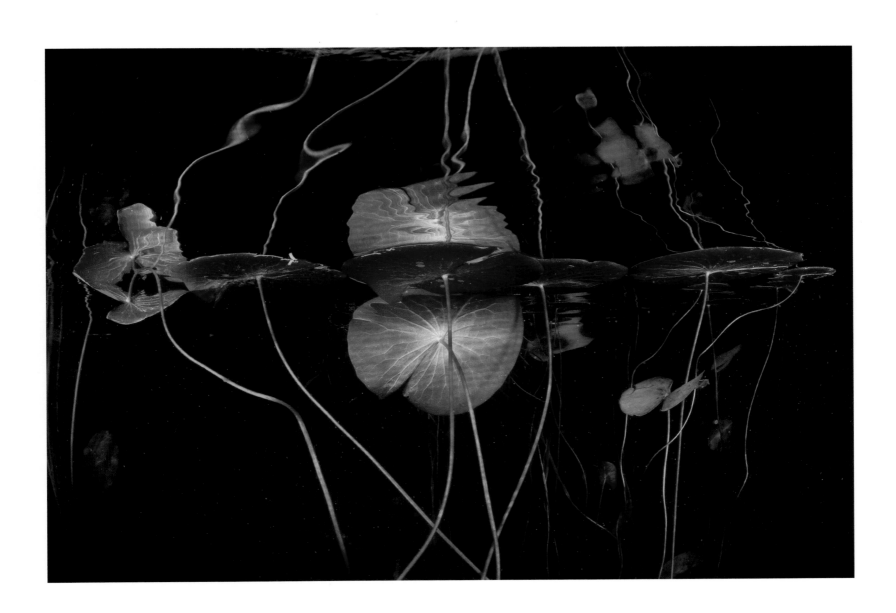

Neon orange zooplankton in the outer Cape's ponds, though only about an eighth-inch long, is impossible to miss. Often found in mid-water, this species tends to swim well, though not especially quickly.

A rolled-up lily leaf will unfurl as it ages and gets closer to the surface of its freshwater habitat.

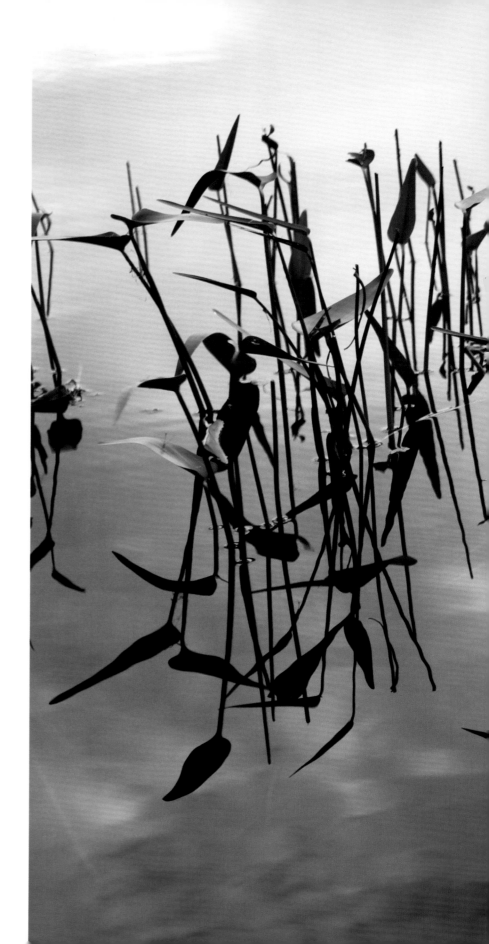

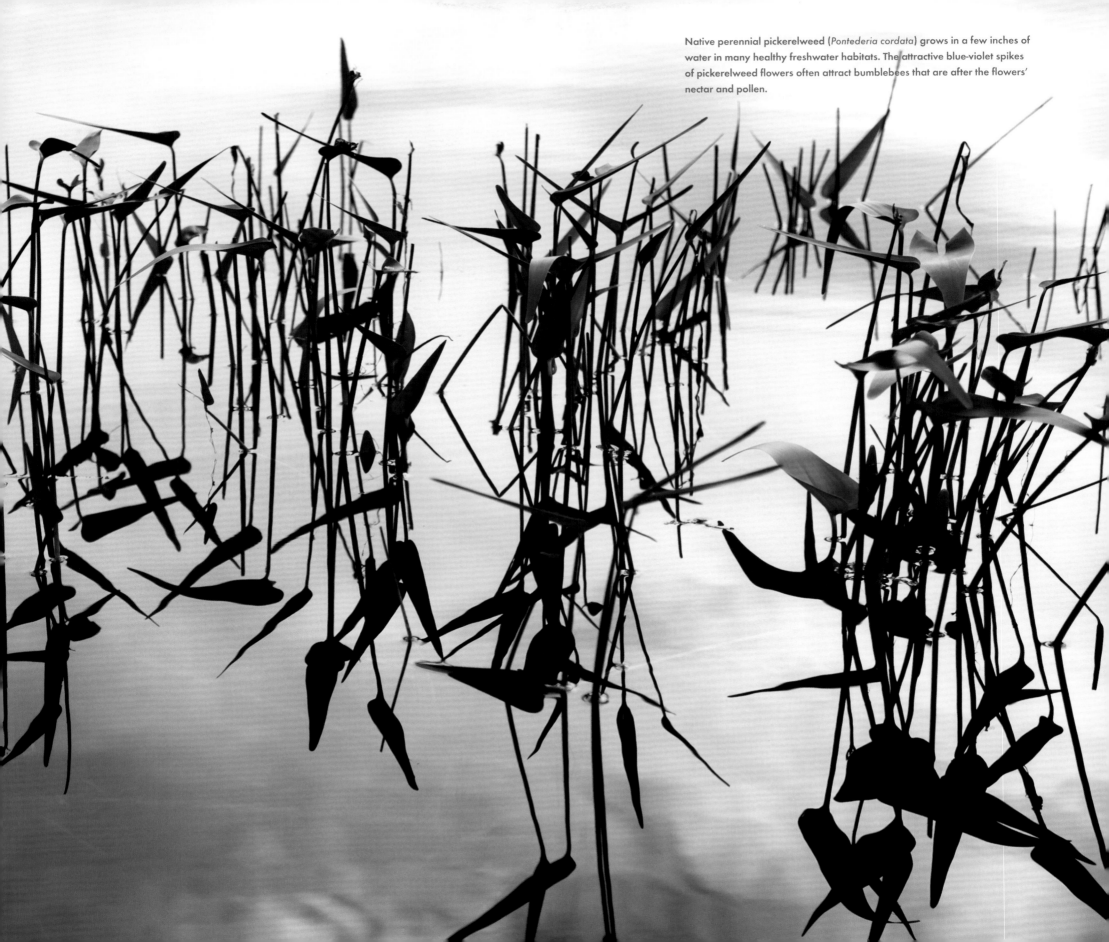

Native perennial pickerelweed (*Pontederia cordata*) grows in a few inches of water in many healthy freshwater habitats. The attractive blue-violet spikes of pickerelweed flowers often attract bumblebees that are after the flowers' nectar and pollen.

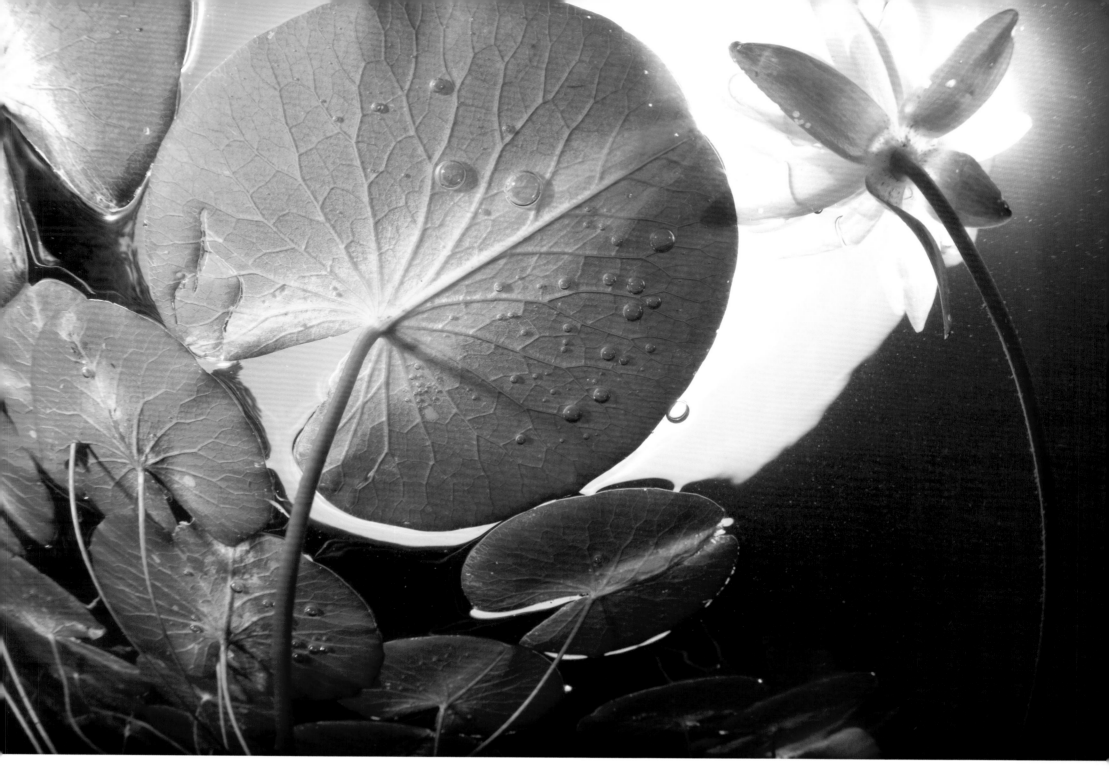

The white water lily (*Nymphaea odorata*) loves muddy-bottomed eutrophic ponds, where its thick roots, known as rhizomes, sink two to three feet into the mud. The substantial roots can even be eaten.

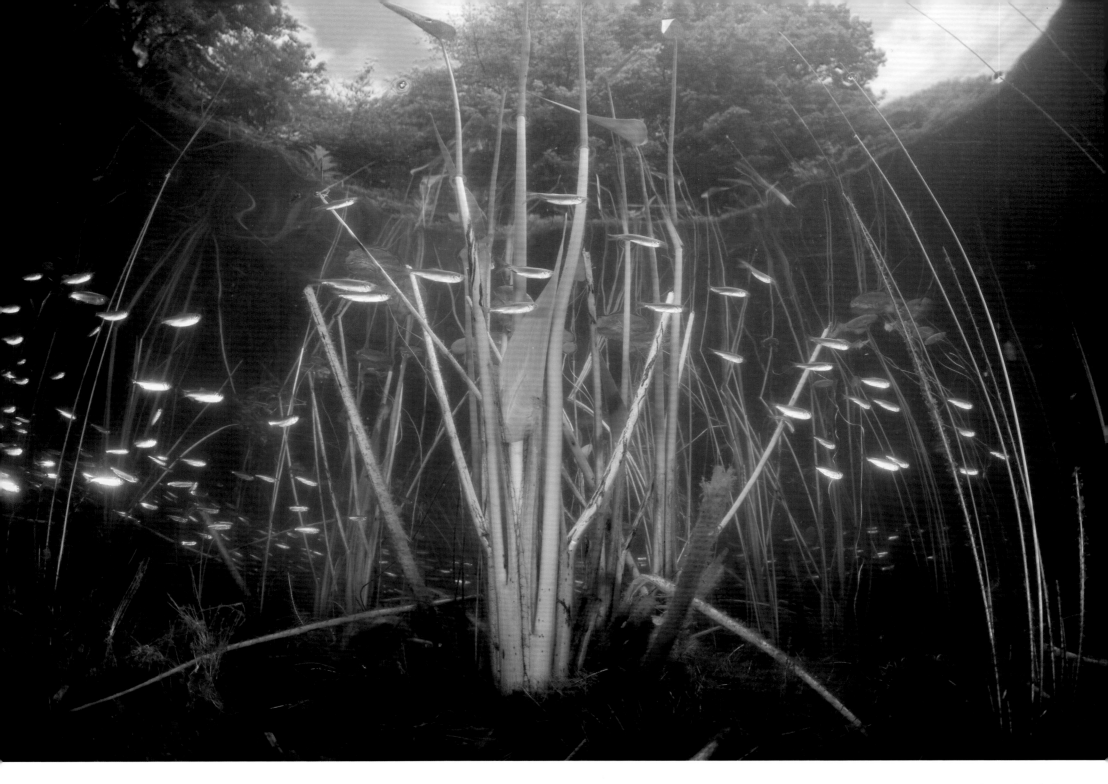

Pond ecosystems begin with microorganisms, including algae, phytoplankton, and zooplankton. Small arthropods, mollusks, and worms feed upon these materials. Fish will then devour the plants and animals from the first and second stages in the pond food web. Each pond on the Cape has a unique ecological balance that relies on the energy transferred and recycled through the local food web.

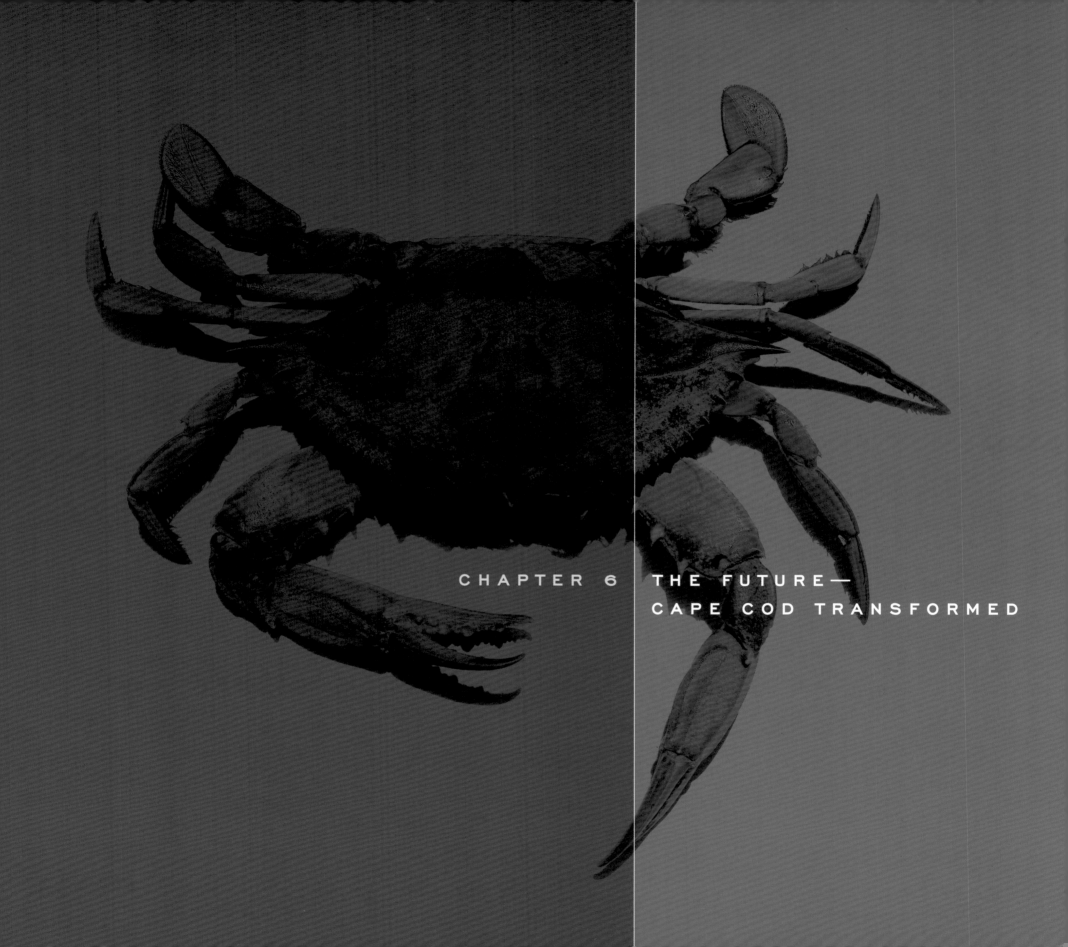

CHAPTER 6 | THE FUTURE—
CAPE COD TRANSFORMED

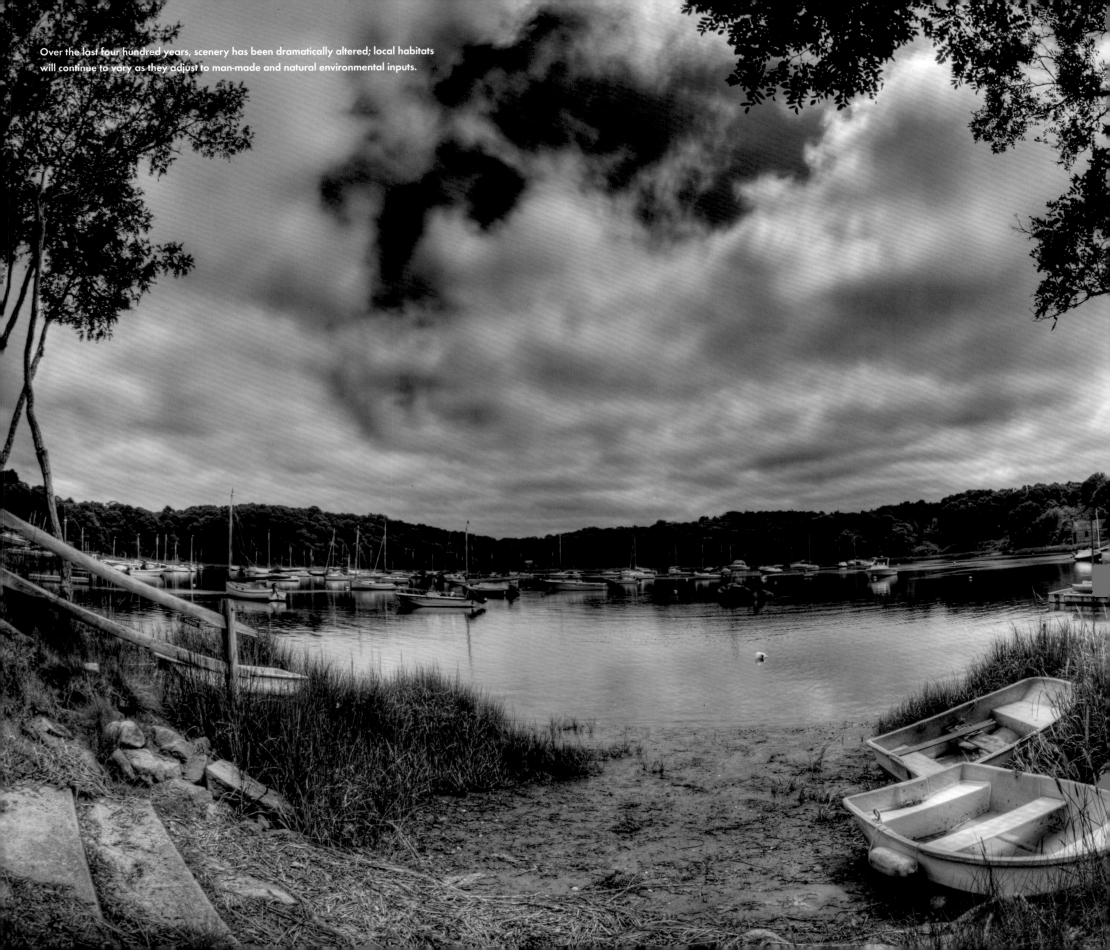

Over the last four hundred years, scenery has been dramatically altered; local habitats will continue to vary as they adjust to man-made and natural environmental inputs.

CHAPTER 6: THE FUTURE—
CAPE COD TRANSFORMED

What will happen to fish and invertebrate populations over the coming decades? Will the Cape and its current environment persist as the climate shifts and human population continues to grow? Change is the one constant in nature, and inevitably Cape Cod will undergo modification of its land and seascape. While a host of imminent challenges face Cape Cod, both Mother Nature and man will have a hand at shaping the future of the peninsula's underwater environment, its inhabitants, and its coast.

Many elements of Cape Cod's coastline remain as they were when first sighted by European explorers hundreds of years ago. It is heartening that coastal communities, from Paleo-Indian camps to contemporary villages, recognize that the water just off their doorsteps is central to their existence and wellbeing. From the immense amounts of protein it supplies through commercial and recreational fishing to the millions of tourists who swim, surf, and sail, the North Atlantic has always assumed valuable roles for mankind. If nurtured in an intelligent manner, this will not change.

To a marine scientist, Cape Cod is a laboratory, and the sea affords unique opportunities to investigate and understand the phenomenon of life from manifold aspects. In fact, marine invertebrates are proving to be a profuse source of bioactive compounds that have pharmacological significance. Researchers at the world-famous Woods Hole Oceanographic Institution in Falmouth have used locally caught long-finned squid to help neuroscientists investigate nervous system functions and debilitating

diseases such as heart disease, stroke, cancer, Alzheimer's, and others. Horseshoe crabs' compound eyes have been used as models for the study of vision. Horseshoe crab blood—specifically, Limulus amoebocyte lysate—which clots in response to endotoxins produced by gram-negative bacteria, is vital in testing humans, pharmaceuticals, and medical devices for toxins. Skate retinas have provided clues about how eyes adapt to light changes and given insight into diseases that cause blindness. Studying reproduction and development in green sea urchins has led to advanced reproductive technologies, including in vitro fertilization. The list of invaluable work and knowledge generated from marine studies goes on and on.

For humans, perhaps the greatest value of the sea is not scientific, economic, or utilitarian, but philosophical and spiritual. Whether approached for the first or the millionth time, the sea is a stimulating world to explore. We can immerse ourselves in its idealistic beauty and unassuming mystery. Water and its associated life dissolve away trivial inconveniences and renew the awe and enthusiasm for existence. But in this dynamic time, with so many environmental, economic, and social challenges, the future integrity of Cape Cod's marine and aquatic ecosystems is at risk.

Even for the most strident naysayer, it is becoming increasingly difficult to deny that Earth's climate is being altered both by mankind and the planet's innate cycles. Natural, well-established cycles, such as fish migration patterns and storm tracks, are quickly becoming less predictable.

As the world's sea surfaces warm, the distribution and abundance of flora and fauna is adjusting. Around the world, enormous population explosions of various species are occurring in places previously unknown for them. At the same time, population crashes are happening in places least expected. Though not obvious yet, the Cape is also experiencing acute ecological alterations. Sea level rise, ocean acidification, and the increased abundance and intensity of storms are also climate-related issues that directly affect Cape Cod's native marine life. If left unchecked, the relentless development of our coastlines worldwide and the growth in human population will create alarming challenges of an increasing magnitude. These concerns will affect the Cape and the people who cherish it, but they will also pose severe ecological threats to sensitive habitats.

The demand and quest for fish has undoubtedly had a major impact on New England and Cape Cod in particular. However, overexploitation of fish stocks—to the point of population collapse—is endemic to fisheries worldwide, not just off the Cape. As soon as one stock of fish is exploited to where it is no longer lucrative to pursue it, fleets direct their attentions toward another, more numerous species without considering the consequences of their actions. Sadly, this practice persists despite sound data showing that although vast and unpredictable, the ocean is far from inexhaustible. Like spawning failures due to estuarine habitat destruction, visible results of over-fishing often lag behind the events that cause them

by several years. Fisheries management has come a long way over the last century, concentrating now on preserving critical habitats and prey rather than fully exploiting them. This idea translates to greater fish populations and thus protects fishermen's long-term wellbeing. Protecting the sea is like banking an ecological asset that yields high dividends, not only of fish but also genetic diversity and a source of materials for restoring overexploited areas.

In the face of these pressures, however, credit should be given to local and state governments, non-governmental and non-profit organizations, as well as to scientists and fishermen, who have taken some measures to control impacts of climate change, coastal development, and overexploitation of resources. The general public has become increasingly aware of the importance of maintaining natural habitats such as salt marshes, bays, ponds, and lakes, as well as the open ocean, thereby protecting wildlife diversity and abundance. Awareness of these many issues is now widespread, and it is time to act. For the sake of future generations, people can no longer afford to ignore wasteful and ignorant habits.

The oceans are the first and last great resource on Earth. The future of Cape Cod's rich natural endowment of marine and aquatic life is very much the responsibility of her people. This endowment, though sufficient to accommodate limited and intelligent development, a measure of exploitation, and the pressures of a changing climate, is finite. The governing agents of Cape Cod have already

The oceans are the first and last great resource on Earth

126

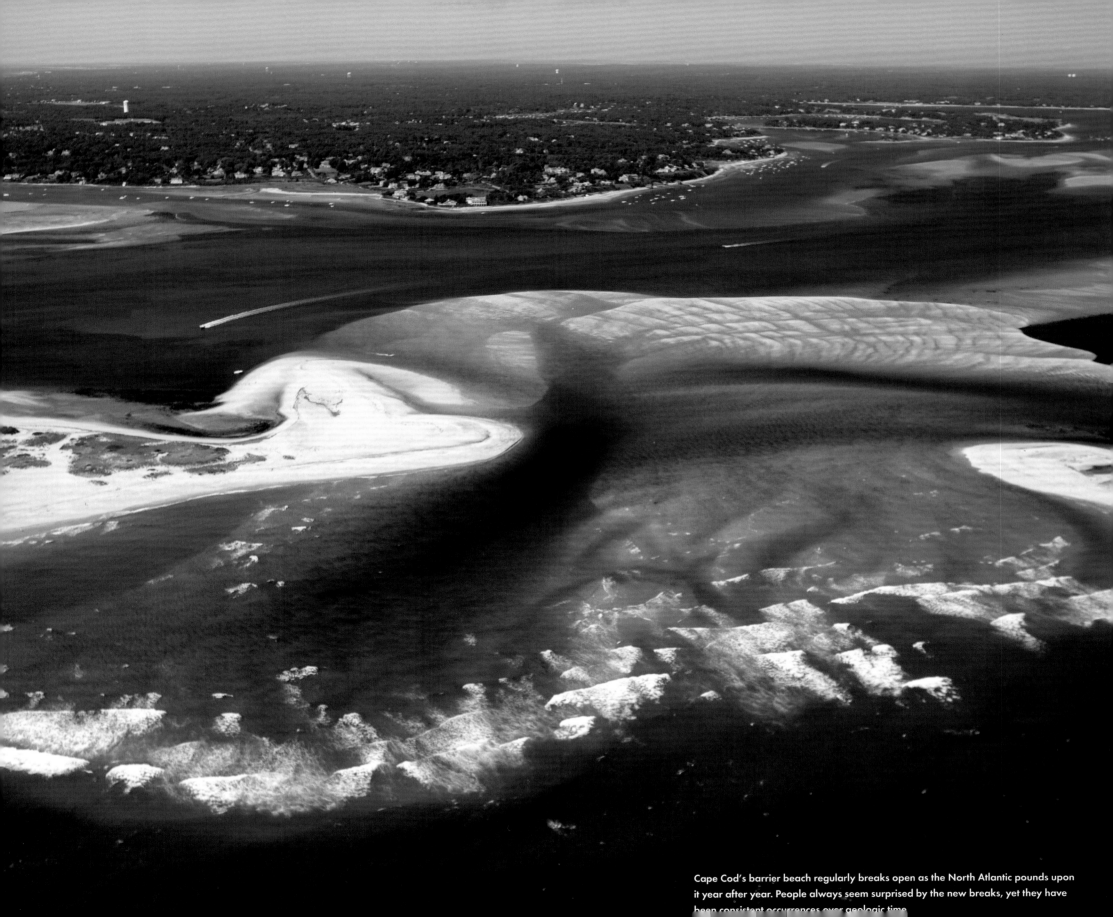

Cape Cod's barrier beach regularly breaks open as the North Atlantic pounds upon it year after year. People always seem surprised by the new breaks, yet they have been consistent occurrences over geologic time.

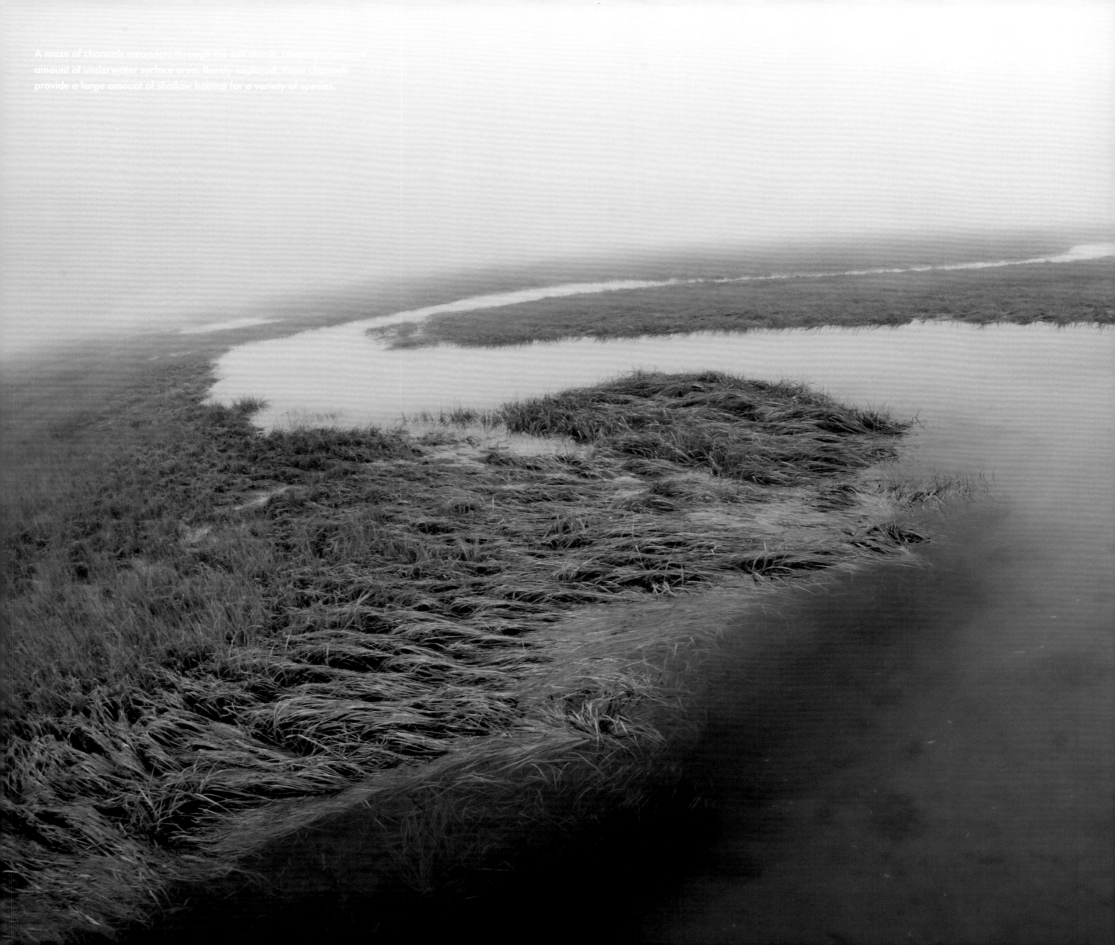

A maze of channels meanders through the salt marsh, creating a massive amount of underwater surface area. Rarely explored, these channels provide a large amount of shallow habitat for a variety of species.

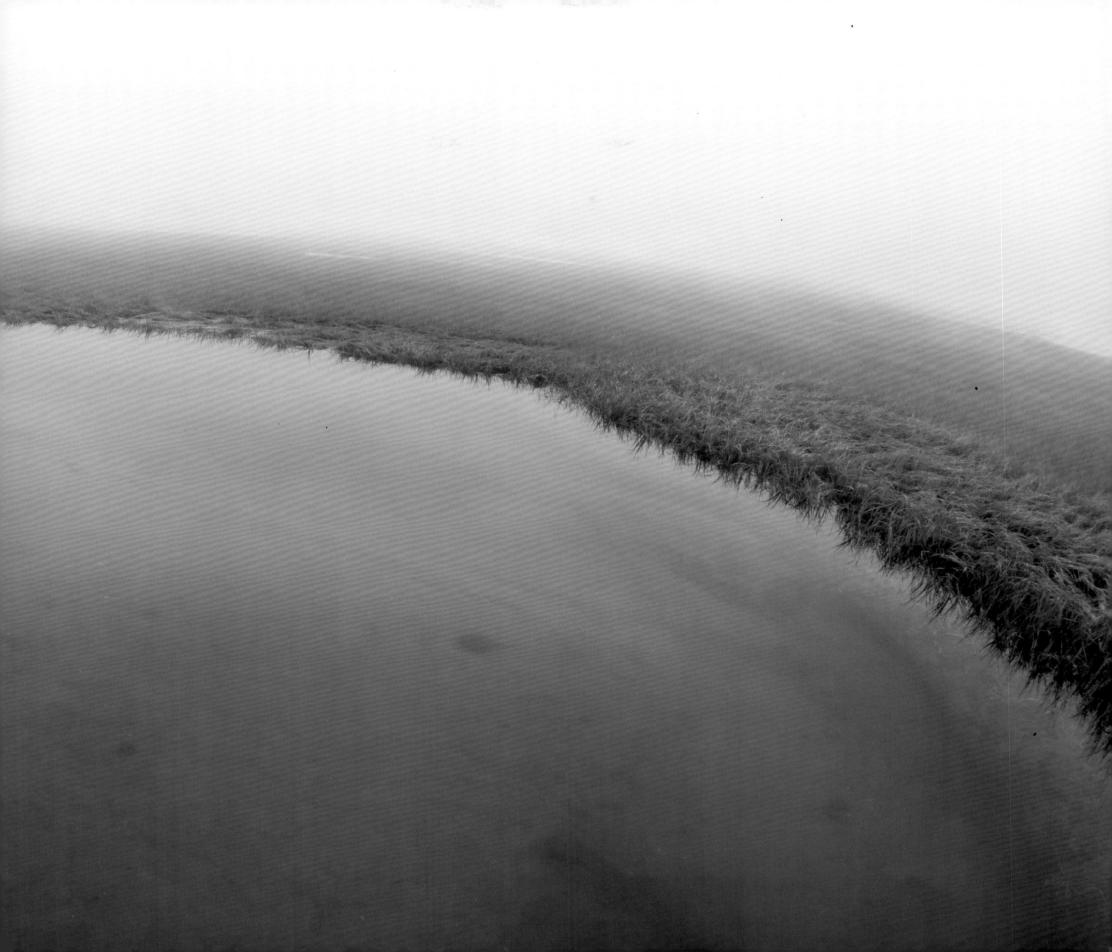

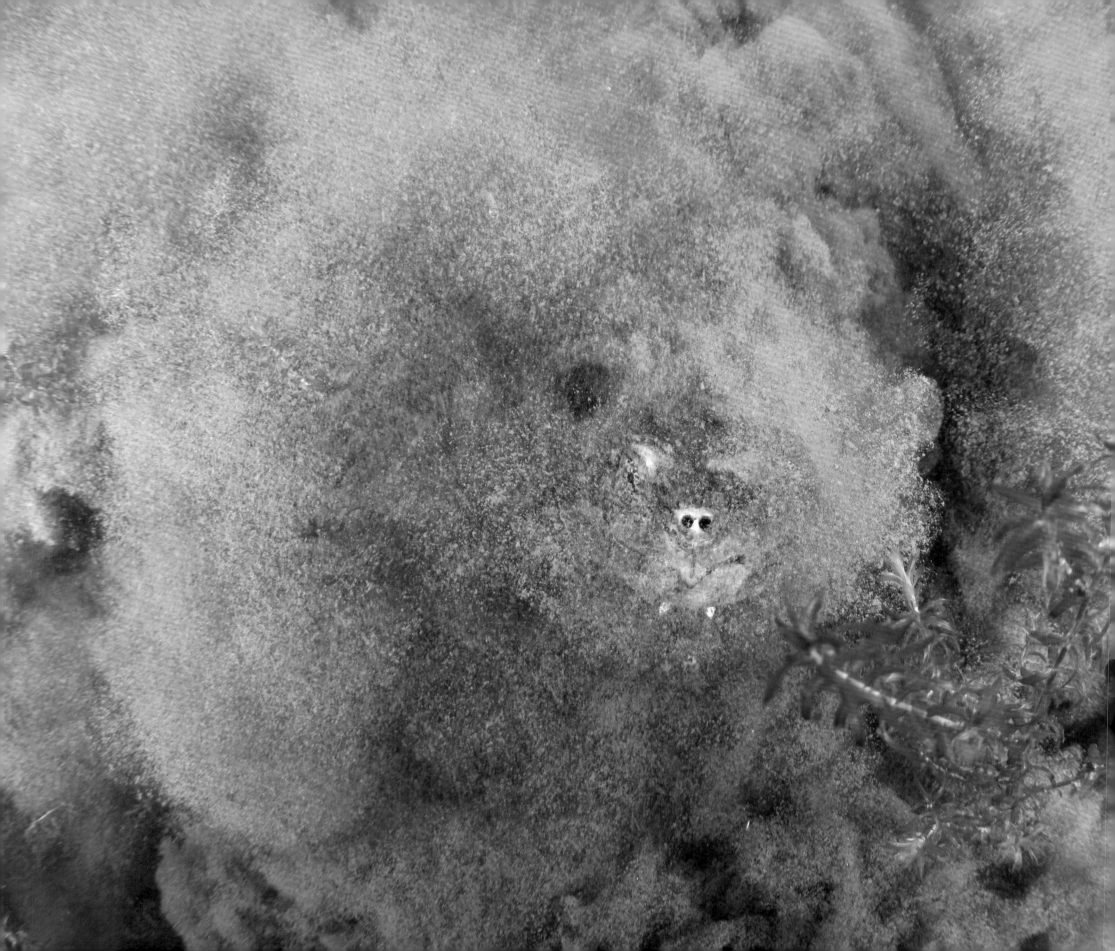

Out of a murky cloud of stirred-up mud, a reptilian apparition appears. It is a full-grown snapping turtle, at least three feet from head to tail. Snappers weighing more than eighty pounds have been recorded. Though common in freshwater, the species is often spotted in seawater systems.

taken positive steps toward protecting its future by developing a representative system of biologically valuable and scenic protected areas. Regardless of such efforts, however, it is vital to keep in mind that the marine environment remains a changing, integrated one. Like each chapter of this book, each distinct ecosystem—the salt marsh, the bay, the ocean, and the bodies of freshwater—comprise the whole. It is not enough to concentrate on simply protecting a few scattered sites with the hope that the remainder of the ecosystem will look after itself. There has never been a greater need for coordination in the management of the peninsula's marine and coastal resources; mounting pressures from economic and social desires to exploit and develop these ecosystems must be matched by a strong environmental component. This will ensure that these fragile environments are carefully and willingly managed for the long-term health of the environment. In its natural state, a healthy environment brings innumerable benefits and pleasures to the people of Cape Cod and the many visitors who come to share, enjoy, and appreciate the Cape's rich natural beauty.

People and communities are presently fixtures on Cape Cod's landscape, but in a geologic sense, we are merely trespassing on a coast that is changing in the flow of time. Whatever happens, because of or despite humans, the sea will eventually be the one to shape Cape Cod's future. As the shoreline alters over the years, communities of life will change, never reaching stasis, never quite the same from season to season. Though much of Cape Cod's geologic and ecological history has been established, there is still much that is unknown about its interconnectedness. The sounds of the cold North Atlantic, echoes of the past and future, tirelessly crashing on sand, rushing through channels, and gently whispering through marsh grasses, continuously remind us of what is indefinite.

Sea stars climb over algae, sponges, hydroids, and barnacles, searching for food. Even with land erosion, particular marine life, like sea stars, should remain unaffected for the near future, as long as their bivalve prey continues to thrive.

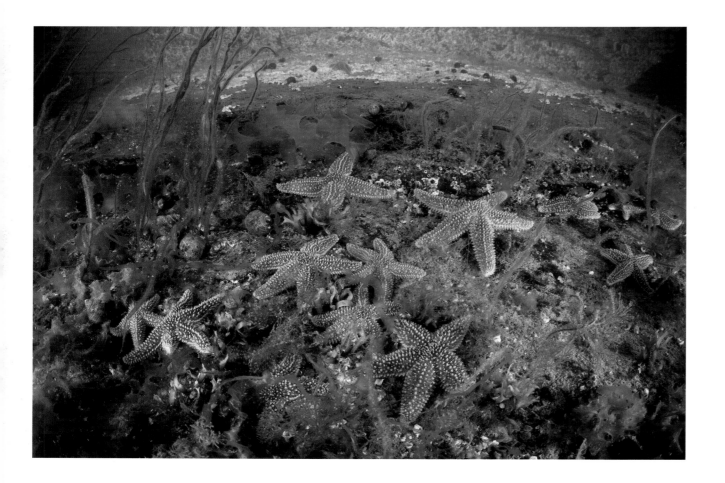

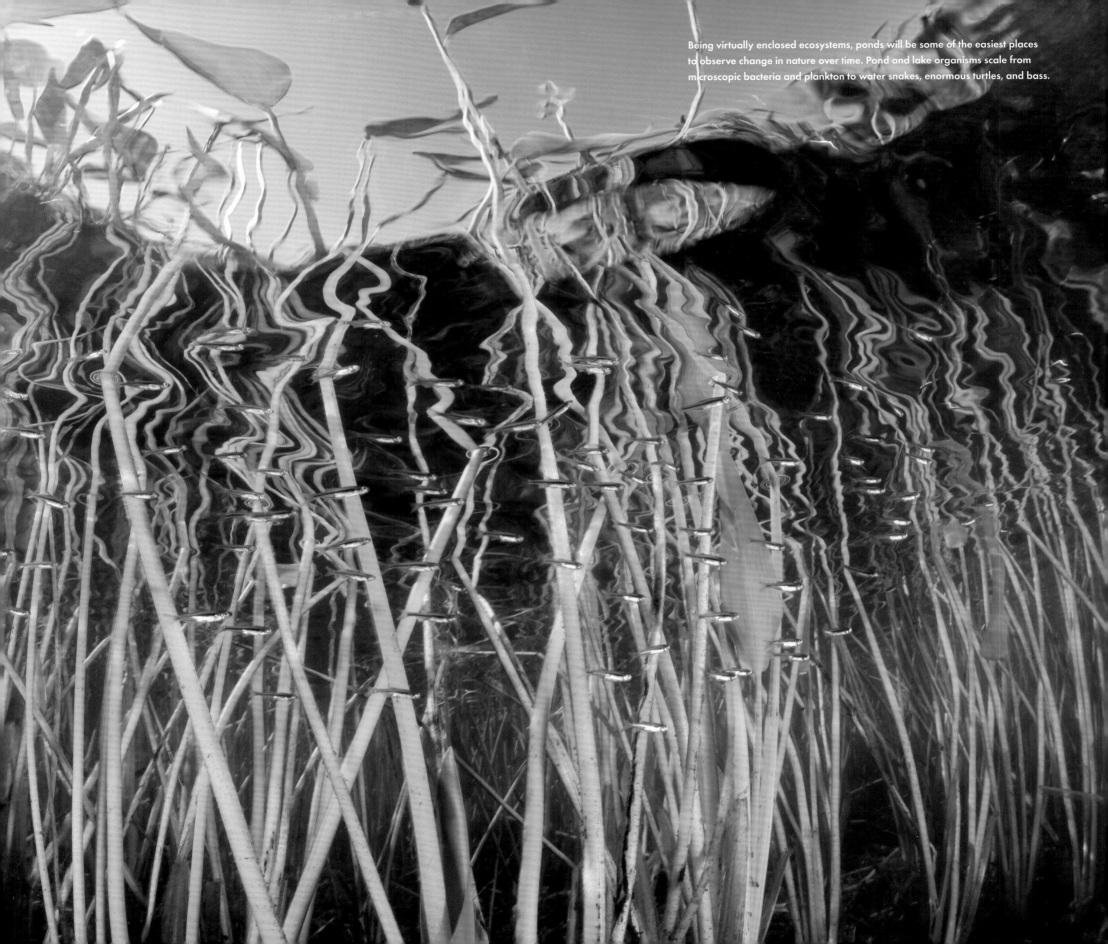

Being virtually enclosed ecosystems, ponds will be some of the easiest places to observe change in nature over time. Pond and lake organisms scale from microscopic bacteria and plankton to water snakes, enormous turtles, and bass.

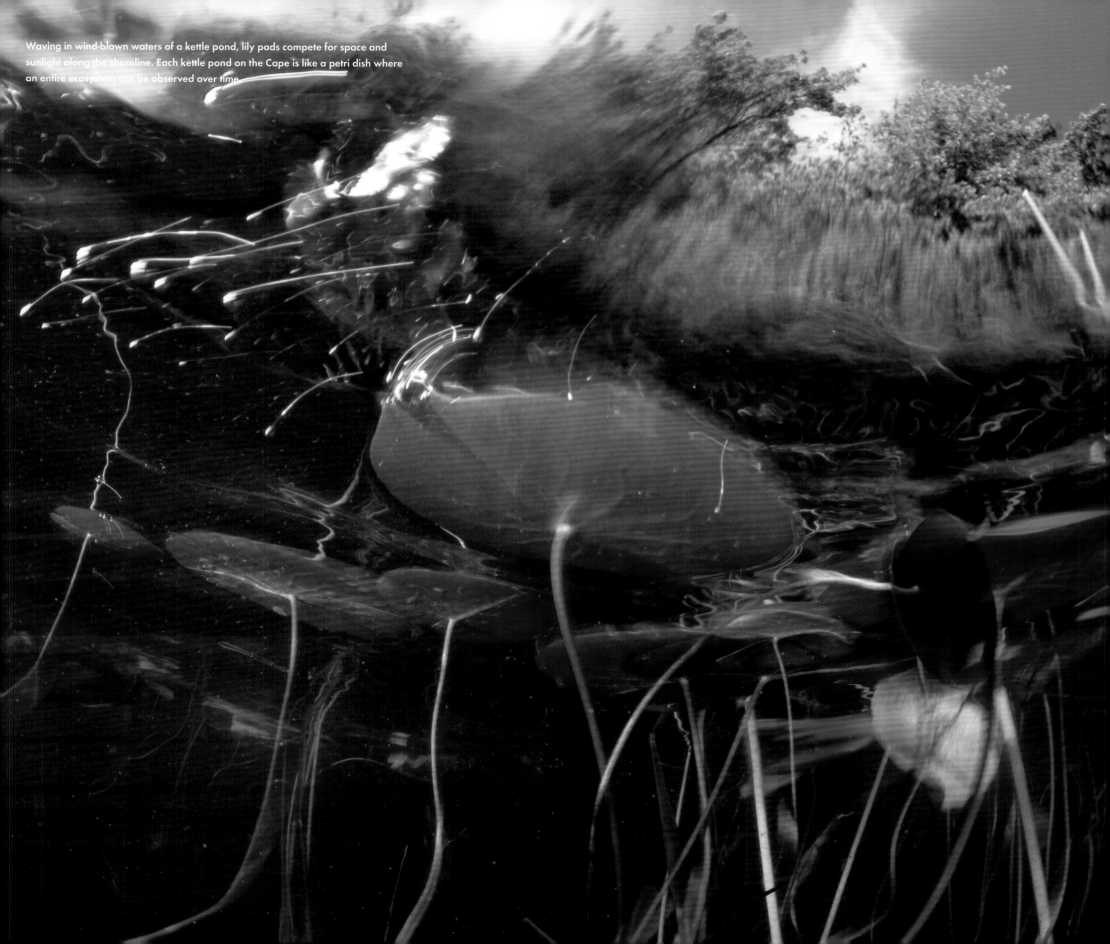

Waving in wind-blown waters of a kettle pond, lily pads compete for space and sunlight along the shoreline. Each kettle pond on the Cape is like a petri dish where an entire ecosystem can be observed over time.

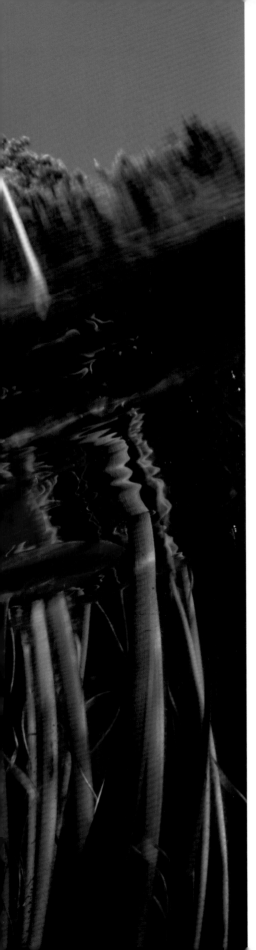

Usually found behind barrier beaches or tidal flats, salt marshes are among the planet's most productive ecosystems. Native marsh grass still flourishes in large swathes of coastal wetland across the Cape, but coastal development is a persistent threat to the marsh ecosystem.

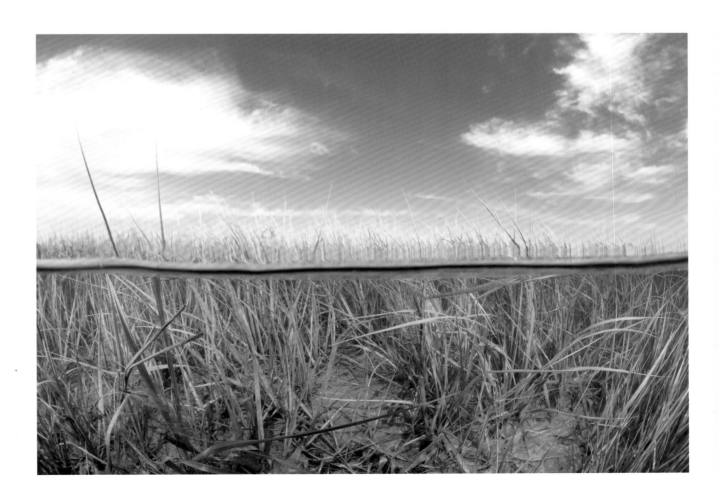

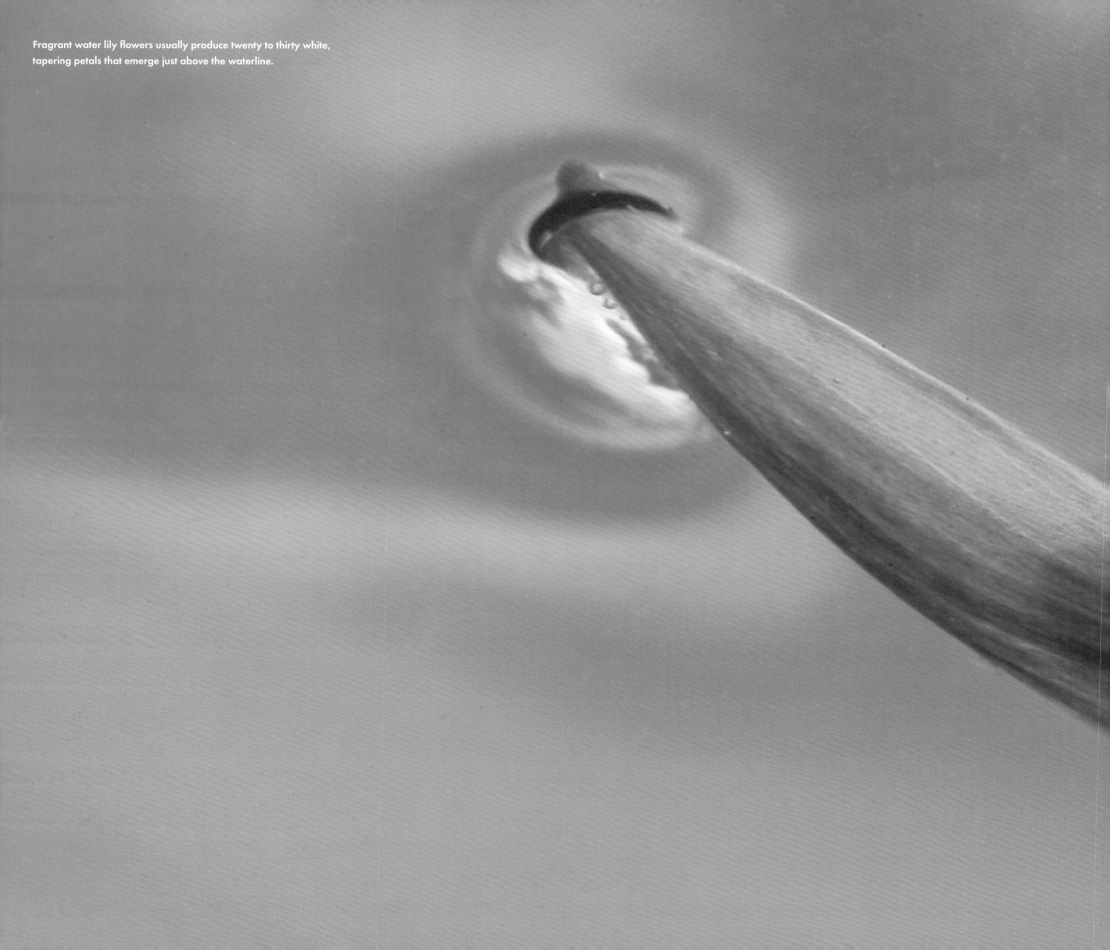

Fragrant water lily flowers usually produce twenty to thirty white, tapering petals that emerge just above the waterline.

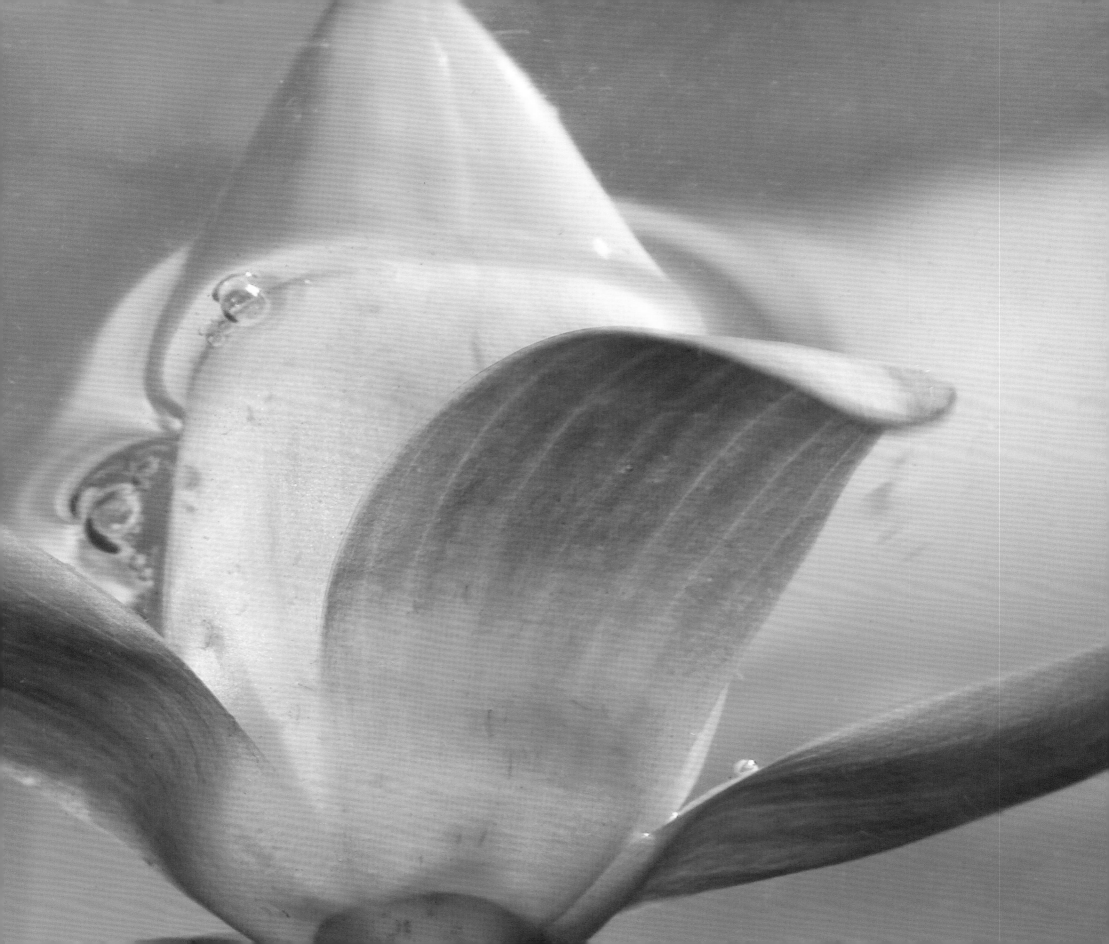

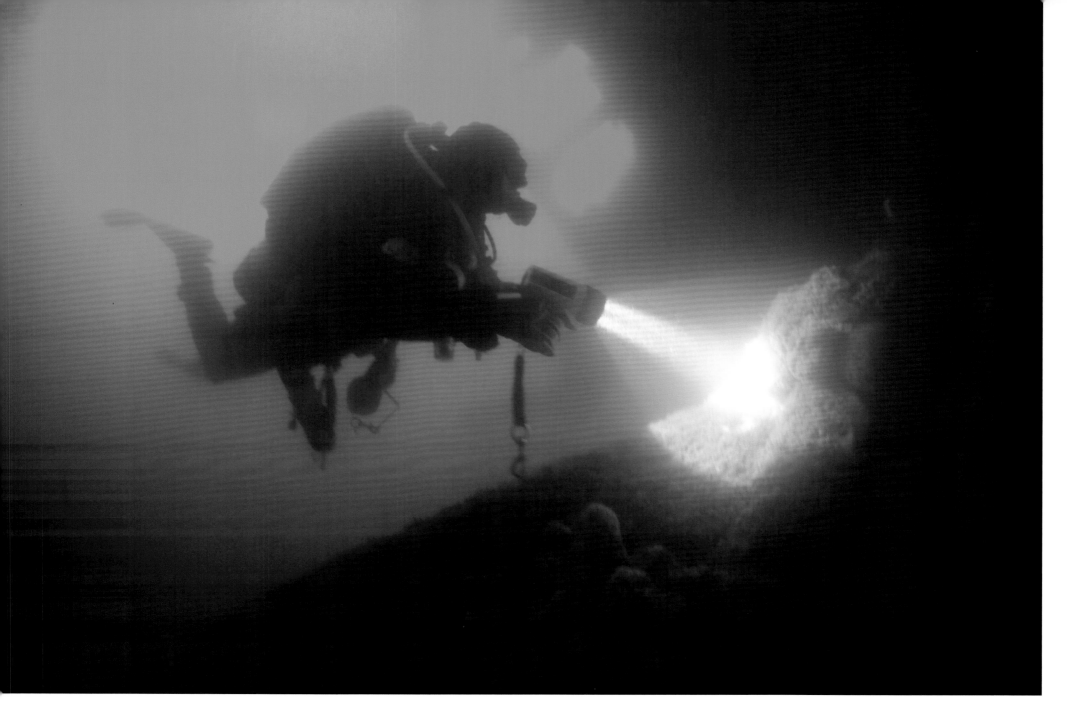

Over the coming decades, man will undoubtedly continue to explore further and deeper, learning more about Cape Cod's natural and man-made history. We are still scratching the surface of understanding the world around us.

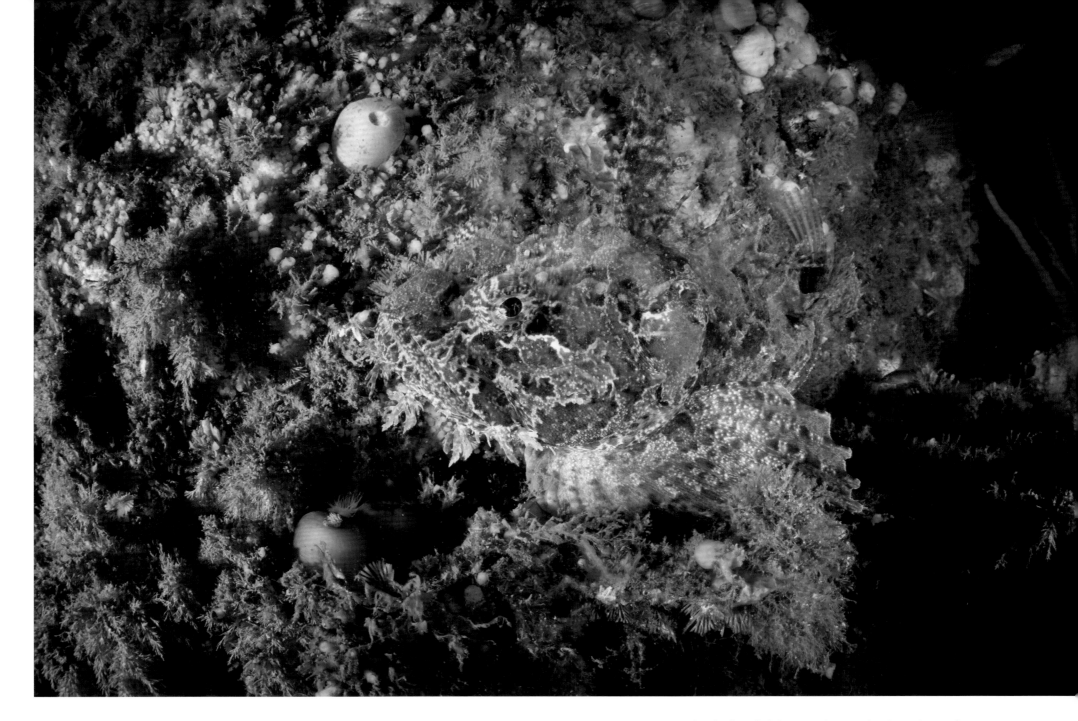

Colored cells, called chromatophores, within the epidermis of a sea raven create an effective camouflage against its living background. There is a delicate balance within fish between flashy traits that assist sexual selection and traits that increase the ability to feed and escape predation.

139

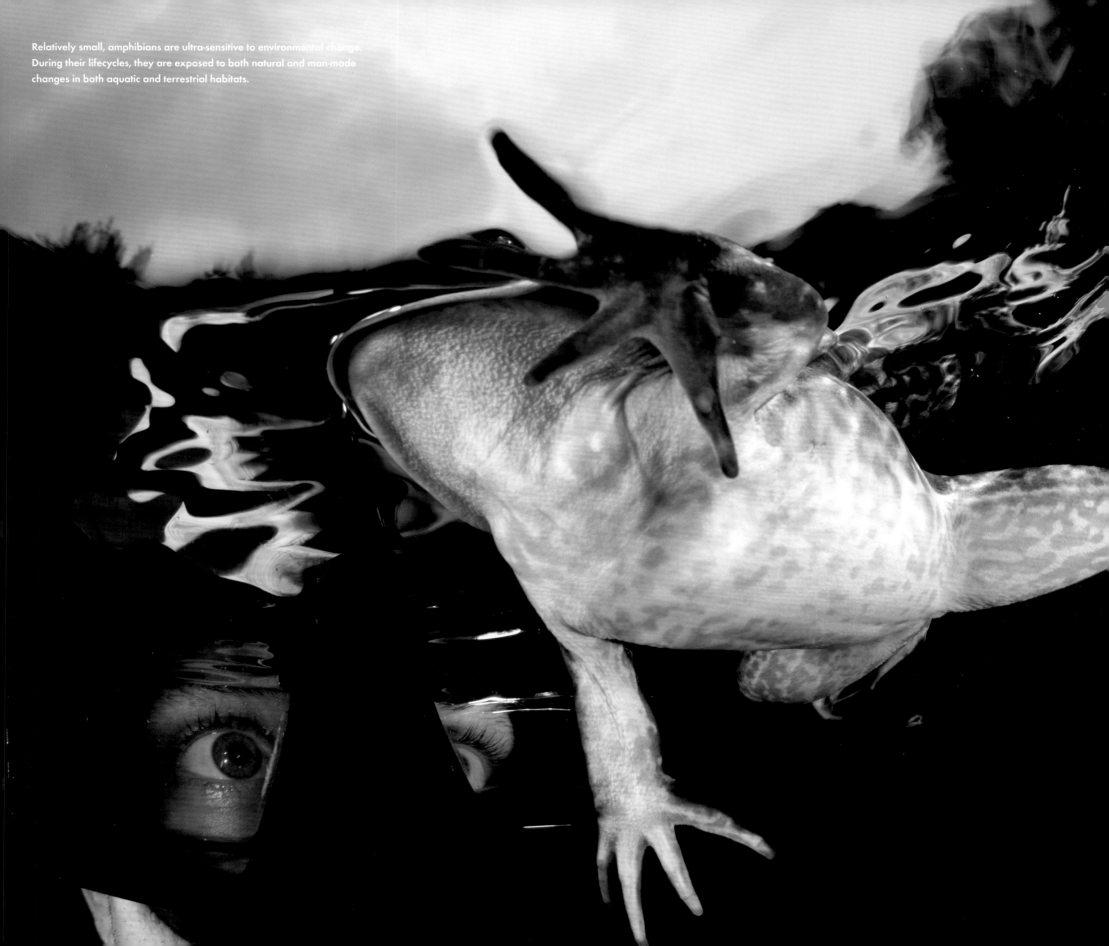

Relatively small, amphibians are ultra-sensitive to environmental change. During their lifecycles, they are exposed to both natural and man-made changes in both aquatic and terrestrial habitats.

A molted carapace, eelgrass, and rockweed washes ashore on a high tide. The incessant tides bring nutrient-filled compost to the shores of Cape Cod on a continual cycle. Without such nutrient input, intertidal vegetation would suffer and shorelines would erode much more quickly.

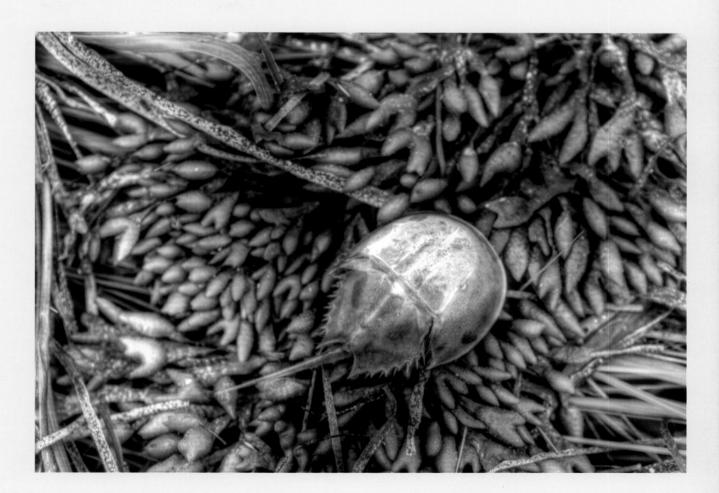

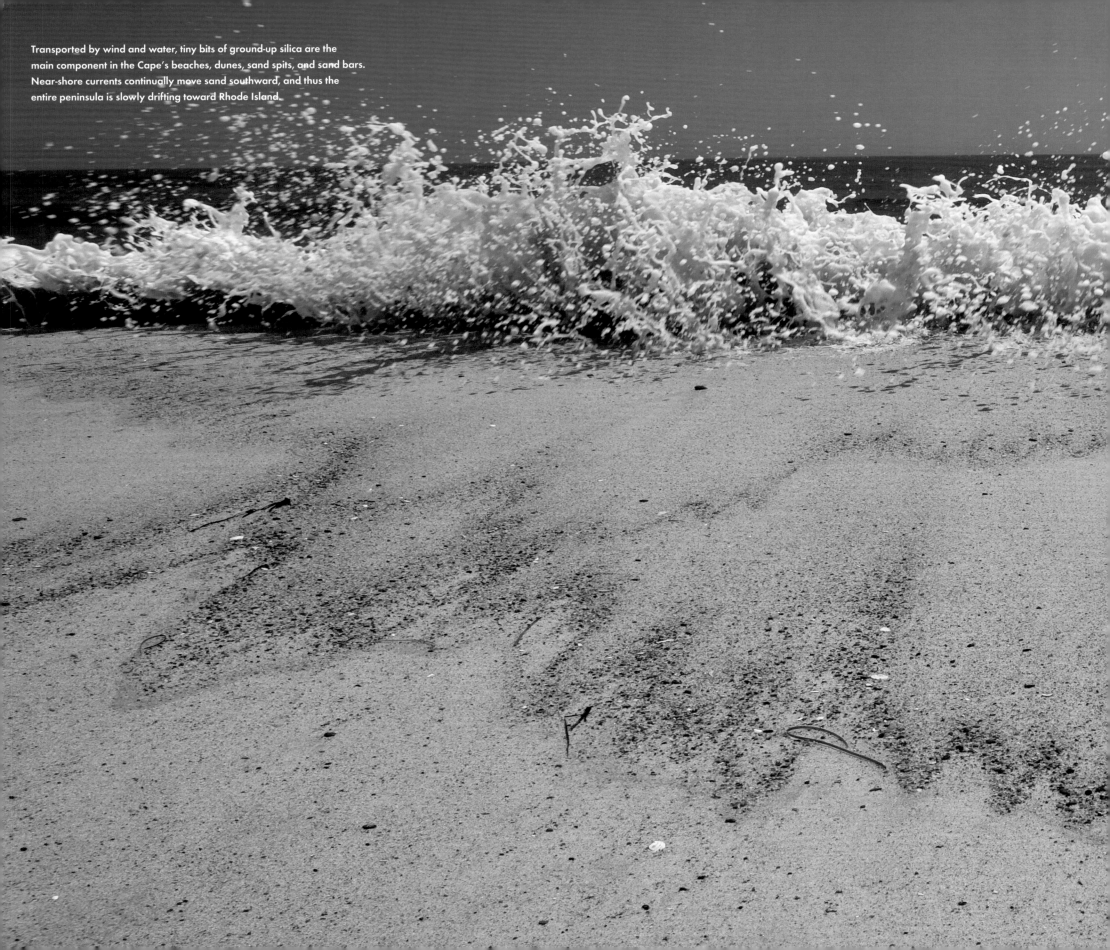

Transported by wind and water, tiny bits of ground-up silica are the main component in the Cape's beaches, dunes, sand spits, and sand bars. Near-shore currents continually move sand southward, and thus the entire peninsula is slowly drifting toward Rhode Island.

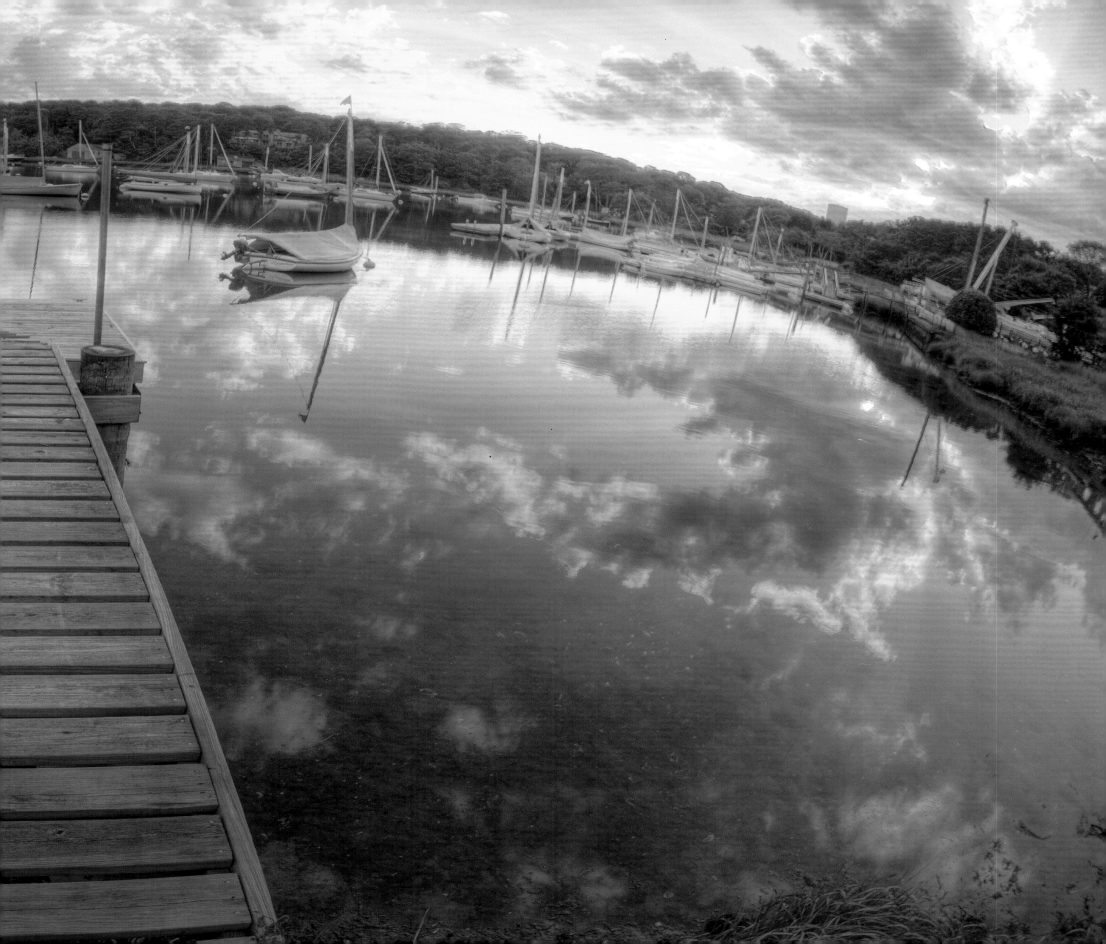

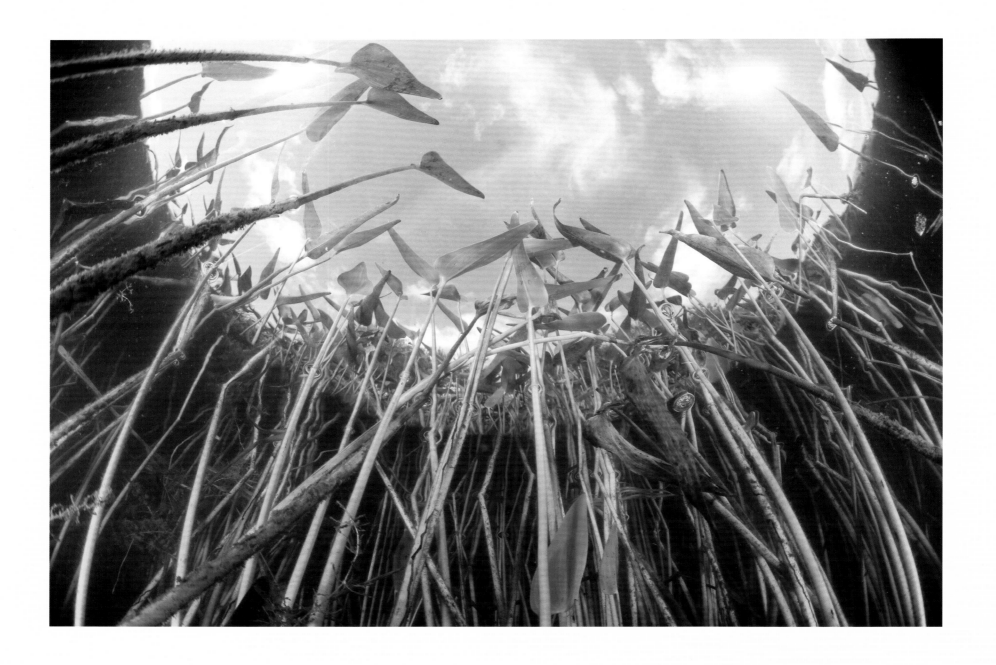

GLOSSARY OF TERMS

Acidification: The ongoing decrease in the pH of the Earth's oceans caused by the uptake of anthropogenic carbon dioxide from the atmosphere.

Algae: A large and diverse group of simple, typically autotrophic organisms, ranging from unicellular to multicellular forms. The largest and most complex marine forms are called seaweeds. They are photosynthetic, like plants, and considered "simple" because they lack the many distinct organs found in land plants.

Amphipods: An order of animals that includes over seven thousand described species of shrimp-like crustaceans ranging from 1 millimeter to 140 millimeters in length. Marine amphipods may live in the water column or on the ocean bottom.

Angiosperm: A flowering plant. They are the most diverse group of land plants.

Anoxic: Depleted of dissolved oxygen. This condition is generally found in areas that have restricted water flow.

Arthropod: An invertebrate that has an exoskeleton, a segmented body, and jointed appendages. Arthropods are members of the phylum Arthropoda and include insects, arachnids, and crustaceans.

Ascidians: Marine filter feeders characterized by a tough outer tunic. Members of the Urochordata subphylum. Ascidians are found all over the world and are often confused with sponges due to their similar appearance.

Autotomization: Self amputation, usually performed as a self-defense mechanism. The lost body part may be regenerated later.

Baleen: Plates or combs of keratin used as sieves by certain cetaceans, such as humpback whales, to filter feed.

Bioactive: Having the capacity to interact with a living tissue or system.

Bivalves: Marine and freshwater mollusks belonging to the class Bivalvia, which contains thirty thousand described species and includes scallops, clams, oysters, and mussels.

Bryozoans: Typically tiny aquatic invertebrate animals in the phylum Bryozoa. These animals sieve food particles out of the water using a lophophore, a crown of tentacles lined with cilia. They often look like miniature corals but are not closely related.

Caprellids: A diverse family of amphipods.

Carnivores: Animals that derive their energy and nutrient requirements from a diet consisting of vertebrate and/or invertebrate animal tissue.

Carpace: A dorsal section of the exoskeleton of crustaceans.

Chitonous: Describing a substance whose main component is chitin, a derivative of glucose. Chitin is the primary substance found in the exoskeletons of crustaceans.

Chromatophores: Cells found in fish, amphibians, crustaceans, and cephalopods that contain pigment or are light-reflecting. The cells are largely responsible for generating skin color.

Copepods: A group of small crustaceans found in nearly every marine and freshwater habitat. They can drift in plankton or live on the ocean floor and are usually the dominant members of the zooplankton, providing food for fish, whales, birds, and other crustaceans.

Cordgrass: *Spartina alterniflora*, a native grass that is found in marsh and estuarine areas. It prevents soil erosion.

DDT: A powerful insecticide that is toxic to animals, including humans. It remains active in the environment for many years and has been banned in the United States for most uses since 1972.

Decapod: A crustacean in the Decapoda order. The decapods include crabs, lobsters, and shrimp.

Diatoms: A group of eukaryotic algae and one of the most common types of phytoplankton. Most diatoms are unicellular and are found in open water.

Dinoflagellates: A large group of flagellated protists, mostly marine plankton. Their populations are distributed depending on temperature, salinity, or depth. About 50 percent of dinoflagellates are photosynthetic.

Echinoderms: A phylum of marine animals that contains about seven thousand species. The group contains sea stars, brittle stars, urchins, sand dollars, sea cucumbers, and crinoids.

Echolocation: Biological sonar used by most whales. It involves using sound in an environment and listening to the echoes that return. This allows the organism to locate and identify objects.

Ecosystem: A system of interdependent organisms that share the same habitat in an area.

Ectosymbionts: Organisms that live on the surface of another organism to the benefit of both.

Ephiphytes: Plants that grow upon another plant non-parasitically.

Estuarine: Describing a semi-enclosed coastal body of brackish water, often with a connection to the open sea, subject to tides, waves, varying salinities, fresh water, and sediment.

Exoskeleton: An external skeleton that supports and protects an animal's body. Crustaceans all have exoskeletons.

Fluviatile: Applying to sediments of river origin.

Gastropods: A group of mollusks commonly known as snails and slugs. This most diversified class in the phylum Mollusca contains from sixty thousand to eighty thousand living species.

Gonopore: A genital pore in some marine invertebrates.

Hydroids: Carnivorous animals, related to jellyfish, anemones, and corals, that feed on minute crustaceans. Some species are solitary, while others live in colonies.

Hydraulic: The mechanical properties of liquids.

Keratin: Fibrous structural proteins that form hard but un-mineralized structures found in reptiles, birds, amphibians, and mammals.

Marine Mammal Protection Act: Enacted on October 21, 1972. Protects all marine mammals and prohibits, with certain exceptions, the "take" of marine mammals in U.S. waters.

Peat: An accumulation of partially decayed vegetation matter that forms in bogs and marshes. Upon drying, peat can be used as a fuel.

Pelagic: A zone of the ocean that is away from the coast and not close to the bottom.

Photic zone: The depth of the water that is exposed to sufficient sunlight for photosynthesis to occur. The depth of the zone can be greatly affected by seasonal turbidity.

Phytoplankton: The autotrophic component of the plankton community. Most phytoplankton, which obtain food through photosynthesis, are too small to be seen with the naked eye.

Pinnipeds: Marine mammals that include seals and walrus.

Planktonic: Drifting in the pelagic zone of oceans or bodies of fresh water. Plankton consist of animals, plants, or bacteria. They provide a crucial food source to many species.

Polychaetes: Segmented annelid worms often called bristle worms. They are widespread, occurring throughout the Earth's oceans at all depths.

Polyps: Multicellular, radially symmetrical organisms that feed on a variety of tiny plankton. They are within the phylum Cnidaria and contain nematocysts, or stinging cells, in their tentacles.

Protozoa: Flagellated microorganisms classified as unicellular eukaryotes. Most scientists use the word to refer to a unicellular heterotrophic protist, such as an amoeba.

Rhizomes: A characteristically horizontal stem of a plant found underground.

Salinity: The saltiness or dissolved salt content of a body of water.

Saprotrophic: A process of chemoautotrophic extracellular digestion involved in the processing of decayed organic matter.

Sessile: Permanently attached to the bottom.

Spermatophore: A capsule or mass created by males of various animals, containing spermatozoa and transferred in entirety to the female's ovipore, a pore-like sexual organ of a female insect, during copulation.

Sulci: Depressions or fissures in the surface of an organ.

Thermohaline: The temperature and salt content of ocean water. These factors determine the density of sea water. Thermohaline circulation refers to large-scale ocean circulation driven by density gradients created by surface heat and freshwater fluxes.

Tidal flats: Sand or mud areas that sometimes abut salt marshes and typically lack recognizable plant life. Tidal flats are neither fully terrestrial nor aquatic.

Trophic: Describing an organism's position in the food web.

Vertebrates: Members of the subphylum Vertebrata. Chordates with backbones or spinal columns, including bony fish, sharks, rays, amphibians, reptiles, mammals, and birds.

Wrasses: A large and diverse family of marine fish, Labridae, many of which are brightly colored.

Zooplankton: The heterotrophic type of plankton drifting in the water column of oceans and bodies of freshwater.

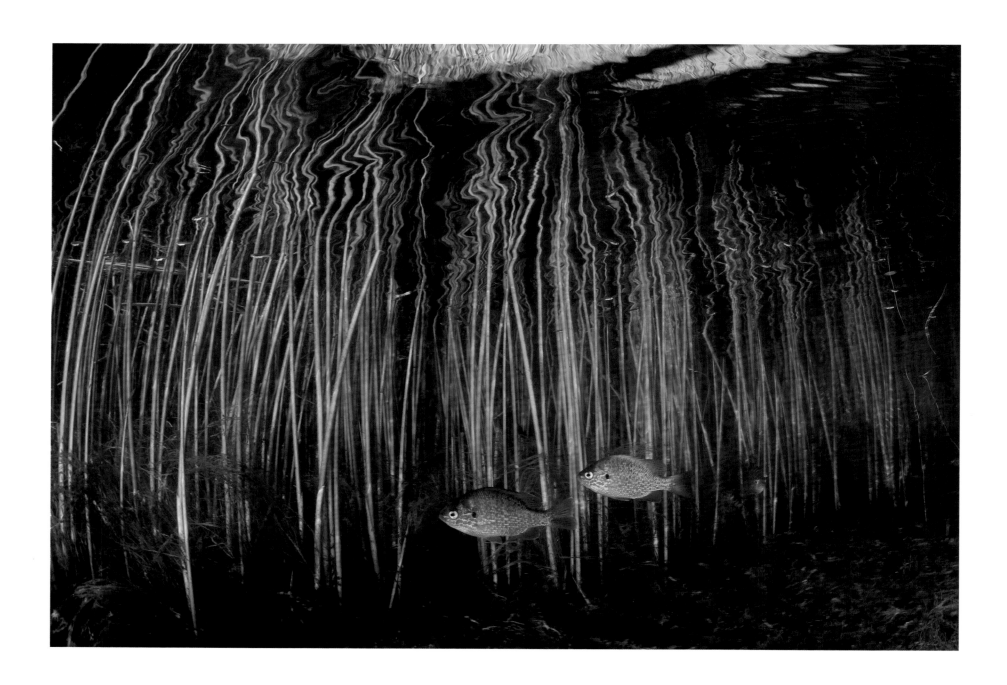